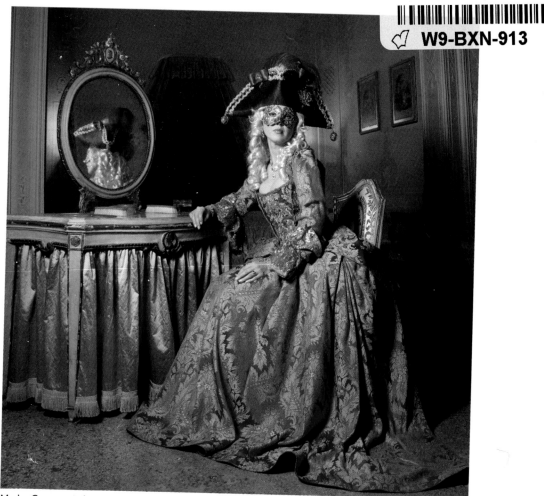

Mariza Gasparotti photographed on the Venice workshop organized by VSP Workshops (www.vspworkshops.com)

Rick Sammon's Digital Photography Secrets

Rick Sammon

WILEY

Wiley Publishing, Inc.

Rick Sammon's Digital Photography Secrets

Published by
Wiley Publishing, Inc.
10475 Crosspoint Boulevard
Indianapolis, IN 46256
www.wiley.com

Copyright © 2009 by Wiley Publishing, Inc., Indianapolis, Indiana

Published simultaneously in Canada

ISBN: 978-0-470-42873-3
Manufactured in the United States of America

10 9 8 7 6 5 4 3 2 1

For general information on our other products and services or to obtain technical support, please contact our Customer Care Department within the U.S. at (800) 762-2974, outside the U.S. at (317) 572-3993 or fax (317) 572-4002.

Wiley also publishes its books in a variety of electronic formats. Some content that appears in print may not be available in electronic books.

Library of Congress Control Number: 2008938484

About the Author

Rick Sammon
(lower tandem jumper), falling to earth at 125 miles per hour, during one of the few times that he was not photographing, writing a book, leading a workshop or giving a seminar.

Credits

Acquisitions Editor
Courtney Allen

Project Editor
Mimi Brodt

Technical Editor
Joe Farace

Copy Editor
Mimi Brodt

Editorial Manager
Robyn Siesky

Business Manager
Amy Knies

Senior Marketing Manager
Sandy Smith

**Vice President and
Executive Group Publisher**
Richard Swadley

Vice President and Publisher
Barry Pruett

Book Designer
Erik Powers

Proofreader
Laura Sinise

Media Development Project Manager
Laura Moss

**Media Development Assistant
Project Manager**
Jenny Swisher

Acknowledgments

As you saw on the cover of this book, I get credit for writing this book. Sure, I put a ton of work into it, but the truth is I had a lot of help – just like every author. It's the same for all artists. Take Tom Cruise, for example, he gets top billing, but he has dozens and dozens of people – including make-up artists, lighting directors, set designers, acting coaches and so on – who make him look good.

So I thought I'd take this opportunity to thank the folks who helped put together this work, as well as those who have helped me along the path to producing this book, which is my 31st.

The guy who initially signed me up for this book is the same guy who made my Canon Digital Rebel and Basic Lighting DVDs happen: Barry Pruett, Vice President and Publisher at Wiley. Barry has a quality that every author needs: faith in the author's belief that someone actually wants to hear what he or she has to say!

Once I was signed up, Courtney Allen, an Acquisitions Editor at Wiley, took over the project, helping me big time with everything that you see between the front and back covers. Not an easy task, especially considering that the book was produced in just a few months.

More help was on the way! Joe Farace, my technical editor, also added his expertise, especially in the digital darkroom section. Thanks, Joe!

Getting back to Wiley, I also want to thank Mimi Brodt, freelance editor, for her work as Copy Editor and Project Editor, Erik Powers of Creative Powers for his phenomenal job at designing and producing the book, and Mike Trent for his work on the front and back cover design. Thank you all for your eagle eyes and artistic flair!

Someone who has been helping me for 58 years also worked on this book. My dad, Robert M. Sammon, Sr., who is 90, actually read each and every word, using his wordsmith skills to improve my words! I could not have done it without you, Dad.

Two more Sammons get my heartfelt thanks: my wife, Susan, and son, Marco. For years, they both supported my efforts and helped with the photographs. Thanks, Susan and Marco, for all your help and love.

Julieanne Kost, Adobe Evangelist, gets a big thank you for inspiring me to get into Photoshop in 1999. Addy Roff at Adobe also get my thanks. Addy has given me the opportunity to share my Photoshop techniques at trade shows around the country.

Some friends at Apple Computers also helped me during the production of this book by getting me up to speed with Aperture 2, the application I use most often to import and edit my photographs. So, more thank you notes go to Don Henderson, Fritz Ogden and Kirk Paulsen.

Other friends in the digital imaging industry who have helped in one way or another include David Leveen of MacSimply and Rickspixelmagic.com, Mike Wong and Craig Keudell of onOne Software, Wes Pitts of *Outdoor Photographer* and *PCPhoto* magazines, Ed Sanchez and Mike Slater of Nik Software, Scott Kelby of *Photoshop User* magazine and Chris Main of *Layers* magazine.

At Mpix.com, my on-line digital imaging lab, I'd like to thank Joe Dellasega, John Rank, Dick Coleman and Richard Miller for their on-going support of my work.

Rick Booth, Steve Inglima, Peter Tvarkunas, Chuck Westfall and Rudy Winston of Canon USA have been ardent supporters of my work, as well as my photography seminars. So have my friends at Canon Professional Service (CPS). My hat is off to these folks, big time! The Canon digital SLRs, lenses and accessories that I use have helped me capture the finest possible pictures for this book.

Jeff Cable of Lexar hooked me up with memory cards (4GB and 8GB because I shoot RAW files) and card readers, helping me bring back great images from my trips.

I'd also like to thank Christine Keys of ExOfficio for supplying me with clothing for keeping me comfortable in the field, which is actually very important to me – because I went to Catholic grammar school and was very uncomfortable in my uniform for years (which seemed like a lifetime).

Of course, all my photographer friends who sent me photographs and tips for the "With a Little Help from My Friends" chapter get a warm thank you. Don't miss a single tip here!

My photo workshop students were, and always are, a tremendous inspiration for me. Many showed me new digital darkroom techniques, some of which I used in this book. During my workshops, I found an old Zen saying to be true: "The teacher learns from the student."

So thank you, one and all. I could not have done it without you!

Dedicated to the four people from whom I have learned the most in life.

In order of appearance . . .

My mother, Josephine, and dad, Robert. My wife, Susan, and son, Marco.

"We are a part of everyone we meet."

Contents

Foreword

For most of us, daily reality includes raising children, mortgage payments, aging parents and career obligations. To balance these demands, many of us enjoy creative pursuits including photography, painting, gardening or visiting museums and galleries. Have you ever wondered, "What would it take to leave your day job and dedicate yourself to making art full-time?" If this seems like a drastic move, consider developing a parallel professional career that allows you to follow your dreams. Whatever your profession, leading a dual life allows you to experience the best of both worlds – financial security and ongoing creative development. Teaching is a natural pursuit for many artists, but sadly being a talented artist doesn't mean that the person is an equally talented teacher.

I've had the pleasure of meeting Rick Sammon and more importantly, seeing him teach. The man is a lightning-fast, silver-haired energy bundle, and the first thing that strikes you is his sparkling eyes and ready smile. Rick loves life, which is very apparent in his passion for music, travel, family and photography. But Rick has one more passion we all benefit from – teaching. He loves to inform, inspire and enlighten, and the idea that this book is called Rick Sammon's Top Digital Photography Secrets is wonderfully absurd. Rick doesn't believe in secrets; if he did he wouldn't have written this book! Part of enjoying life for Rick is inspiring and sharing with others, and as an educator I know how much he benefits from teaching. Perhaps Rick wrote this book for himself – that is how much he loves to teach and share!

In exchange for reading this book, I challenge you to share one "secret" you learned that helped you to make better images with two other people. Show, explain and inspire your passion to your friends and family with the same energy that Rick put into these pages. Believe me – teaching will make you a better photographer and image-maker.

Best regards,

Katrin Eismann
Artist, Author and Educator
Chair, MPS Digital Photography
School of Visual Arts

Preface

First off, thank you for picking up a copy of this book/DVD set. Your interest in my ideas about taking digital pictures is much appreciated. I hope you learn a lot, and I hope you have a lot of fun capturing your reality with your imagination.

Let's talk about the book first.

This book is packed with more than 200 ideas for taking pictures indoors, outdoors, in bright light and in low light, with and without a flash and with reflectors and diffusers. I'll also share some ideas on how to take pictures by candlelight and how to paint with light.

You'll find one tip per page. How easy and cool is that!

In some cases, I've included two or more pictures per page to illustrate a before-and-after technique or how an effect can enhance a series of pictures.

Reality leaves a lot to the imagination. – John Lennon

You may want to start with the Introduction, where you'll find my *Digital Photography Recipe for Smokin' Photos*. If you want camera tech talk, I think you'll enjoy the *Digital SLR Must Know Info* chapter.

If you like photographing landscapes, animals, close-ups and people, you may want to jump to those chapters. I've included my favorite tips and techniques to get you started.

I've also included chapters on *My Photo Gear* and on *Home and On-Location Digital Darkrooms*. Check 'em out to learn about the kind of gear I use and the gear I recommend.

And speaking of the digital darkroom, the chapter *Top Digital Darkroom Techniques* includes, that's right, my top tips for digitally enhancing pictures. What I've done here is to make the enhancements as easy to follow as possible. After you learn my techniques, experiment with them on your images.

One of my favorite chapters in this book is *With a Little Help from My Friends*. There you'll find great tips from great photographers whom I am lucky – very lucky – to call my friends. Don't stop with their tips! Check out their Web sites to continue your digital photography learning experience.

Also check out the Web sites in the chapter, *Cool Web Sites*. Yup! More photo – and digital darkroom – learning and fun!

Okay, here's the scoop on the DVD.

Pop the DVD into your computer's DVD drive, click on the different QuickTime movies, and you'll get personal digital photography lessons from yours truly. Hey, it's the next best thing to taking a workshop with me (which I hope you can do someday).

Because they are QuickTime movies, you can start and stop them whenever you like, and even fast-forward and rewind if you want to skip or review a segment.

The movies – which cover flash, focus, lenses, portraits, shooting in low light and more – are a sampler of the videos from some of my other Wiley DVDs, which cover lighting and how to use Canon Digital Rebel cameras. Check them out at www.wiley.com. If you shop at amazon.com, you can find my DVDs by typing in Rick Sammon in the Search window.

So, you'll find a ton of tips, tricks and technique in this book and on the DVD. You'll also learn about some of my favorite photo philosophies.

When you're through changing, you're through.
– Bruce Barton

In going through the material, please keep this adage in mind:
I hear, I forget. I see, I remember. I do, I understand.

Hey, you will hear me say a lot and you'll see a lot in the book and on the DVD. The real magic happens when you start to "do" and understand.

So go out and do it – and don't forget to have fun in the process.

I began this preface with a favorite quote and a photograph I felt illustrated the quote, so I thought I'd end with another favorite quote, illustrated by two pictures. The idea is that as a photographer, it's important to keep changing, growing and evolving.

Rick Sammon
Croton-on-Hudson, NY
October 2008

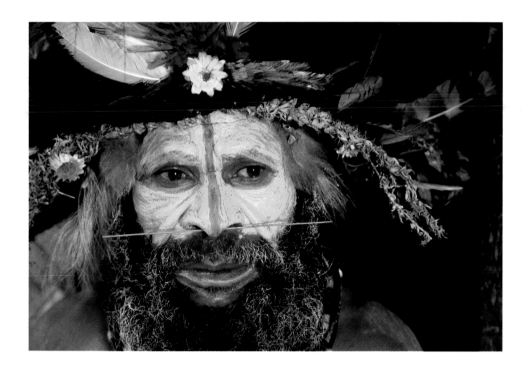

Intro

A Digital Photography Recipe for Smokin' Photos
10 Ingredients for Dishing Up Successful Images

Hey all, as you'll see on the following pages, I've packed this book with my favorite digital photography secrets – a full-course meal on digital photography, if you will.

But if you can't wait to dig in, and want to quickly cook up some sumptuous photographs, here's a quick, 10-step recipe that I think you'll find appetizing.

To illustrate the results of my recipe, I'll use some photographs that I took on a recent trip to Papua New Guinea. My guess is that many of you probably will not get to (or even want to go to) that exotic destination, but that's okay. The same ingredients can be used to create images that will quench your photographic thirst in any location around the world.

Let's dig in!

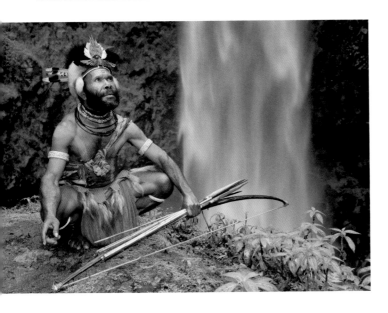

Interesting Subject

I know it sounds simple, but having an interesting subject, such as this Huli Wigman posed by a remote waterfall, is important in the making of a good photograph. For example, a photo of me watering my lawn in my shorts would not be as interesting as this exotic-looking image. Seek out interesting subjects, and they will add interest to your photographs.

Good Composition

A well-balanced photograph is like a well-balanced meal: very satisfying. Placing the main subject off-center is usually more interesting than placing the subject dead center in the middle of the frame. Experiment with positioning the subject in different parts or sections of the frame to find the best composition for a particular scene. Usually, dead center is deadly.

In addition, carefully compose your pictures so the background elements complement the main subject. In people photography, for example, the subject should stand out from the background in the frame. That can be accomplished by using a long lens (200mm or more) and shooting at a wide aperture (around f/2.8) and focusing on the subject. With that lens/f-stop combination, the subject will be sharp and the background will be blurred. In addition, the closer you are to the subject, the more blurred the background becomes. You can also make the subject stand out by composing your picture so that a relatively plain background, or darker background, allows your subject to stand out.

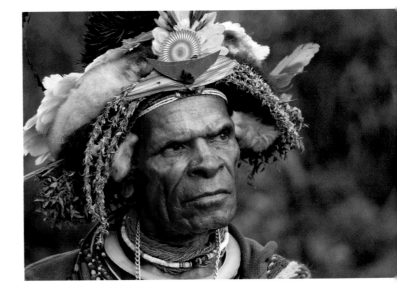

Creative Cropping.

Getting the best possible crop in-camera is a good idea. However, sometimes that's not possible due to the lens you are using or the camera-to-subject distance. What's more, after you take a picture, you may see a picture within a picture, which you can create by simply cropping in the digital darkroom. I like the full-frame image of these sing-sing (festival) performers. However, the tighter crop draws more interest to the main subject, as well as cropping out the spectators in the background on the left side of the frame.

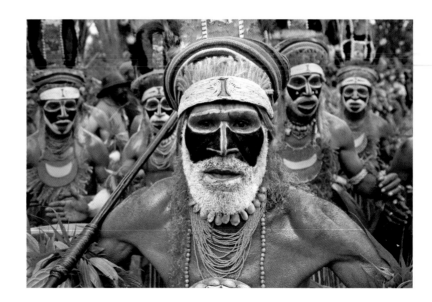

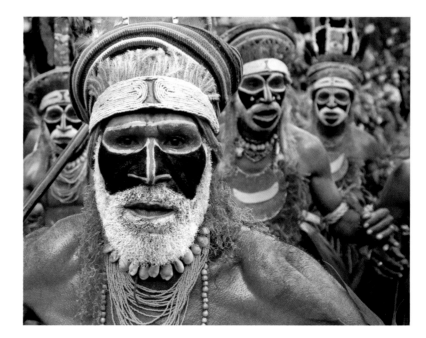

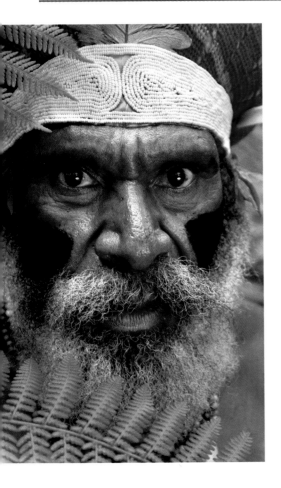

Careful Focus

Having an Auto Focus (AF) camera does not mean the camera knows where to focus within a specific scene. Carefully use the AF focus points in your camera's viewfinder and make sure the most important part of the scene is selected. When it comes to a person (or an animal) the main focusing point is usually the eyes. Also don't overlook the importance of the Focus Lock feature on your camera, which lets you lock in focus for a particular part of the scene, after which you can recompose and take the picture. Refer to your camera's manual to learn more about how your specific camera's Auto Focus and Focus Lock features function.

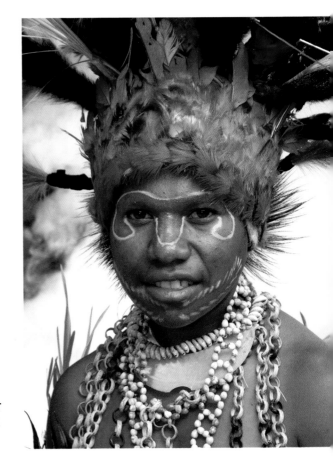

See the Light

Our eyes have the ability to sense light. In photographic terms, our eyes have a dynamic range of about 11 f-stops, which is why, in a high-contrast scene, we can see details in shadow areas and why highlight areas are not washed out. Our cameras, however, don't "see" exactly what and how we see. They have a dynamic range of about five or six f-stops. Therefore, we need to be able to see and understand the contrast range of a scene, from the brightest area to the darkest area, and know what our camera can and can't capture in order to make a good exposure decision. Read on for more details.

Fine-Tune Your Exposure

In most cases, when thinking about the exposure, we want to expose for the highlights (the brightest parts of the scene). That's because when highlights in a digital file are "washed out" or overexposed by more than one f-stop, they are difficult (or impossible) to recover later in the digital darkroom. RAW files offer more exposure latitude (are more forgiving) than JPEG files, making it easier to recover seemingly lost highlights. As a general rule, to avoid washed-out areas in a scene, I use the Exposure Compensation (+/-) feature on my camera and reduce the exposure in the Average Metering Mode (when my camera is set on the Aperture Priority or Shutter Priority exposure mode) by $-\frac{1}{3}$. That helps to prevent bright areas of a scene from becoming overexposed. In addition, don't overlook the importance of fine-tuning your exposure using your camera's Exposure Compensation feature. Sure, you could use the Spot Metering mode on your camera or use the Manual Exposure mode, but I think you'll find that using the Exposure Compensation dial on your camera is much faster and easier.

Of course, it's important to check the Histogram and Overexposure Warning indication on your camera's LCD monitor, to ensure a good exposure. If you are not sure how to activate these features on your camera, be sure to refer to your camera's manual.

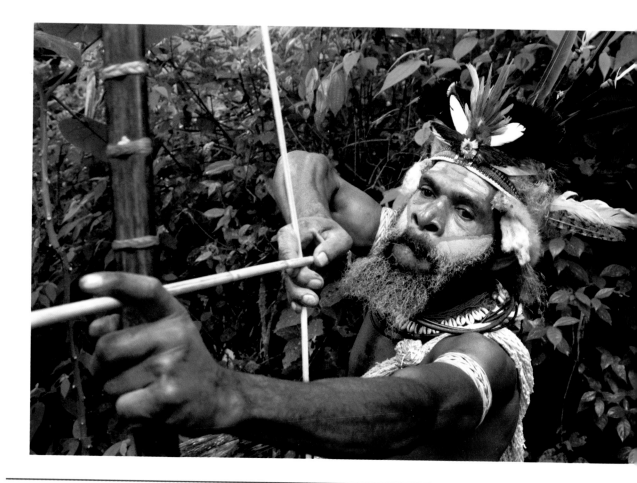

Control the Light

Sometimes, the contrast range of a scene is too great to be recorded by our cameras. That's when we need to control the light by using accessories. Basically, we have three types of accessories that can be used for controlling the light. Read on to learn about each of these three options.

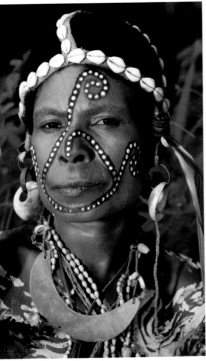 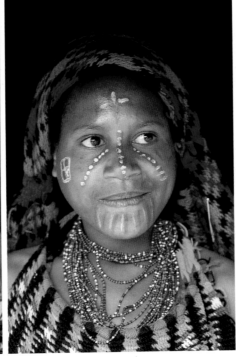 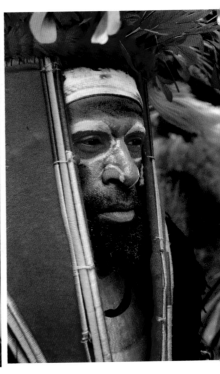

Flash – Here I used a flash to evenly illuminate the face of this woman who was sitting in the shade. Sunlight filtering through the leaves of the tree created unflattering shadows on her face, which were eliminated by using an accessory flash (which was held off-camera and triggered by a wireless transmitter mounted in the camera's hot shoe).

Reflectors – Here I used a reflector to bounce sunlight onto the face of a subject who was sitting in the shade in front of a dark background. The reflector also added some nice catch light to the subject's eyes.

Diffusers – Here I used a diffuser, which is shaped like a reflector but is used to filter light falling on a subject instead of reflecting onto the subject, to soften strong shadows on the man's face that were created by direct sunlight.

If you are new to photography and have not used reflectors and diffusers, I have some with/without examples at: http://www.ricksammon.com/RS_Tote.html.

Check Your Camera Settings

One of the cool things about digital photography is that you can change many camera settings in an instant: ISO, White Balance, Image Quality, Exposure Compensation, Focus Point, Metering Mode and so on. The not-so-cool thing is that it's easy to forget about individual camera settings (as I have done more than a few times in the past) which can result in a ruined shot. Checking your camera settings from time to time will help avoid disappointing results.

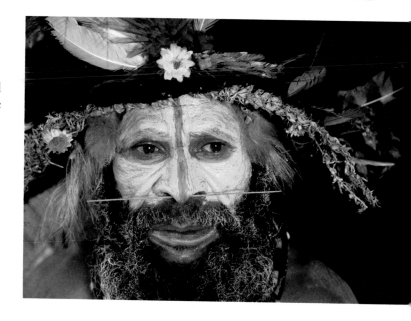

Work and Play with Light

Capturing light with our cameras is only part of the fun (and challenge) of photography. Working and playing with light in Photoshop (and other digital darkroom programs), and experimenting with different plug-ins, is also part of the fun.

To create this image, I used two plug-ins from onOne Software (www.ononesoftware.com): Photo Tools and PhotoFrame 3. In Photo Tools, I used Color Treatments/Davis/Hand Tinting/Skin Only to change the colors in the image, and then I used PhotoFrame 3/Toothbrush to add the digital frame around the photograph.

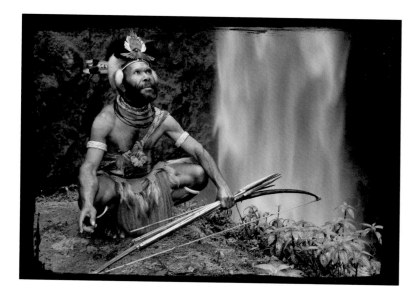

Have Fun

Most of you took up photography as a hobby for the same reason I did: to have fun. I find the more fun I have with my photography, and the more I enjoy the process, the more pleased I am with my pictures. So, keep digital tech talk in mind, but don't forget why you got into photography in the first place!

Part I

Digital SLR Must-Know Info

Gain an understanding of your camera's image sensor, shutter, LCD monitor, camera settings, memory cards, custom functions and what you see versus what your camera sees. You'll be in the know after reading this chapter.

Data Contacts and Mirror

Your lens and camera "talk" to each other – communicating f-stop, focal length, focus and exposure information – via the electrical contacts on the lens mount and camera mount.

Keep these contacts clean and avoid touching them to keep the communication channels open. If you get a focus, f-stop or other error messages on your LCD monitor, try cleaning the contacts with a micro-fiber cloth (available at camera and eyeglass stores).

When it comes to the mirror, never touch it with anything. You can use a low-volume photo blower (available at camera stores) to remove dust from the mirror, which does not show up in your pictures but does appear in your viewfinder. However, never use compressed air, because it contains propellants that may stain and ruin your mirror. If you do get hard-to-remove marks on the mirror, it's best to have it professionally cleaned.

Illustration: courtesy Canon USA.

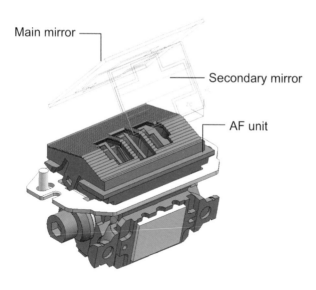

Main mirror

Secondary mirror

AF unit

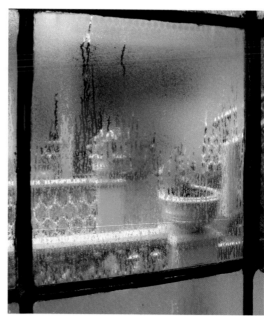

Auto Focus vs. Manual Focus

In most cases, your auto-focus camera can focus faster than you can. Auto-focus units use contrast in the scene to set the focus. In low light and low contrast situations, you may need to switch to manual focus because the AF system will "hunt" for perfect focus. You'll also want to switch to manual focus when shooting through a chain link fence, through leaves and branches and when shooting through glass, as I did to capture this rainy day scene in a small, roadside town outside of Mexico City.

On some entry-level digital SLRs, some auto-focus lenses will not auto focus properly, so you will need to focus manually. In addition, some brands of tele-converters may prevent auto focusing when used on entry-level digital SLRs. Off-brand lenses and tele-converters also may affect auto-focusing function, accuracy and speed.

Illustration: courtesy Canon USA.

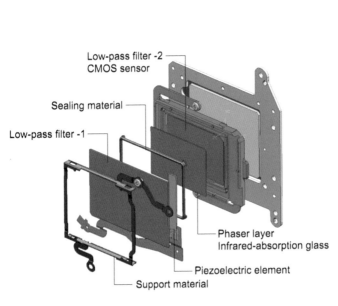

Low-pass filter -2
CMOS sensor

Sealing material

Low-pass filter -1

Phaser layer
Infrared-absorption glass

Piezoelectric element

Support material

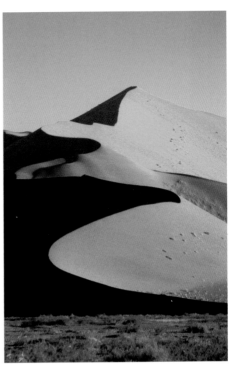

Be Sensitive to Your Image Sensor

Later in this section I talk about different size image sensors and their advantages and disadvantages. For now, I just want to give you a look at the image sensor setup so you're not afraid to clean the sensor to prevent black specks and blobs from appearing on your images. You see, when you clean the sensor, you are not really cleaning the sensor, but rather the low-pass filter that covers and protects it. The specks are shadows caused by dust and other particles appearing on the filter. When you clean this filter, be sure to use only products designed specifically for photo sensor cleaning, and follow the instructions very, very carefully.

When I shoot in dusty conditions, such as when I was photographing the sand dunes in Namibia, I clean my sensor every night. Better safe than sorry is my motto.

Illustration: courtesy Canon USA.

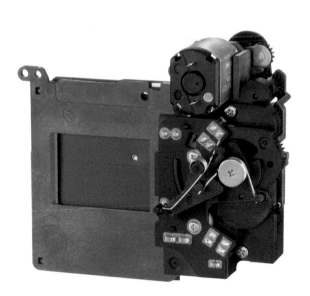

Shutter

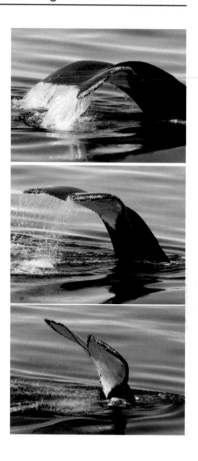

A Shutter's "Mileage"

Would you buy a used car without knowing the mileage? Of course not.

When it comes to buying a used camera, it's also important to know its "mileage"; that is, the number of shutter activations. And if you are buying a new camera and plan to take a ton of pictures, it's important to know the estimated "mileage" (again in shutter activations). For example, Canon's EOS 40D has an estimated number of shutter activations of about 100,000. That may sound like more images than you'll ever take, but a sports photographer could take that many pictures in a year – or less. Higher-end digital SLR cameras have more durable shutters. The shutter in my Canon EOS 1D Mark III, which I used to photograph this series of whale tail photographs in Antarctica, has a life expediency of about 300,000 activations.

Before you head out on the road with a new or used camera, check its mileage. Some cameras offer counters. For those that don't, you have to rely on the previous owner's honesty. And speaking of honesty, "driving conditions," or what kind of use the previous owner put the camera through, are also a factor when considering purchasing a used digital SLR.

Don't panic if you plan to shoot hundreds of thousands of pictures. Shutter replacements cost between $250 and $500, which is not bad when you own a high-end digital SLR that cost more than $5,000.

Illustration: courtesy Canon USA.

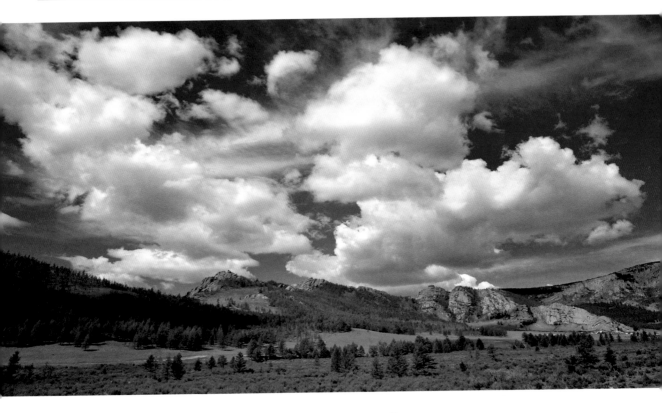

Your Eyes vs. Your Camera's "Eye"

Our eyes are incredible light sensitive devices. We can see a dynamic range of about 11 f-stops. That's why in a scene like this Mongolian landscape, I could see into the shadows and the highlights in the bright clouds were not washed out.

Our digital cameras can see about five or six f-stops. Therefore, it's our job as photographers to produce images that look like the scenes we see – or look like we want them to look.

The key is to realize that what we see with our eyes is not what the camera sees with its "eye." Learning how to see the contrast range of a scene – and knowing how to compress it with accessories like diffusers, reflectors, filters and flash units, and how to control light in the digital darkroom – will make us better photographers.

In addition, seeing the light will help keep us from being disappointed when what we see in real life is not what we see on our camera's LCD monitor – perhaps saving us from deleting "outtakes" that can be turned into "keepers."

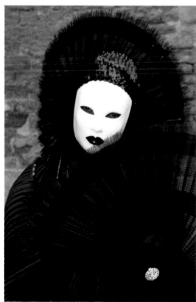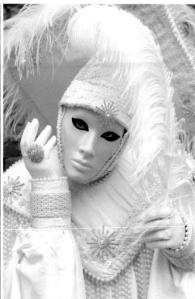

Brightness Values and the +/− Exposure Compensation Control

Here are two pictures I took during Carnevale in Venice. One person is wearing a black costume and one is wearing a white costume.

Get this. With my camera set on any of the automatic exposure modes and the exposure compensation set at zero, the picture of the person wearing the black costume would have come out too light, and the picture of the person wearing the white costume would have come out too dark. Here's why.

In the photograph of the person wearing the dark costume, all that black would have fooled the camera's meter into thinking that the scene was darker than it was, therefore increasing the exposure to a point where the image would have been slightly overexposed. The same thing would have happened when photographing any very dark subject – say the dark bark of a tree.

Likewise, in the photograph of the person wearing the white costume, all that white would have fooled the camera's meter into thinking that the scene was brighter than it was, therefore decreasing the exposure to a point where the image would have been slightly underexposed. The same thing would have happened when shooting at the beach on a bright, sunny day or when shooting in the snow.

Now I know it will sound backward, but what you need to do is this: When photographing very light subjects, set your exposure compensation at +1 (as a starting point); when photographing very dark subjects, set your exposure compensation at − 1 (again as a starting point).

If you are not sure about the exposure, bracket your exposures, and then take additional pictures over and under the recommended exposure setting.

Once again, learning how to see the light is the key to getting a good in-camera exposure.

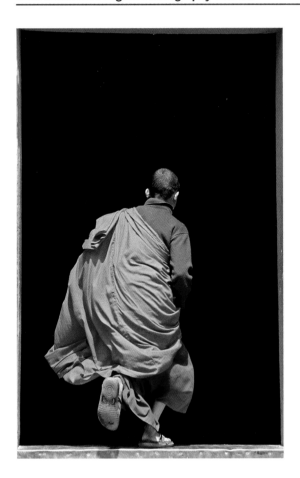

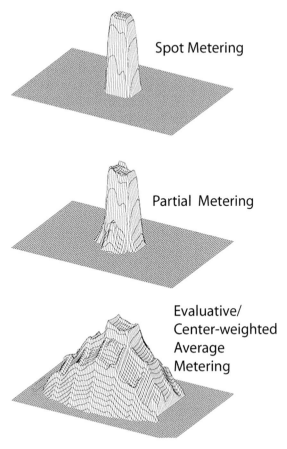

Spot Metering

Partial Metering

Evaluative/
Center-weighted
Average
Metering

Control What Your Exposure Meter "Sees"

Here's another important thing to think about when comes to seeing the light: You can control what your camera's meter "sees."

Basically, digital SLR cameras, and even some digital compact cameras, have three metering modes: spot metering, which measures the center spot of the viewfinder; partial metering, which measures the central area of the frame; and evaluative/center-weighted average metering, which measures most of the frame but puts the emphasis on the center part of the image.

For my monk photograph, I chose the partial metering mode because the monk was surrounded by a large, dark area – which would have fooled the camera's meter into overexposing the monk had I chosen the evaluative/center-weighted average metering mode.

Check out the metering patterns on this page and keep them in mind when you are composing your pictures. Choosing the correct metering mode could make the difference between a right-on exposure and a poor exposure.

Illustration: courtesy Canon USA.

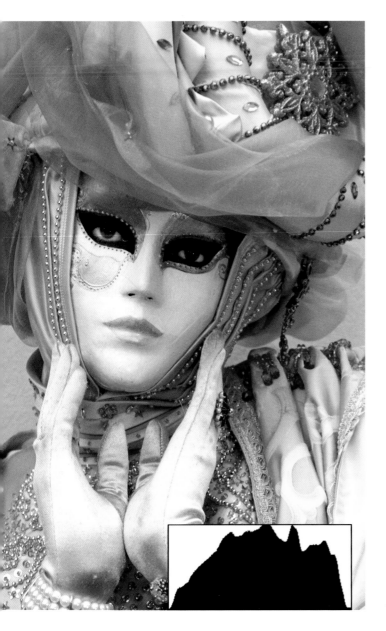

LCD Monitor Info

When I teach a photography workshop, one of the first points I stress is the importance of checking the histogram (a graph that shows the distribution of the light values in an image) on the camera's LCD monitor. The idea is to check to see if the shadows are blocked up (indicated by a spike on the left side of the histogram) and if the highlights are overexposed (indicated by a spike on the right side of the histogram). I talk about the importance of checking the overexposure warning on the camera's LCD monitor, which blinks to show overexposed areas.

I also point out the importance of shooting RAW files, which are more forgiving when it comes to exposure than JPEG files, which toss away information during the compression process. In fact, on some of my workshops, I wear my "RAW Rules" t-shirt. There's more to come on shooting RAW files on the following pages.

But here's the thing. The histogram and the overexposure warning on the camera's LCD monitor are not for the RAW file of an image. Rather, they are the displays for a JPEG of that file – because a JPEG is easier to display and that's what you see on the LCD, not the RAW file you just captured.

So why check the display when you are shooting RAW files? Well, that histogram is still a pretty good indication of what you're getting. Just keep in mind that with your RAW file, you can rescue up to one f-stop of overexposed areas later in the digital darkroom.

By the way, if you are new to histograms, I included the histogram for this picture that I took in Venice to show you one example of a good histogram – no spikes at the left or right ends of the "mountain range."

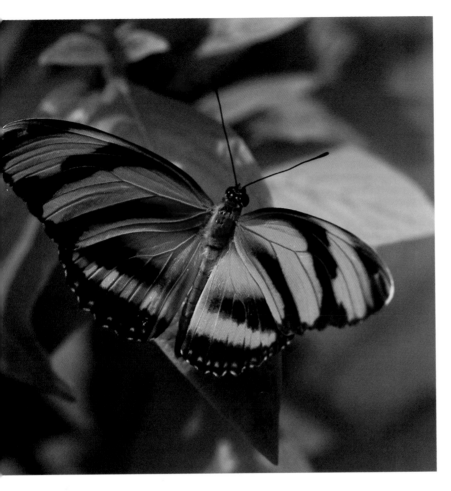

Customize Your Camera

Most digital SLRs, even low-end models, offer what's called Custom Functions. Custom Functions, accessed through a Custom Function menu, let you customize your camera's settings, including fine-tuning automatic exposure compensation, turning on/off long exposure noise reduction, linking the metering system to the spot focusing point, adjusting auto focus sensitivity, selecting the auto focus point, and a host of other adjustments. The more sophisticated the camera, the more Custom Functions you have at your fingertips.

One of the more popular Custom Functions, especially among sports and wildlife photographers, is the ability to use one button to set the focus (usually the AF button on the back of the camera), and to use only the shutter release button to take the picture - as I did for this picture of a butterfly I took at Butterfly World in Coconut Creek, Florida. The benefit is that you can start/stop focus with your thumb, without accidentally taking a picture, and then press the shutter release button at the precise moment of action with your index finger to take the picture.

Play around with Custom Functions and see how they can not only help you take better pictures, but also how they can help you have more fun with your camera.

Cooling Off and Warming Up Images

Earlier in this chapter I touched upon capturing good color in your images. Here is another feature, found on mid-range and high-end digital cameras, that lets you get great color and even fine-tune color. It's a Custom Function called Color Temperature, and it lets you set the precise color temperature (my EOS 1Ds Mark III lets me choose from 2500K to 10000K) for a scene, and even offers White Balance Color Correction, which basically lets you apply a digital color conversion/compensating filter in-camera.

Historical Note: The symbol K is used on the Kelvin scale and is a thermodynamic (absolute) temperature where absolute zero is zero (0 K.)

In this trio of photographs, the top picture was taken with no Color Temperature adjustment and with the White Balance set on Automatic. For the middle image, I set the Color Temperature to 2500K, cooling off the image. For the bottom image I set the Color Temperature to 10000K, warming up the image.

Sure, you can create the same effect in the digital darkroom using Color Temperature, Color Balance and Photo Filters adjustments, but it's fun to try to create different kinds of in-camera effects – and sometimes essential if you are shooting commercially.

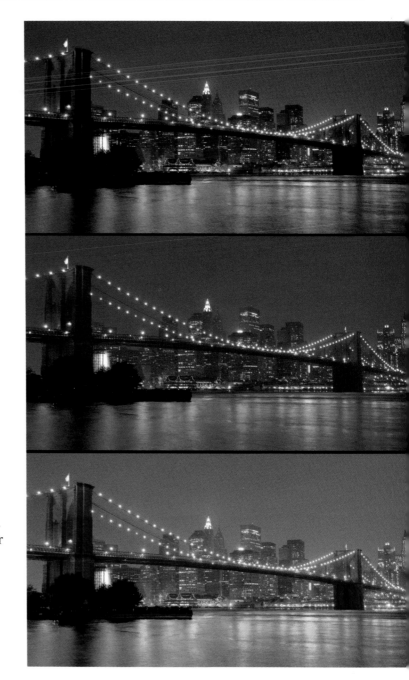

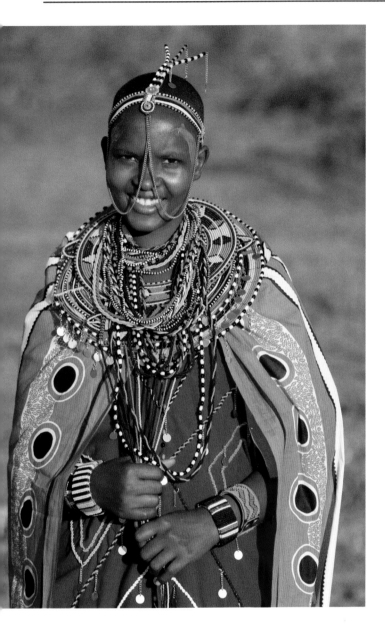

sRGB vs. Adobe RGB and RAW vs. sRAW

I am a nut about capturing color. Great color! In fact, when I am out on location, as I was when I photographed this Masai woman in Kenya, I look for color – and try my hardest to get good color in-camera.

One way to ensure the best color images is to set your camera to the Adobe RGB (not a custom function) color space. When you set your camera to the other color option, sRGB, you are choosing a smaller color space, one with fewer colors.

There is an easy way to remember why sRGB has few colors: The "s" in sRGB stands for "smaller" color space.

That said, you may not notice the difference in the two color spaces unless you are doing commercial work or making super big prints of scenes with a super wide color and contrast range.

Let's talk RAW. Some cameras offer both a RAW mode and an sRAW mode. When you shoot in the sRAW mode, your file is much smaller than a RAW file, meaning that there is less information in the file. For example, on my Canon EOS 1D Mark III, a RAW file is 10.1 megapixels, compared to the 2.5 megapixel sRAW file.

For me, RAW is the only way to go, because I want the maximum image quality to make the maximum size print.

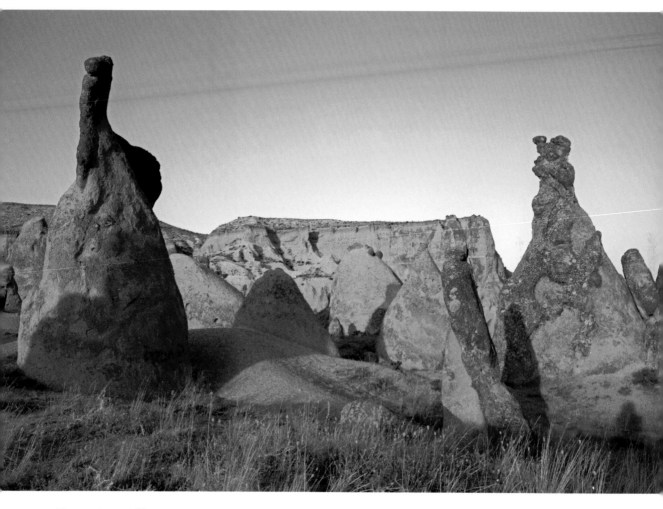

Get It All in Focus

Check out this landscape photograph I took in Turkey. Everything in the scene is in sharp focus, from the blades of grass in the foreground to the distant background.

One way to get a tack sharp shot is to use your digital SLR's mirror lockup feature, which locks up the mirror to reduce camera shake created when you press the shutter release button. Here's the technique. Set your camera on a tripod and compose and focus the scene, lock up the mirror (see your camera manual) and then use the camera's self-timer or a cable release to take the shot.

Not all digital SLRs have a mirror lockup feature.

On some cameras, you can set mirror lockup so that the mirror stays up for additional exposures. On most cameras, however, the mirror returns to its normal position after each picture is taken.

Mirror lockup can also be effective in getting sharp shots when using telephoto lenses and macro lenses, because both types of lenses tend to exaggerate camera shake, which can cause blurry pictures.

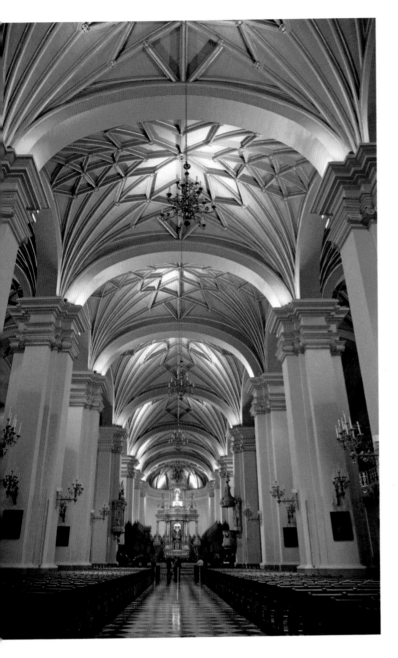

F-stop Info

When I first became interested in photography in 1975, there was a popular expression about how to get a good, extremely sharp picture with great depth-of-field: "f/22 and be there." The idea was that if you set your lens at f/22 and have a good subject, you'd have a good chance of getting a good shot with the maximum amount of depth-of-field.

With digital SLRs, shooting at f/22 may not always be the best idea because pictures may look a bit soft. Here's the "tech talk" from my friend Rudy Winston of Canon. "What happens is this: The aperture blades have the potential to deflect and bend light as it passes by them and scatter it as it heads toward the digital image sensor. At fairly wide aperture settings, the vast majority of the light rays entering through the aperture are unaffected – only those on the outermost peripheries are impacted by the aperture blades. The wide opening means that nearly all the transmitted light continues on its way, sharply focused by the lens."

I hardly ever take a picture at f/22, choosing f/11 as my smallest f-stop, as I did here when photographing the interior of this church in Peru.

When it comes to choosing an f-stop, you basically want to choose a wide f-stop (f/2.8, f/4.5) for shallow depth-of-field, and a small f-stop (f/8, f/11) for greater depth-of-field. Note that at the same f-stop setting, you'll get more depth-of-field from the same shooting position when using a wide-angle lens than you will when using a telephoto lens.

Internal Filter Flare

It's a good idea to remove any lens filter when shooting into the sun, because the reflection of the sun can bounce off the front element of the lens onto the filter and create a ghost image. Usually, the ghost image appears on the opposite side of the frame from where the sun is positioned. You can erase a ghost image using the Clone Stamp tool in Photoshop, but here's another idea.

When you compose the picture, don't crop as tight as you normally would. Rather, leave some extra room around the main subject. That way, the ghost image may appear outside the final frame – away from the main subject. When you crop the image, you'll also crop out the ghost image, which is what I did here for this picture I took of a shipwreck off the coast of Namibia.

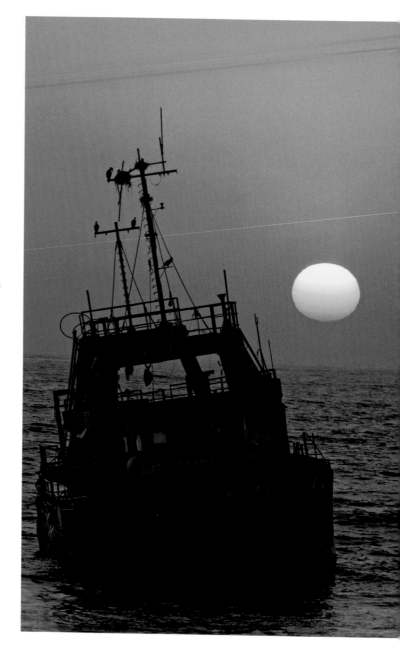

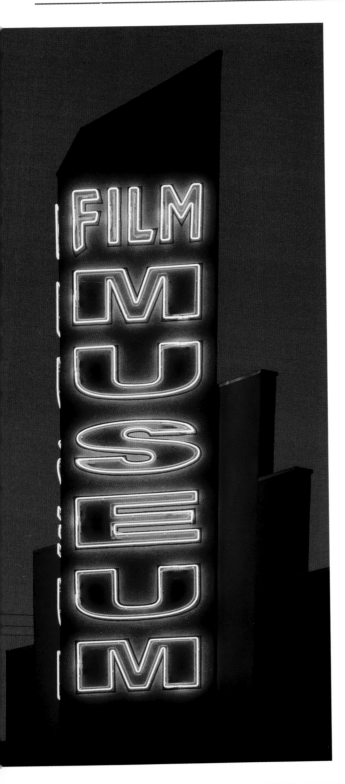

When Pixels Bloom

Here is a fact about digital SLRs. Knowing it will keep you from freaking out when you are looking at a big enlargement of a scene (on your monitor or in a print) where very bright and dark areas meet.In this photograph of a neon sign, the light from the sign is spilling over to the dark areas in the scene. That's normal.

On a digital image sensor, where very dark and very light areas meet, the light from bright areas can spill over from the bright pixels to the dark pixels, creating a halo around those dark areas. In digital photography terms, this is called blooming.

You can't see the blooming effect (different than the light-spilling-over effect) in this picture because it's small on this page. When viewing an image like this on your monitor, you may not see the effect either, especially when the image is viewed below 50 or so percent magnification. If you think there is a chance of blooming in a picture, the first thing you should do is enlarge your picture to at least 200 percent on your camera's LCD screen. Also keep in mind that when you increase the contrast and sharpness of the image, you increase the blooming effect.

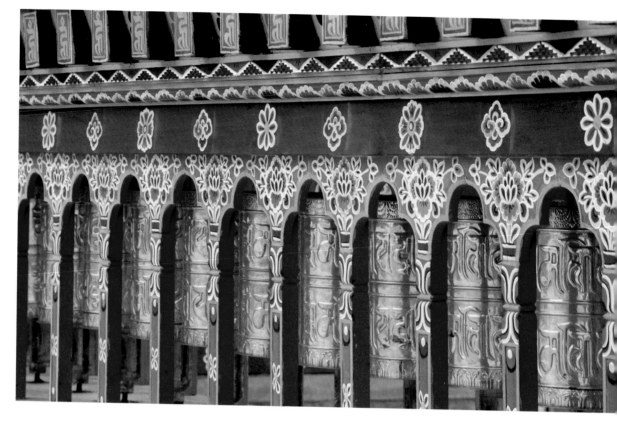

Memory Card Info

This photograph of some prayer wheels, which I took in the Royal Kingdom of Bhutan, is packed with details. It got me thinking about a memory card experiment you should try.

Format your memory card. Compose a scene with lots of detail – trees and grass and foliage in a landscape, or a headshot of a person with a beard. Take five exposures with your ISO set at 400. Now check your camera to see how many exposures you have remaining. Note that number.

Now, format your memory card again. This time, compose a scene with few details – say a sky with clouds or a baby's face. Take five exposures with your ISO set at 100. Now, check to see how many exposures you have remaining.

As you'll see, you'll have more remaining exposures after your few details/low ISO settings. That's because the amount of information contained within a file affects its size, and files with more detail and more digital noise (which you get at higher ISO settings) are larger than files with fewer details and less noise.

Something else you should know about memory cards: Always format them in-camera and not with your computer. In-camera formatting sets up the memory card for that particular camera.

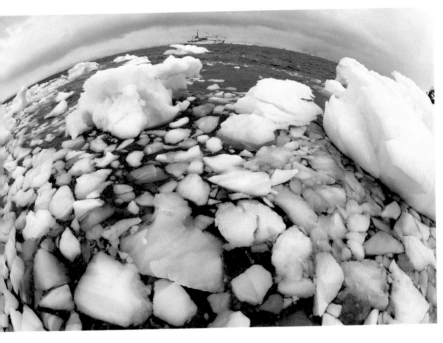

Full-Frame Image Sensor Advantage

Digital SLRs basically come in two flavors: full-frame, which means the image sensor is the same size as a 35mm film frame (24x36mm); and less than full-frame size, which means that the image sensor is smaller than a 35mm film frame.

Full-frame sensors capture more pixels than smaller sensors, so you get more detail, which is important when you're interested in making large prints. The big difference between full-frame and less than full-frame sensors is that SLR lenses "behave" as they would on a 35mm film camera. Thus you'll capture more of a particular scene taking an identical shot with a full-frame sensor, versus a less than full-frame sensor. For example, if you put a 15mm full-frame fisheye lens on a full-frame image sensor camera, as I did for this photograph that I took in Antarctica, you get the full-frame effect. On a less than-full frame camera, you would simply get a wide-angle view.

Less than full-frame image sensor cameras have different degrees of image magnification, usually 1.3x, 1.5x or 1.6x. So, my 15mm lens on a camera with a 1.3x image magnification acts like a 19.5mm lens in the angle of view that it has. The perspective and depth-of-field is the same as it would be for a 15mm lens.

There is a plus side to using a less than full-frame image sensor camera, and that's when it comes to sports and wildlife photography. For example, a 100-400mm lens on a camera with a 1.3x image magnification acts like a 130mm to 520mm lens – getting you theoretically "closer" to the subject. In actuality it just changes the angle of view to that of a longer lens.

When I am shooting, I use my 17-40mm wide-angle zoom on my full-frame sensor camera (Canon EOS 1Ds Mark III), and I use 70-200mm or 100-400mm telephoto zoom on my 1.3x sensor camera (Canon EOS 1D Mark III).

Keep in mind that all sensors are not created equal. Some cameras offer on-sensor noise reduction, which is an advantage when shooting in low light and during long exposures. How the image is processed is also important. Entry-level cameras may not have the same type of sophisticated image processor as top-of-the-line cameras.

Firmware Updates

Your digital SLR comes with built-in firmware that sets the performance of many of the camera's functions, such as auto focusing and metering. From time to time, camera manufacturers update the firmware, optimizing the performance of their cameras. You can easily download the firmware from the camera manufacturer's Web site to your camera via the cable that comes with your camera, but not all digital SLRs do it the same way. Be sure to check your camera manual or manufacturer's Web site for details on downloading and installing firmware updates.

All digital SLR owners should check the manufacturer's Web site from time to time for notification about these updates. They are important. In fact, even camera manufacturers make mistakes, and some of those mistakes can be corrected with a quick fix with firmware updates.

On a side note, also check the Web site for updates to your ink jet printer's software. New drivers are introduced from time to time that will make your printer perform at its best.

Camera Care

Your digital camera is a precision piece of equipment, and it should be handled with tender loving care. To ensure years of use (even though an updated model will probably be introduced every 18 months and sometimes more frequently), here are some things to remember.

Never leave your camera around anything with a strong magnetic field, such as a television set, loudspeakers at a rock concert, or an electrical motor. Keeping clear of antennas that emit strong radio signals is a good idea, too. Strong magnetic fields and radio signals can damage image data.

Magnetic fields can also damage memory cards, as can static electricity. Contrary to rumors, however, airport X-rays don't damage digital cameras or memory cards.

High heat and severe cold can cause a camera to malfunction. At very low temperatures, the LCD panels may not work, and you can run out of battery power quickly.

Finally, test your camera from time to time to make sure it's working properly. To do this, take a few test shots and process them in your digital darkroom.

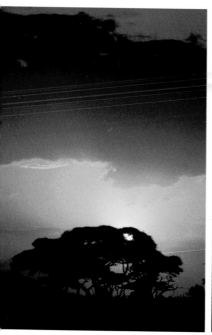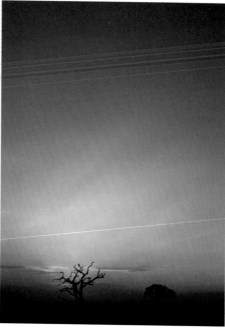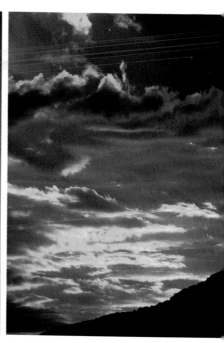

Check Out Your Camera's Software

I am sure many of you use Adobe Photoshop, Photoshop Elements, Adobe Lightroom or Apple Aperture to manage and enhance your images. That's cool! I do the same thing, because I have to know what's going on the world of digital imaging.

But here's a suggestion. Check out the software that comes with your camera (Canon's is called DPP, or Digital Photo Professional). It has many of the same features of Photoshop, Aperture and Lightroom. The difference? It's often free!

My experience has shown that the camera-dedicated software is slower than Photoshop or Aperture; the camera manufacturers say that it takes time to process the file to its full capacity. I have seen results that have illustrated that claim, especially when it comes to reducing noise.

What's more, some camera-manufacturer software makes it easy to remove dust spots from a series of images, which is what I did for this trio of sunset photos. In the software program, you identify the dust spot in one image, tell the software where the spot is located, and at the click of a mouse, all the spots in a series of pictures are removed.

Take the time to check out the software that comes with your camera, and you'll see that you have a new tool to enhance and manage your images – again, usually for free.

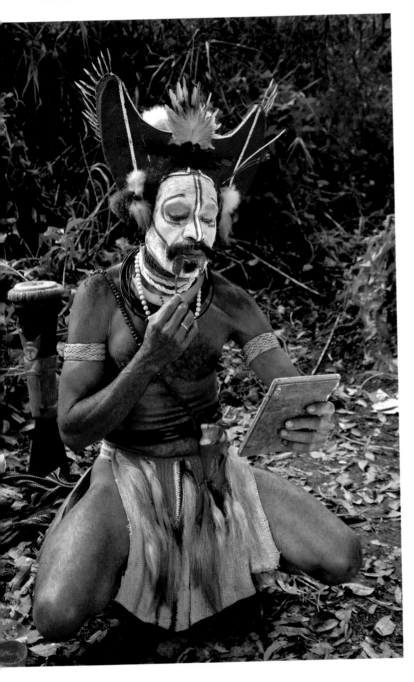

Recovering "Lost" Files

Imagine traveling halfway around the world (as I did to get this shot of a Huli Wigman in Papau New Guinea), getting great shots, inserting your memory card into your card reader and then not seeing an icon for the card on your desktop – or seeing the icon, opening the folder and then not seeing any of your great pictures.

If that happens, don't freak out! Some files get corrupted for a variety of reasons and can't be read – but they may still be accessible. Or, there could be a communication error between a card reader, cable and your computer. What's more, even if a card is accidentally erased, chances are the pictures are still there, if the card is not formatted.

Most memory cards come with CDs that contain a software program that helps you rescue "lost" files. You can also download recovery programs from the memory card manufacturer's Web site.

Two independent recovery programs I have found are CardRaider (http://www.ecamm.com/mac/cardraider) and Data Rescue (http://www.datarescue.com/photorescue). Check out their sites, and don't leave home without some sort of data recovery program. It will help you recover from a nervous breakdown when you think you have lost some once-in-a-lifetime shots.

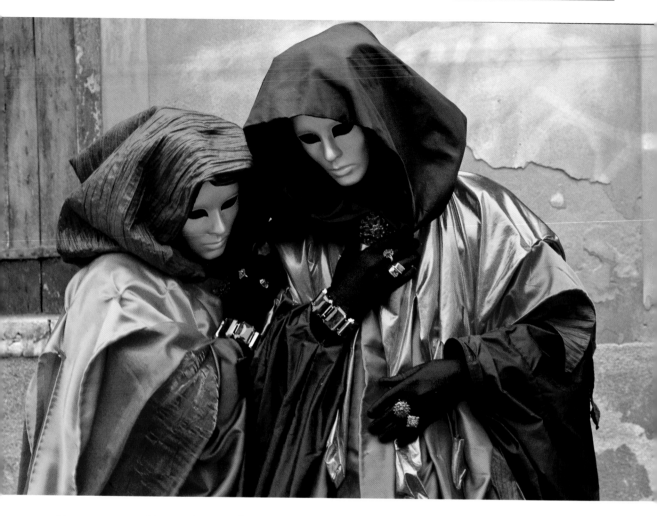

Cameras Don't Take Pictures, People Do

Here's something really important you should know about your camera: It does not take pictures, you do!

On my workshops and in my presentations, I ask the question, "It all starts with the camera, right?" But then I say, "I was only kidding! It all starts with the idea we have in our mind."

Sure, it's important to know what your camera can and can't do, and it's important to know all the camera's settings so that you can basically be on autopilot when you are shooting – much like a jazz musician is when he or she is improvising. But it's even more important to convey your ideas with pictures. My idea for this picture, which I took during Carnevale in Venice, Italy, was to show the interaction between the two subjects. My idea was to picture them in a romantic setting, which is why I positioned them in the shade in a secluded courtyard.

Speaking of ideas, there is no such thing as a bad idea in photography. Here is a photography joke that illustrates that point: One out of focus picture is a mistake, but 20 out of focus pictures is a style.

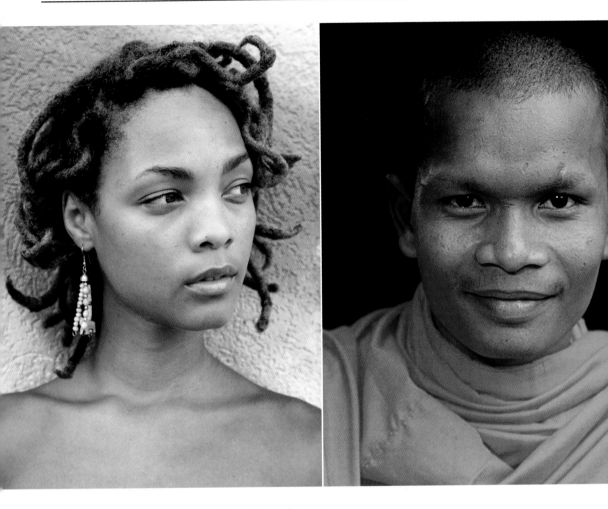

The Camera Looks Both Ways

Here is something that may surprise you. Your camera looks both ways; in picturing the subject, you are also picturing a part of yourself. I know this is not a tech tip, but as with my "Cameras Don't Take Pictures, People Do" tip, it's important.

When photographing a person, keep in mind that the mood, the energy, the feeling and the emotion you project will be reflected in the subject. Another way to put this is that you are a mirror; pictures you take are a reflection of both you and your subject. Check out these two shots, one of a girl I photographed in Little Five Points in Atlanta, Georgia; and one of a Buddhist monk I photographed in Cambodia. I don't have to tell you how I was feeling when I took each picture.

Part II

Landscape and Scenic Photography

Technically speaking, photographically speaking and digitally speaking, this chapter features my favorite landscape images and info. You'll also learn how to photograph in sunlight, twilight and moonlight. You'll even learn how to paint with light.

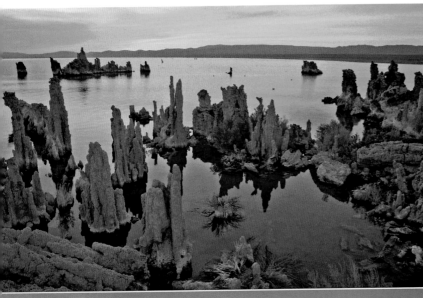

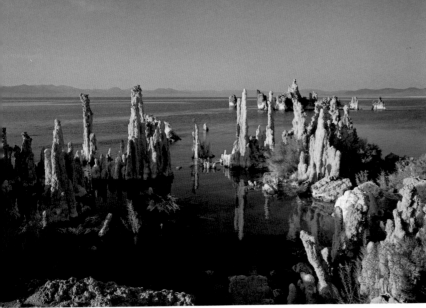

Be Prepared, Be Patient

When it comes to landscape photography, two non-technical aspects of the process are very important: being prepared and being patient.

Before I go to a new location, I try to learn as much as I can about it: the weather, sunrise and sunset times, access, clothing, etc.

I also check out other photographers' photos of the area and their tips. For example, when I went to Mono Lake in California, I learned that I needed hiking boots to climb in the best location for a sunrise shot. I learned the precise time of sunrise, and I learned that I needed a wide-angle lens (at least 16mm) to capture the view. I also learned the most popular sunrise spot (where I took this picture) begins to get crowded with photographers about an hour before sunrise, so I arrived on the scene two hours before sunrise to secure my spot.

Being prepared for Mono Lake was one factor that made the difference between the top and bottom images you see here. The other factor, previously mentioned, was patience. The top photo is the result of going back to the same location three mornings in the row and waiting for just the right light. It's my favorite from my last morning's shoot.

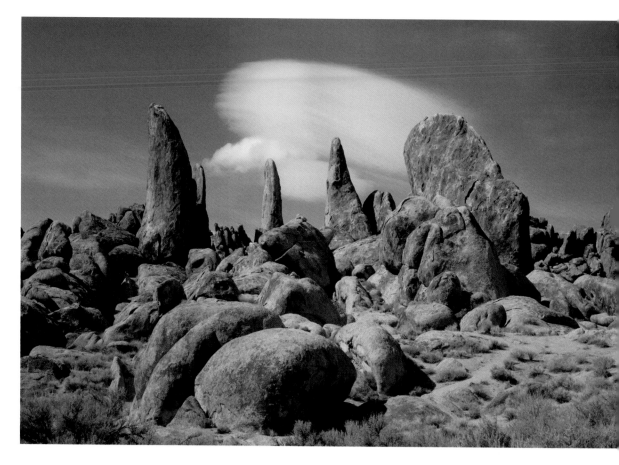

Get It All in Focus

When I take a landscape or scenic photograph, I like the picture to look like the scene looked to my eyes – with everything in focus. That's easy to do, if you follow these steps.

First, use a wide-angle lens or choose a wide-angle setting on a wide-angle zoom lens – no longer than 24mm.

Next, choose a small f-stop, no wider than f/11.

Set your camera on the one-shot focus mode and choose the center focusing point in your camera's viewfinder. Position that point one-third of the distance into the scene and lock the focus (by pressing the shutter release button down halfway).

Now all you have to do is recompose the scene in your viewfinder and shoot.

If you don't follow this procedure and instead set the focus at infinity, foreground objects may be out of focus.

Remember, just because you have an auto focus camera, it does not mean the camera knows where you want to focus.

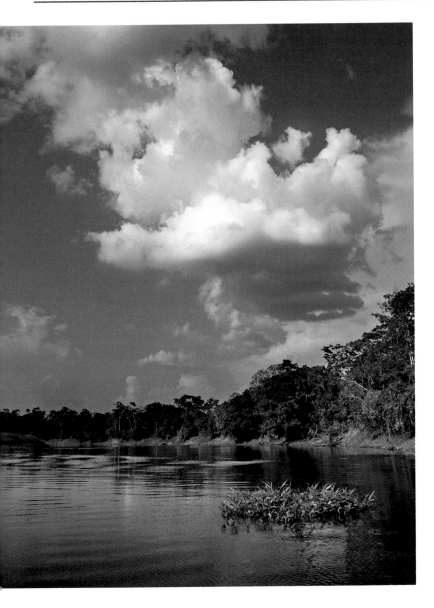

Pack a Polarizing Filter

Perhaps the most useful screw-on filter (as opposed to a digital filter) for landscape photography is a polarizing filter. A polarizing filter can continuously vary the amount of polarized light that passes through it. In doing so, it can darken a blue sky and make white clouds appear whiter, depending on the lighting conditions and how the filter is rotated.

A polarizing filter can also reduce reflections on water to the point where you can see through it. A polarizing filter is most effective when the sun is off to your right or left, but not effective when the sun is directly in front of or behind you.

A polarizing filter can also make your pictures look sharper, because it helps to reduce reflections on atmospheric haze. Polarizing filters rotate in their mount so you can dial in (select) different amounts of polarization, from maximum to minimum. When the maximum effect is achieved, the amount of light reaching the image sensor may be reduced by up to 1 1/2 stops. When shooting in an automatic exposure mode, the camera automatically compensates for that difference.

A digital polarization filter is available from www.niksoftware.com and is part of its Color Efex Pro 3.0 plug-in filter set. It darkens a blue sky and makes white clouds brighter, but it can't reduce reflections.

Establish a Sense of Place

When we include a foreground element in a scene, we give the viewer of the photograph a reference point from which to view the scene.

By framing San Diego's famed Hotel Del Coronado with a tree in the foreground, I hope the viewer of the photograph can feel as though he or she is standing in the scene.

For shots like this, where I want everything in the scene in focus, I follow the technique mentioned earlier in this chapter entitled *Get It All in Focus*.

Think in Three Dimensions

Hey, I know I could have added tips on creating depth in our photographs on the previous page, but it's so important that I wanted to give it its own topic. So let's go!

We see the world in three dimensions: height, width and depth. Our cameras see only two dimensions: height and width. Therefore, one of our jobs as photographers is to try to create a sense of depth in our images.

One method for creating a sense of depth, as illustrated in the photo on the right on the previous page, and in the bottom photo here, is to place a foreground element in the scene. Yet another is to photograph the subject at an angle. Photographing the subject at an angle draws the viewer into the scene, as does a foreground element. Combine the two techniques and you have a picture with depth and dimension – rather than a flat photo, as illustrated in the top image.

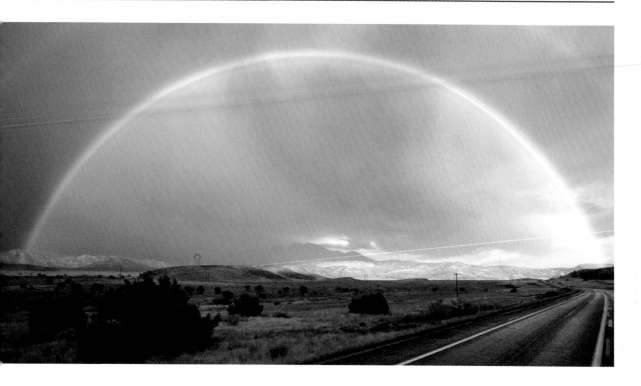

Watch the Edges and Know Your Boundaries

Here is another tip that may sound very basic, but it's actually one of the most important tips when it comes to landscape photography – and all photography for that matter.

Before you take a picture, run your eye around the edges of the image in your viewfinder and check for objects, perhaps a tree branch or a fence post that can detract from or add to your photograph. These small objects can make or break a photographer. Of course, you may be able to crop them out or clone them out in Photoshop, but as always, it's much better to get the best possible in-camera photograph.

Here is something else to keep in mind when composing a picture. A painter looks at the blank canvas and decides what he or she wants to include in the painting. A photographer looks at scene and decides what not to include – elements that will detract from the main subject.

For this rainbow photograph, which I took in Moab, Utah, I decided to include the road as an "anchor point" for the rainbow.

Also keep in mind that photography, like all art forms, is very subjective. Take a white piece of paper and cover the road in this picture. You may like it better than my version, because the human element is cropped out – although the wires from the telephone poles will still be in the frame.

Crop Creatively

This picture may not look that impressive on this page, because of its small size. However, the 7x24-inch panorama print of this image looks pretty cool on my wall.

I cropped the image from a full-frame picture I took in Cappadocia, Turkey. What you see is only about 1/4 of the original image.

When I composed the picture, the photograph you see here is the image I had in mind. The lower part of the frame was dark, showing no detail, and the upper part of the frame was not that interesting.

By careful cropping, I drew attention to the main subjects in the scene – the rock formations.

Play around with cropping your images, and you'll see that you can often come up with a nice picture within a picture.

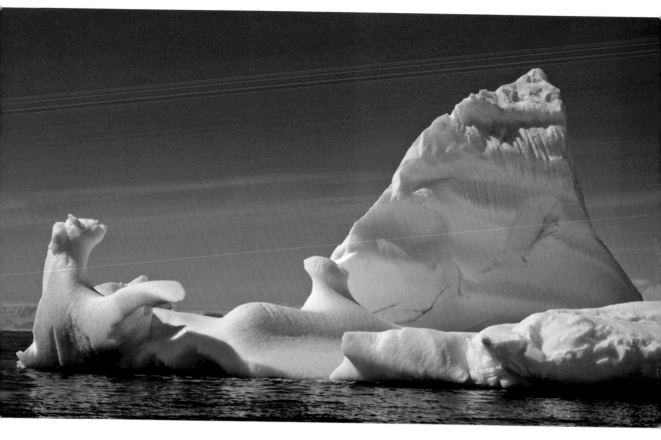

Watch the Horizon Line

Here's an easy, but important tip: Keep the horizon line level. That's sometimes not a simple task, especially when you are photographing from a bouncing boat, as I was when I took this picture in Antarctica.

If the horizon line is askew, you can straighten it later in the digital darkroom using a variety of tools and techniques. In Aperture, for example, you could use the Straighten tool. In Photoshop, you could use the Measure Ruler and Rotate Canvas Adjustment.

The placement of the horizon line in a photograph is also important. I find that if the sky is boring and the foreground is interesting, I'll compose the picture with the horizon line near the top of the frame. If the foreground is boring but the rest of the scene is interesting, I'll compose the picture with the horizon line near the bottom of the frame.

By the Light of the Moon

Here's a popular photo expression: There is always enough light to take a picture, if you have a tripod.

When shooting in moonlight, you'll need a tripod to steady your shot during what will be a long exposure as required by a low-light environment.

Here is a photograph that illustrates that point. One night when the moon was full, I went over to the Croton Dam in Croton-on-Hudson, New York, which is about five minutes from my house. I mounted my camera on a tripod, set the ISO to 800, set the exposure mode to Av (aperture priority), activated the camera's self-timer (to prevent camera shake at the time of exposure) and took the shot.

My exposure was 40 seconds at f/4.

Moonlight has a beautiful soft quality. The next time the moon is full, pack up your gear and go out and take some moonscapes. Good fun – and good picture opportunities.

Shooting Sunrises and Sunsets

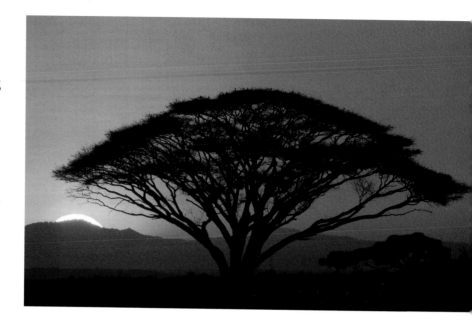

Everyone enjoys a beautiful sunrise or sunset. And because you are reading this book, I know you want to get great sunrise and sunset photographs. Here are some suggestions to capture those magic moments.

Do a Web search to find the time of the sunrise or sunset.

Bring a telephoto zoom and a wide-angle zoom. Photographs taken with a telephoto zoom show the sun larger than it appears in the photographs taken with a wide-angle zoom.

Set your camera to the RAW image quality setting so you can capture a wide contrast range.

Set the ISO to 100 for the cleanest (least digital noise) possible shot. This low ISO setting may require the use of a tripod.

Remove any filters on the lens so as not to get a ghost image of the sun.

Compose the scene with a foreground element.

Frame the scene so that the horizon line is not in the center of the frame. Placing the horizon line near the top or bottom of the frame is more pleasing.

Set the shooting mode to Aperture Priority mode, the metering mode to Center-Weighted and the Exposure Compensation at −1.

One of my goals in sunrise and sunset photography is to preserve the highlights in the scene. In this picture, which I took in Kenya with my Canon 100-400mm IS lens set at 400mm, the clouds around the rising sun are the highlights. If the highlights are overexposed, I reduce the exposure until I get a good exposure of the highlights.

I also take several exposures during the sunrise and sunset. By doing this, I end up with a selection of images and I can focus my efforts on the best of them in the digital darkroom.

I also wear sunglasses and try not to look directly into the sun.

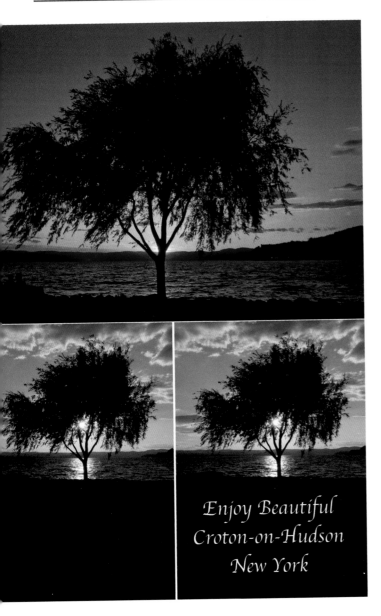

*Enjoy Beautiful
Croton-on-Hudson
New York*

More Tips on Sunrise and Sunset Shots

Try placing the sun directly behind a foreground for a dramatic silhouette. This is especially helpful in reducing the contrast range of the scene and when the sun is very bright.

Be careful you don't unintentionally include very dark foreground areas of the scene. Dark areas, however, can be beneficial when you want to add type to a picture, as illustrated here.

Clean your image sensor before you shoot, because dust spots are easy to spot in the sky.

Don't be so quick to delete pictures that are not bursting with color. You can increase the intensity and/ or vibrance in Photoshop, Aperture and Lightroom. What's the difference between saturation and vibrance? Well, when you increase the saturation, you increase the saturation of all the colors within the scene. When you increase the vibrance, you are increasing the saturation, or intensity, only of the colors that are not already saturated within your image. That's an important difference – because when you increase the saturation in an image where the colors are already saturated, you may lose detail in those areas – and losing detail is something you always want to avoid.

Increasing the contrast of a sunset shot in the digital darkroom can also enhance the scene.

After the Sun Sets

Hey, just because the sun has dropped below the horizon does not mean it's time to stop shooting. In fact, many times the sky comes alive with color and patterns that are more spectacular than the actual sunset. Here are a few quick tips for those situations.

Mount your camera on a tripod.

Set the ISO to 400, set the image quality setting to RAW, choose the Aperture Priority mode and select the Center-weighted metering mode.

Shoot with a wide-angle zoom lens. For this shot, I set my 17-40mm lens to 24mm to capture a wide view of this Hudson River sunset.

Set your exposure compensation to – 1/2 to increase the color saturation of the scene.

Due to the longer shutter speeds, often below 1/2 of a second, use your camera's self-timer to release the shutter – which avoids blurry pictures caused by camera shake.

Keep taking pictures until the colors in the sky fade.

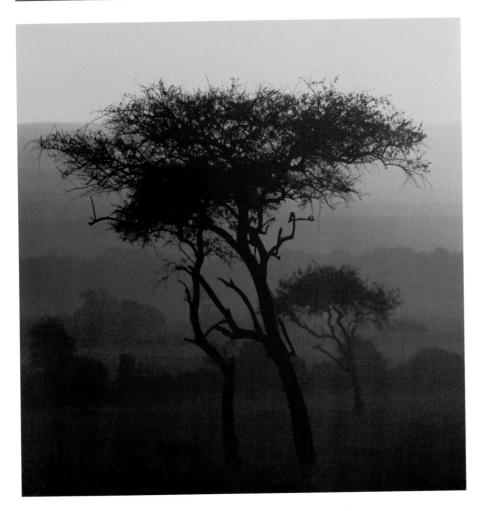

When It's Hazy, Hot and Humid

I enjoy the heat. As long as it's not too humid, I'm okay. My digital camera, like all digital SLRs, is also not a fan of humidity.

When the humidity is high, lenses fog up when we move outdoors from an air-conditioned room or car. We can wipe off the moisture on a lens with a lint-free cloth, but some moisture may remain, and the lens may fog up again. In some situations, it will be best to wait several minutes before shooting.

One thing I avoid at all costs is changing lenses when I move from cool and dry conditions to hot and humid conditions. If the inside of the camera is cold, the mirror and the filter that's over the image sensor can fog up – and stay fogged up for a long time. Even worse, the fogging may cause spots on the image sensor that will show up in a picture. If you think you'll be shooting in humid areas, you probably want to get pro SLR lenses, which cost more than the standard lenses camera manufacturers offer. Pro lenses are sealed against moisture, making them well suited for shooting in the tropics. Pro cameras are also sealed against moisture, but that does not prevent internal fogging when changing lenses.

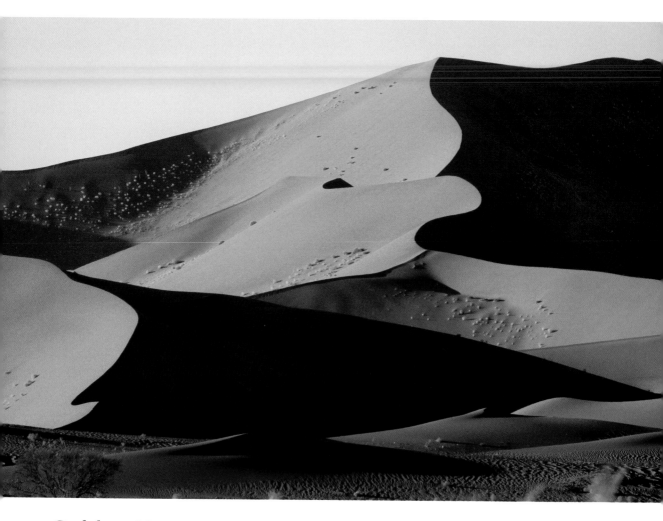

Golden Hours

Professional photographers refer to taking pictures in early morning and late afternoon as shooting during the "golden hours," when deeper shades of red, orange and yellow light cast a beautiful glow to outdoor scenes. What's more, deep shadows, created when the sun is low in the sky, add a sense of depth and dimension to our two-dimensional photographs.

From a financial standpoint, pictures taken during the golden hours sell better (they are golden) than pictures taken during midday. When the sun is higher in the sky, the light is cooler, giving pictures a bluish cast. It's also less flattering, because landscapes look flat due to the overhead lighting.

I took this picture in Namibia during the golden hours of late afternoon. For pictures like this that pop with color and detail, try to plan your day so you can shoot when the light is just right.

Favorite Wide-Angle Zoom

My favorite wide-angle zoom is my Canon 17-40mm f/4 lens. Set at the 17mm setting and with an f/stop of 11, I can get tremendous depth-of-field in my pictures, especially if I set the focus one-third into the scene.

That lens is about half the price of the Canon 16-35mm f/2.8 lens. The f/2.8 lens allows more light into the camera, making it better suited for indoor and low-light level photography. However, I do most of my shooting outdoors, so for me, and outdoors photographers who want to save some money, the 17-40mm lens is a good choice.

If you look closely at this picture, which I took at Bodie State Historic Park in California, you'll see that it's tack sharp and everything in the scene is in focus.

Favorite Telephoto Zoom

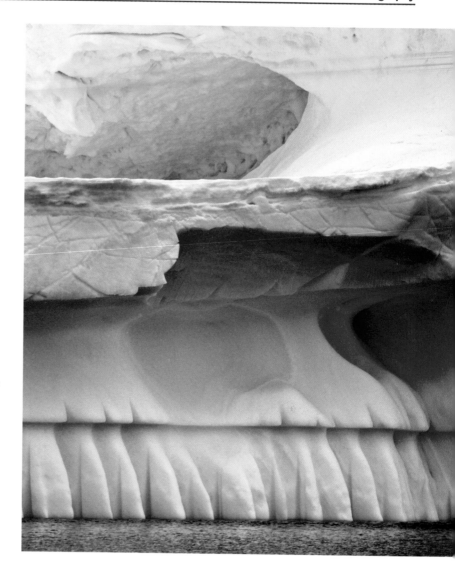

I took this close-up of an iceberg with my favorite telephoto zoom lens for landscape and scenic photography: my Canon 70-200mm f/4 IS lens. Often, I like to zoom in on a particular area of a scene to isolate part of the main subject. Telephoto lenses can also help to "cut the clutter" in a busy landscape scene, or in other scenes which really have no main subject.

Landscape and scenic close-ups add to the storytelling of an adventure or outing, especially when it comes to giving slide shows and producing photo books.

When you are out and about taking landscapes and scenic photographs, don't forget your telephoto zoom. Not only will it help you tell the story, but you may find pictures within a picture that you'll prefer over a sweeping landscape.

Rules of Composition

Rules, of course, are meant to be broken. Being aware of them, however, is a good place to start.

When it comes to composing landscapes and scenic shots, one rule is this: Dead center is deadly. In other words, if you place the subject in the dead center of the frame, it makes for a dull shot. Likewise, if you place the horizon line in the center of the frames, that's also kind of deadly – but I have been known to do that when it seems right.

In this picture, which I took at the Ice Hotel near Quebec, Canada, the main subjects – the ice carving and the entrance to the hotel – are off-center, making the viewer's eyes wander around the picture looking for different elements as opposed to being "stuck" on the subject in the center of the frame.

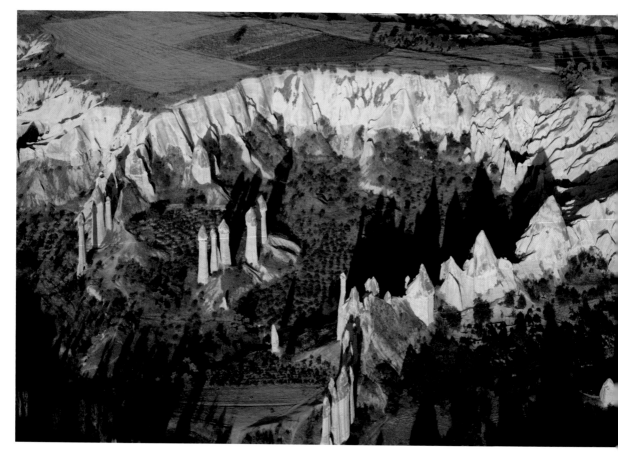

Shooting from Above

I took this picture from a hot-air balloon while floating over Love Valley in Cappadocia, Turkey, early one morning. The shadows add a sense of depth to the scene, and my wide-angle zoom let me capture a wide angle of view.

When shooting from hot-air balloons, helicopters and light planes, I usually shoot with a 17-40mm wide-angle zoom. I use a polarizing filter to darken the sky and lighten the clouds.

When it comes to composition, I try not to place the horizon line in the center of the frame, and I try to keep it level.

Planes and helicopters present special challenges. First, Plexiglas widows soften pictures, create reflections and reduce contrast. When shooting though Plexiglas windows, I cup my hand around my lens and hold it close to the window – to help reduce reflections. Because the pictures are soft, I sharpen them and increase the contrast in Photoshop or Aperture.

Second, vibrations from the plane's or helicopter's engine can cause blurry pictures. To ensure a sharp shot, I shoot at a shutter speed of at least 1/500th of second.

Compose for a Cover or E-Card

One of my photo philosophies is, "The name of the game is to fill the frame." In other words, try to compose your pictures so the subject fills the frame, and so there is little dead space around the subject. Composing in this manner gives a photograph more impact than a photograph in which the subject is lost in dead space.

Here is another photo philosophy that basically says the same thing: "When you think you are close, get closer."

That said, sometimes it's a good idea to leave dead space in a picture, as illustrated in this picture I took of Elephant Rock in the Valley of Fire, Nevada. I composed the picture with some "breathing room" at the top of the frame – room in which a magazine editor could drop in the magazine's name.

Hey, I know you may not be shooting for a cover, but composing with this technique leaves you room to drop in type for an e-card or a printed card too.

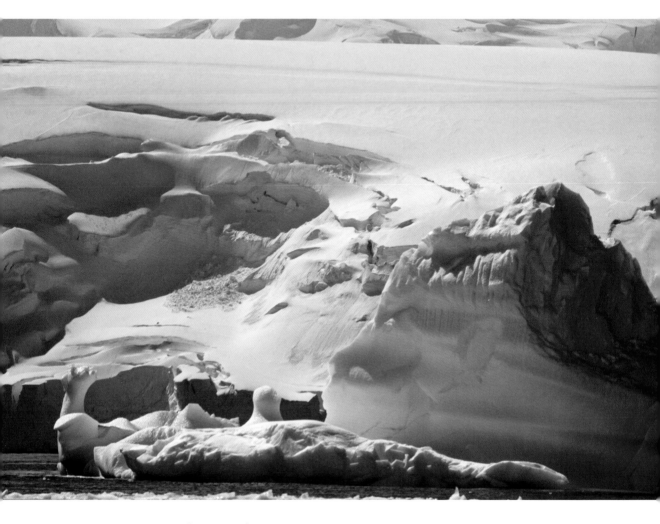

Move Around a Subject

Viewed from this angle, the ice floe in the foreground of this Antarctica scene does not look as though it would make an interesting photograph, because, among other reasons, the ice floe gets lost in the scene. However, when I spotted it, I remembered the old photo adage about walking, driving or motoring (and even flying) around an object for perhaps creating a more interesting photograph.

I asked the driver of our inflatable boat if she would motor around the formation, and she accommodated my request. The move paid off. The picture of the same ice flow that you saw earlier in the chapter is my favorite from my Antarctica adventure. I am sure you spotted the "polar bear" resting on its back in that image. If you did not see it, now is a good time to flip back a few pages!

Be on the move and you'll find new and exciting photographs.

RAW Rules

I only shoot RAW files. Here's why.

A RAW file contains all the digital data for a picture. Plus, it has greater exposure latitude than a JPEG file, meaning it's more forgiving when it comes to exposure.

A JPEG file, because it's compressed, tosses away information, especially in the highlight areas of a scene. Therefore, shooting RAW files becomes particularly important when taking pictures in high-contrast scenes, and when you might make an exposure mistake.

With a JPEG file, those tossed highlights are lost and gone forever. With a RAW file, you can rescue up to a stop of overexposed highlights in the digital darkroom. Rescuing the highlights in this Antarctica photograph is exactly what I had to do, because I forgot to reset the Exposure Compensation on my camera from +1 back to 0 from a previous shot.

What's more, JPEG files come out of your camera already sharpened, saturated and with the contrast increased. This can have an adverse effect on a picture, especially in a scene with a lot of contrast and saturation. In fact, an increase in contrast and sharpness can result in a loss of detail, as does an increase in saturation. With a RAW file, again, the image is not enhanced in any way in the camera.

RAW files take up much more room on a memory card, hard drive, CD and DVD than JPEG files. Additionally, RAW files require at least minimal processing in the digital darkroom, while JPEG files do not automatically necessitate processing. However, that's a small price to pay for priceless photographs.

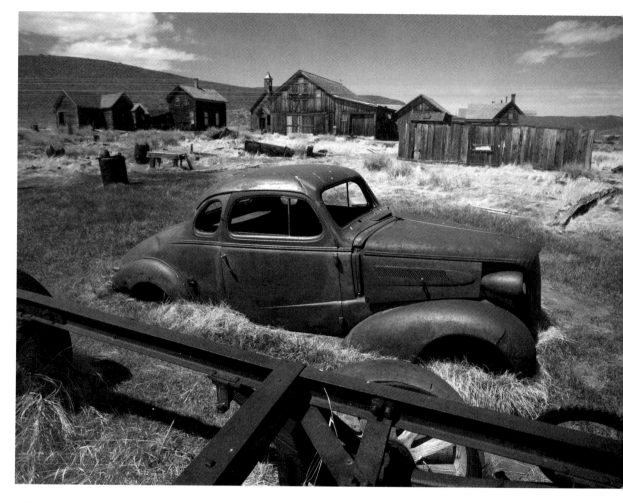

Play with Picture Styles

Many digital cameras offer settings that let you change the color, tone, contrast and sharpness of your pictures. In Canon EOS digital SLRs, they are called "Picture Styles." Other manufacturers use different names. Picture Styles can be great fun to use. They let you see, on the spot, via your camera's LCD monitor, how the effect of the Picture Style you choose (black-and-white, sepia, saturated and so on) will look.

I don't use Picture Styles for my serious pictures, but I do use them for fun snapshots and to see how a scene may look in black-and-white or with some other Picture Style applied to an image.

I don't use them for two reasons. First, all the Picture Style effects can easily be created in the digital darkroom. Second, I don't want to be "stuck" with a certain effect, even if, at the time, I think it's the best style for a picture.

What's more, for any style, black-and-white for example, you have more control over the effect in the digital darkroom.

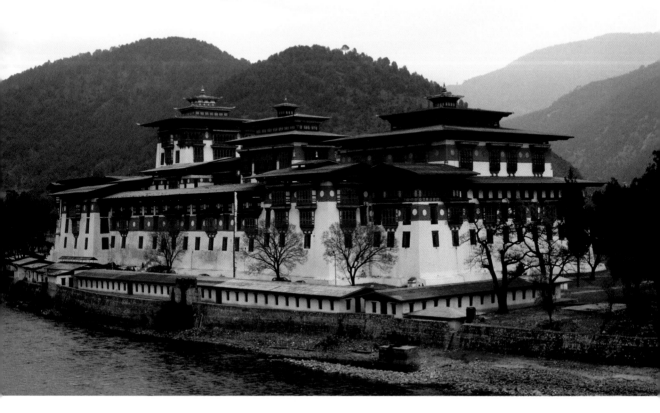

Shooting on Overcast Days

The main tip here is not to put away your camera when the sky is cloudy, but to go out and shoot. In fact, you can get some beautiful, moody, subdued shots on overcast days because you will not get the kind of harsh shadows you get on sunny days. In fact, the lower contrast range actually makes it easier to take pictures.

Due to the lower light level, if you want to shoot at a low ISO, and at a small f-stop (for good depth-of-field), I recommend toting a tripod because you'll be shooting at low shutter speeds.

If there is a chance of rain, bring a waterproof camera protector (see the *Photo Gear* chapter) and an umbrella. And of course, never leave home without a micro-fiber cloth (available at eyeglass stores) to wipe moisture off your lens.

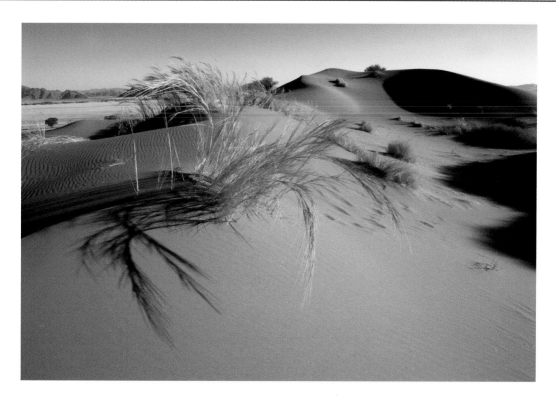

Must Use a Lens Hood

A lens hood is an essential accessory. It shields the front element of the lens, or the filter that's on the lens, from direct light, such as from the sun or from a street light at night. When direct light falls on the front element or filter, it causes what's called "lens flare," which can degrade or ruin an image.

At its worst, lens flare shows up as hot spots in a picture. To a lesser degree, lens flare can make pictures look soft, because it reduces the contrast in images.

That's why I always use and recommend a lens hood.

There is a time when you don't want to use a lens hood, and that's when you are using the *wrong* lens hood for a particular lens. For example, if you use a lens hood for a 24-105mm lens on a 17-40mm lens, at the 17mm setting, you'll get some vignetting (darkening of the edges of the frame) in your pictures, especially at the wide-angle settings. This happens because the 24-105mm lens hood will actually show up in the corners of the image. I know, because I made that mistake – once.

A good way to track which lens hood goes with each lens is to label each lens hood with the name of the lens for which it's designed. That's what I have been doing since I made the mistake myself. Dymo® (www.dymo.com) makes all kinds of label makers at all kinds of price points.

Sure, you can sometimes fix vignetting in the digital darkroom, but why not start out with the best possible image?

I took this picture in Namibia with my 17-40mm lens with the proper lens hood attached.

Take Fun Shots

Why did you get into photography in the first place? My guess is that you wanted to have fun.

I'm with you on that. Even today, I still like to have fun – and I like to take funs shots, which are a nice addition to my slide presentations and books.

I took this fun shot in the Gobi Desert in Mongolia. Including my shadow in the scene added to the humorous element of the picture.

So that's a quick tip! Remember to have fun when you are out taking pictures!

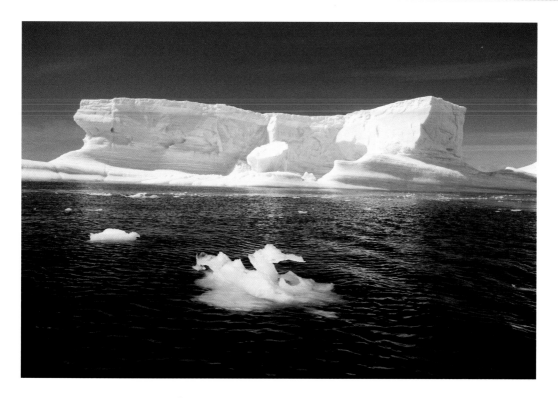

Using ND Graduated Filters

When the sky is much brighter than the landscape, a graduated neutral-density (ND) filter can reduce the contrast range in the scene for more even exposure. These filters are darker (grey in color) at the top and gradually become lighter and eventually clear at the bottom (or vice versa if you mount them in the opposite position). They don't affect the color of the scene, because they only darken a portion of it. They fit into an adjustable holder on the front of the lens that lets you adjust the filter's position.

I often use on-camera neutral-density graduated filters, as I did when photographing this ice floe in Antarctica.

Graduated filters are available in different degrees of gradation. You'll want to use a graduated filter with a gradual change on a landscape scene (where the horizon line is not perfectly defined) and a graduated filter with an abrupt change on a seascape (where the horizon line is very defined).

To turn a gray sky into a blue sky, there are blue graduated filters. Orange, red and other colors of graduated filters are also available to add dramatic color to a gray sky.

Traditional graduated filters are available in different densities (one stop, two stops, etc.) for fine-tuning the contrast range under many different lighting conditions.

A final note on traditional lens filters: If you want the sharpest possible pictures, keep your filters clean and finger mark free.

Digital graduated filters are available in Photo Tools from onOne Software (www.ononesoftware.com) and in Nik Color Efex Pro 3 from Nik Software (www.niksoftware.com).

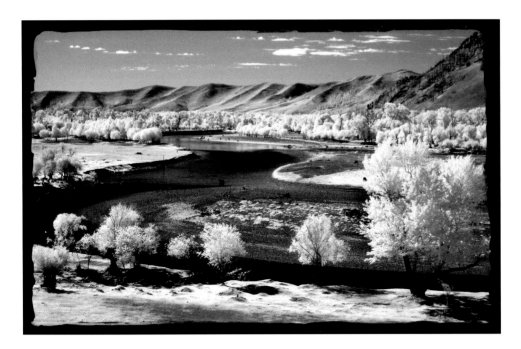

Convert to IR

Digital infrared (IR) photography opens up a whole new world of creativity – even for photographers who already have a creative bent. The infrared part of the light spectrum is outside the range of what we can see. With a digital camera, we can record what is, to our naked eyes, "invisible light" and block the "visible " portion, often resulting in an unusual or unexpected image of everyday scenes. Today, it's easier than ever to jump into the world of IR imaging. There are several companies, including LifePixel (www.lifepixel.com) and IRDigital (www.irdigital.net) that will convert many Canon and Nikon cameras (SLRs and compact models) to IR-only cameras. Once the camera is converted, however, say good-bye to full-color pictures with that camera. You can save $16 on your conversion at Lifepixel.com by using this code upon checkout: ricksammon.

IR images look creative and artistic because some of the reality is removed from the scene. Removing the true color is the first step in removing the reality. Then we get to the real fun: green foliage turns white, making it look as though it's covered with a thin coat of snow or ice – or even vanilla frosting.

Different types of conversions are available from the vendors, from traditional IR to vivid color IR. The choice is yours! See their Web sites for details and examples.

Play around in Photoshop or Photoshop Elements and you have even more creative options with your IR pictures. Add a digital frame, as I did here using a Brush frame in Photo Frame Pro 3 from onOne Software (www.ononesoftware.com), and your pictures look even more artistic.

I took this picture in Mongolia with my IR-converted Canon SD-800 compact camera.

Digital IR effects are available in Photo Tools from onOne Software (www.ononesoftware.com) and in Nik Color Efex Pro 3 from Nik Software (www.niksoftware.com).

Check Out a Postcard Stand and Get a Guide

When I first became interested in photography, a professional photographer friend of mine, Lou Jones (www.fotojones.com), shared one of his secrets with me. He told me that when he goes to a new destination, he checks out the postcard stands to get ideas for photographs.

Today, 35 years later, when I go to new destinations, I do what Lou does. Sure, some of the postcard pictures are hokey, but they still give me an idea of what the local sights look like.

In addition to checking out the postcard stands, I always work with a guide. Sometimes, I arrange for the guide before I leave home. Other times, I hire a local guide on site. Having the right guide can do wonders in helping you get around in the area and in taking you to special locations that are not listed as tourist hot spots.

Yet another way to get ideas for pictures is to do a Google search of your destination before you leave home. I always do that. Before I went to Turkey, I did a search for Turkey photographs.

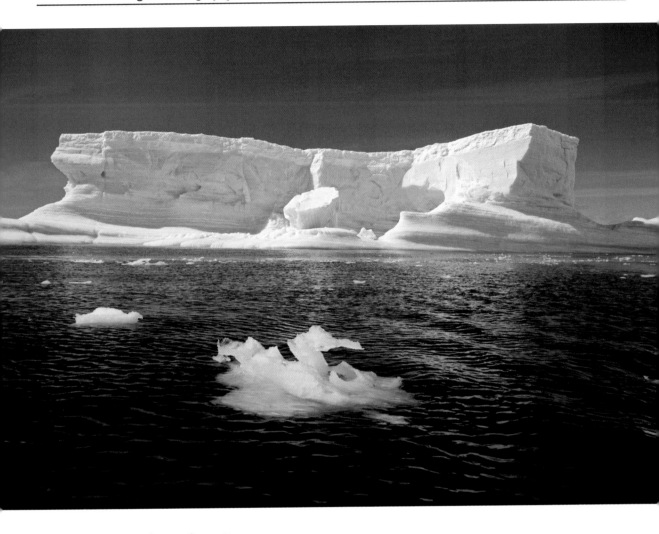

Shooting by the Sea

I love photographing seascapes, but salt spray from the sea is not a good match for digital cameras.

Because salt spray is almost ever present at the beach, I always carry a micro-fiber cloth to wipe spray, which can cause soft pictures, off the front element of my lens or the filter I have on my lens. I carry another cloth to keep my camera and lens as clean as possible. Under these working conditions, a skylight filter is highly recommended to protect your lens or filter.

When I shoot at the beach, I always shoot with two cameras, one with a wide-angle zoom and one with a telephoto zoom. With two cameras, I don't need to change lenses. Changing lenses might expose the camera's mirror and filter that's over the image sensor to damaging salt spray.

Keepin' it clean is the way to go when shooting by the sea.

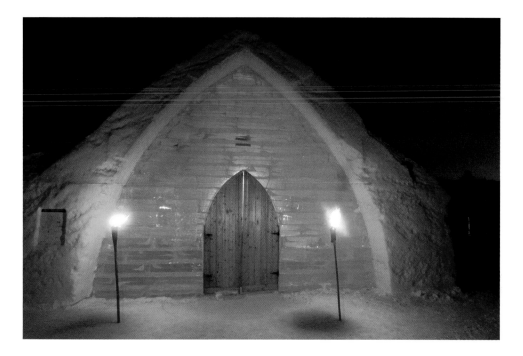

Shooting at Night

Here is another picture of the Ice Hotel near Quebec that you "visited" earlier in this chapter. This is the entrance to the Ice Hotel's chapel.

Pictures taken at night often take on a more creative look than daytime pictures due to the different lighting that illuminates the scene. That's one reason I really enjoy shooting at night.

When I shoot at night, I always tote a tripod so I can shoot at slow shutter speeds without camera shake, which can cause blurry pictures.

I set my ISO to 400 and my White Balance to Daylight (because I like warm toned pictures).

I use my camera's self-timer, which avoids camera shake that may be caused by pressing the shutter release button.

I also use the camera's noise-reduction feature, which is a better way to reduce digital noise in a file than reducing noise later in the digital darkroom. However, like all in-camera noise-reduction features, it slows down the time between taking pictures, while it processes the image, and sometimes takes several seconds. Therefore, I have to plan my shots carefully.

Nighttime photography, due to the often wide-contrast range, is another time when RAW files are the best choice, because they have wider exposure latitude than JPEG files.

As always, I check my camera's histogram and overexposure warning indication to make sure I have a good exposure.

Finally, I follow my mother's advice: I wear white at night for safety in traffic situations.

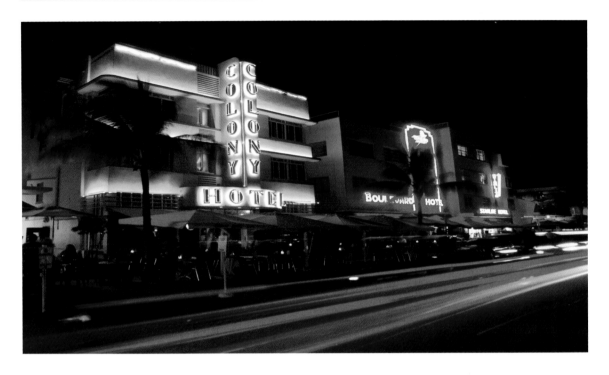

Blurring Night Lights

One of the cool effects we can create in camera is blurring moving lights at night. Blurring the lights takes some of the reality out of the scene, and when we take out some of the reality, a picture becomes more creative and more artistic.

Here are a few guidelines for creating photographs like this one, which I took in Miami's South Beach.

Set your camera on a sturdy tripod.

Set the ISO to 100.

Set the camera to the Tv (shutter priority) mode and select a shutter speed of 10 seconds or slower. I took this picture with the shutter speed set at 10 seconds.

Use the camera's self-timer to take the picture. That will prevent blurry pictures caused by camera shake when you press the shutter release button.

Take a shot, check the histogram and overexposure warning on the LCD monitor on back of your camera to make sure your highlights are not washed out – which can happen in high contrast scenes. If they are washed out, use your camera's exposure compensation (+/-) feature to fine-tune your exposures by reducing the exposure time or aperture.

Take additional pictures at different slow shutter speeds to see how you can improve your pictures.

When photographing moving cars, getting the red taillights in the picture will look much better than just getting the white headlights.

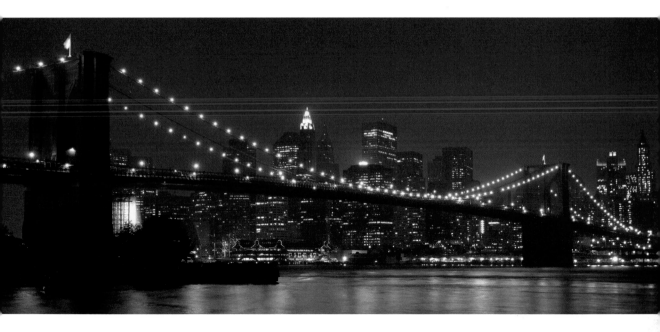

Shoot for a Panorama

Panoramas offer an unusually wide view of a scene, drawing extra interest to a photograph. One popular method for creating a panorama is to use a panorama camera, which costs thousands of dollars. Another is to create the panorama in the digital darkroom, taking a series of pictures and stitching them together.

Here's a much easier method. Use a very wide-angle lens and compose your picture for a panorama. When you open the picture in the digital darkroom, simply crop out the top and bottom parts of the image – leaving only the main subject. That's what I did for this picture of the Brooklyn Bridge.

When shooting with a panorama in mind, you really have to compose very carefully, so you don't crop out any important part of the frame.

Don't Forget the Details

Oftentimes, we get so swept away with the beauty of a landscape that we don't focus on the details in a scene or at a location. Including these close-up shots helps us to tell the story of a location or a day in the field. They also make nice pictures in and of themselves.

When I photograph details, I like to have the entire frame in focus – as opposed to taking macro pictures in which depth of field is limited. To achieve that goal, I mount my camera on a tripod, use a wide-angle lens set at a small aperture (usually f/11), set the ISO at 100 for the cleanest (least noisy) possible image, set the image quality to RAW and use the camera's self-timer to take the picture (which prevents camera shake).

Another goal is to "cut the clutter." Along the path where I took this picture were dozens of rocks and hundreds of ferns – making for a very cluttered scene. Isolating one rock and a few ferns was the key to getting this nice detail shot.

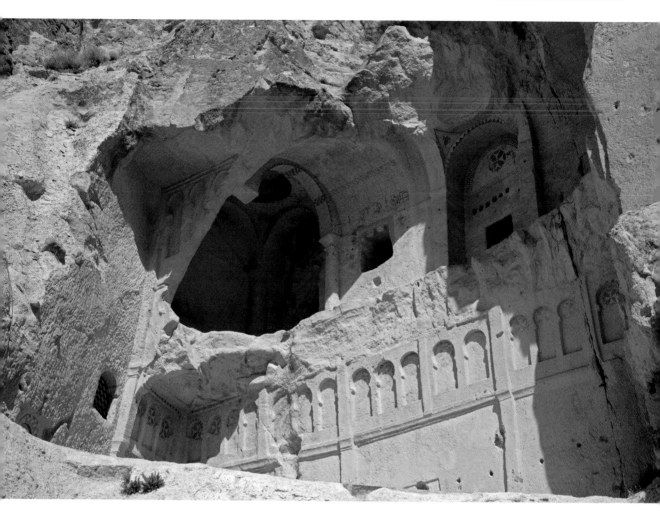

Envision the End Result

Check out this picture I took in Cappadocia, Turkey, of an ancient city carved out of a mountain. You can see detail in the area of the scene that is in bright sunlight, yet you can also see detail in the shadow areas.

My straight-out-of-the-camera shot did not show what you are seeing. Because I exposed for the highlights, which I always do to prevent them from being overexposed, the shadow areas were a bit blocked up (underexposed.) To fix this problem, I opened the RAW file in Aperture and then opened up the shadow areas using the Highlights & Shadows adjustment, which allows users to open up shadows and tone down highlights fairly independently. How cool is that?

The idea is that whenever you take a picture, always try to envision the end result. Think about the dozens of adjustments that are available in the digital darkroom to enhance (and fix) your pictures.

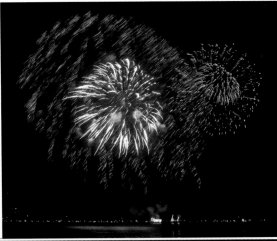
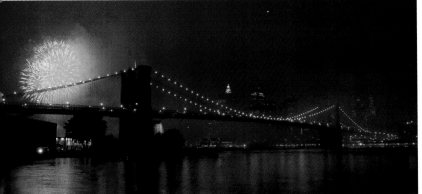

Photographing Fireworks

Fireworks photographs are not easy to take, mostly because the light level changes, sometimes by a few f-stops, from burst to burst. What's more, each burst is in a different place in the sky. Another challenge is to capture the burst right at its peak.

Here are my tips for photographing fireworks. Even though I followed these rules the three pictures you see here are the best out of about 100 I took at two different fireworks displays. So, the first tip is to be prepared to take lots and lots of pictures.

Here are my other tips.

Bring a small flashlight so you can see what you are doing and where you are going!

Choose a location. This is very important. For two of the pictures here, I had a good location. For the Brooklyn Bridge fireworks shots, I did not have the best location, and I was locked into that position due to the large crowds.

Mount your camera with a wide-angle lens or wide-angle zoom on tripod. You want the tripod to steady your camera (use the self-timer to release the shutter) and the wide-angle lens to capture the fireworks in the sky.

Set the ISO to 200, the exposure mode to Manual and begin by setting the exposure at f/11 at 2 seconds. You'll have to change this setting from time to time, but I find it's a good starting point.

Activate the long-exposure noise reduction feature in your camera if it has one. Noise shows up in dark areas, and you'll have plenty of dark areas in the scene. If your camera does not have that feature, plan on reducing the noise in the digital darkroom.

As I suggested, plan on taking lots of pictures.

Finally, have fun! Fireworks displays are a blast – literally!

Always Look Up, Down and Back – and be Careful!

There's an old photo expression: Always look up, down and back. The idea is that rather than being focused only on what's in front of you, you should also look around for other photo opportunities. When I follow that advice, I do find that I see more photo opportunities. So do my workshop students.

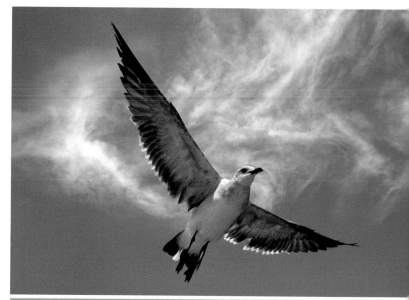

However, a word of caution when looking around: Be aware of what's going on around you. Once I was almost killed while photographing high-flying seagulls at a fishing dock in Maine early one morning. I was so focused on what was going on overhead that I did not notice a huge truck, packed with a fresh catch, backing up – with no warning beep, by the way.

The truck knocked me down and almost ran over my head. No kidding. I rolled out of the way to safety. I was very, very lucky.

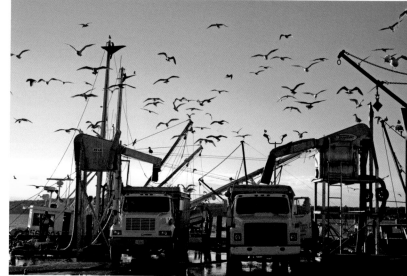

I got a few cuts and bruises and was covered head-to-toe with fish scales. My camera also survived, as I held it in the air when I rolled away from the truck.

Always think safety first when taking pictures.

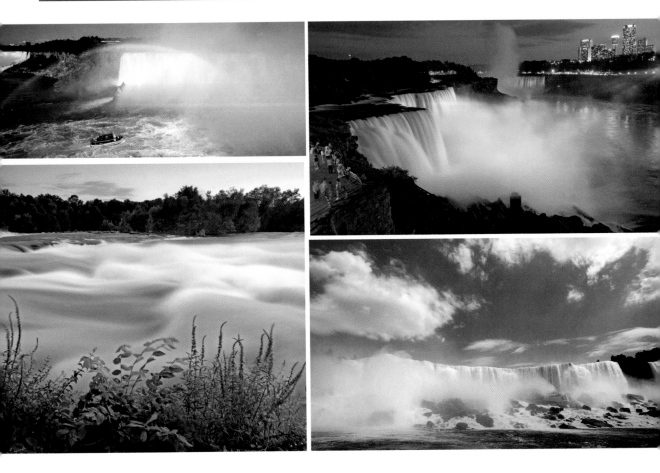

The Self-Assignment

When I teach a workshop, I give students the task of imagining they are on assignment for a magazine or local newspaper, and they need enough pictures to "tell the story" of a location. I suggest shooting from dawn to dusk, experimenting with shutter speeds to freeze and blur action, finding unique angles, using different lenses for wide-angle and close-up views, composing pictures for a cover and a two-page spread and so on. I also ask them to write a caption for each picture – "writing" the caption in their minds as they look though the viewfinder. This helps with the creative process, because they verbalize what the picture is "saying."

The next time you are out and about, give yourself the magazine story assignment. You'll see that by setting goals, you force yourself to take a wider variety of pictures.

Here are a few pictures from my self-assignment to Niagara Falls. What fun!

Landscapes in HDR

Later in this book, specifically in the *Digital Darkroom* chapter, I touch on HDR (High Dynamic Range) images. Basically, HDR images, through the processing of several images taken at different exposures (from underexposing to overexposing a scene), create a single image that shows the entire brightness range of the scene. How amazing is that?

I have found that perhaps the best use of HDR is for landscapes. One of my favorite HDR landscape images, created with Photomatix Pro (discussed in the Digital Darkroom chapter) is the top image on this page. It was created from seven exposures of the same scene, the lower image here being the middle exposure.

So you might be asking, "Rick, if you love HDR landscapes as much as you say you do, how come only one is pictured in this chapter?"

Well . . . all HDR images tend to look alike. That's great if you are trying to develop a style – and if you want all your images to have the same "look." What's more, it's super easy to get a good exposure with HDR – because the good exposure is assembled for you in the HDR software.

My advice when it comes to HDR. Master it – then use it wisely. Like any other special effect or technique, it can get old after a while. But first, master all the principles of landscape photography; you'll be a better photographer for it.

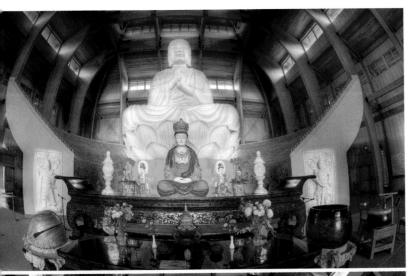

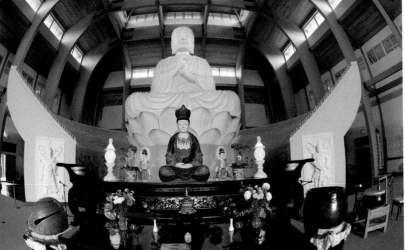

Take HDR Inside

Okay, I know I am stretching it a bit . . . but I guess you could call this a scenic view of the inside of a Buddhist temple near my home in Croton-on-Hudson, NY. Call it poetic license.

Anyway, I wanted to share with you one more HDR image, created using the same technique that I mentioned on the previous page.

Not only can you take HDR inside, but you can take many of the points covered in this chapter inside, including: Get It All in Focus, Think in Three Dimensions, Watch the Edges and Know Your Boundaries, and, of course, RAW Rules!

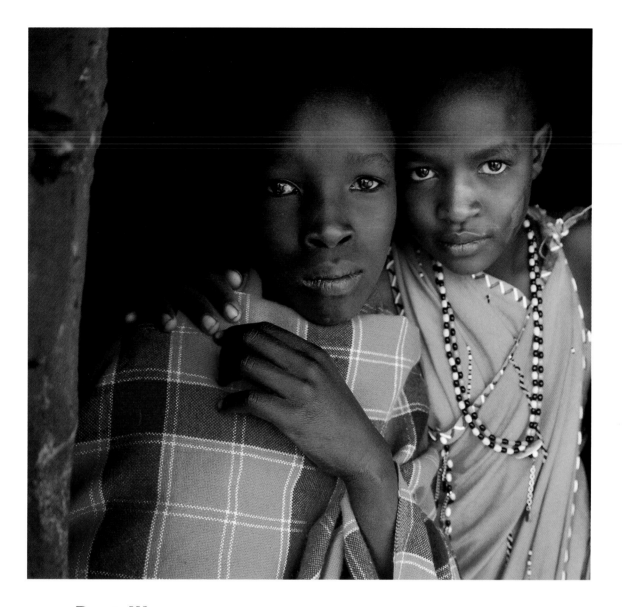

Part III

Photographing People

The camera looks both ways – in picturing the subject, you are also picturing a part of yourself. This chapter illustrates that point. Oh yeah, lots of tech talk here about lenses, flashes, reflectors and diffusers, too.

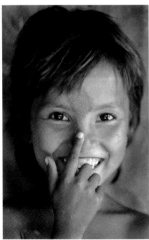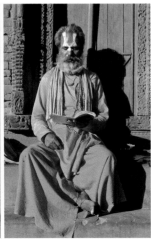

Fun Facts for Better People Pictures

I'll start off this chapter with some interesting facts about people pictures – facts that can help you become a better photographer. We naturally prefer pictures of people in which their pupils are open wide as compared to pictures of people in which their pupils are closed down. That's one reason why we like pictures of people taken in subdued lighting conditions, in the shade and on cloudy days – situations where the pupils are open wider than they are in bright light and on sunny days. Thus lighting, and coordinately the subject's pupils, can affect whether the viewer finds the picture appealing.

Black-and-white portraiture is attention getting, but contrast is actually more important than removing the color from an image. So think contrast, which you can add with a reflector or flash, when taking people pictures.

The majority of famous painters "illuminated" their subjects from above and to the left. For whatever reasons, we seem to prefer images taken with this kind of lighting. Here are three of my pictures that illustrate that lighting technique. Hey, if it works for famous painters and if it works for me, it will work for you!

In very low light and at night, your eyes have an ISO of about 800. Mid-range digital SLRs have a high ISO setting of 1600, and high-end SLRs have high ISO settings of 1600, 3200 and even 6400! So in effect, a camera can see better at night that you can – so don't stop taking pictures when the light gets low and when the sun goes down.

We see colors differently at different times of the day – depending on our mood and emotional state. Before you make a print, look at it on your monitor at different times of the day to see if you still like your original version. You may want to tweak the color to find the final product that you like best.

Also keep in mind that different cultures "see" colors differently. For example, in Mexico, blue, not black, can signify mourning. Knowing this can help you tell a story – and remember it may be a different story from one audience to the next.

You can learn more facts about people pictures and why we like them in one of my favorite books: *Perception and Imaging* by Dr. Richard Zakia. You'll find more info on seeing at iLab (http://ilab.usc.edu).

Drag the Shutter to Create a Sense of Motion

My guess is that you did not buy a cool digital camera so you could set it on the Green Mode (fully automatic) for point-and-shoot photography! You chose your camera so that you could take great shots, not simple snapshots.

In this example, by using some basic camera adjustments, capturing the grace and movement of these flamenco dancers, who were performing in low light, was easy. Here's how to do it.

First, due to the low light level, you'll need to set your ISO to 400, 800 or maybe even higher.

Second, set your camera on the M (manual) mode and dial in the correct f-stop and shutter speed combination for a good exposure – but make sure you have a shutter speed of around $1/8^{th}$ of a second. Take a test shot. Your subject(s) will be blurry, but don't worry. At this point you are only testing the natural light exposure.

Third, turn on your accessory flash (or pop up your built-in flash) and set it to TTL (Through-The-Lens) fully automatic exposure.

Now, here's the secret to capturing the motion. As soon as you press the shutter release button, move the camera from left to right or vice versa. It's that motion of the camera that helps to create the sense of motion in the scene.

You'll need to experiment with different slow shutter speeds to get the precise effect for which you are looking. I took eight shots to get this one.

If your subject is over- or underexposed, you can use the Flash Exposure Compensation feature, which is usually found on the accessory flash or in-camera, to adjust the exposure.

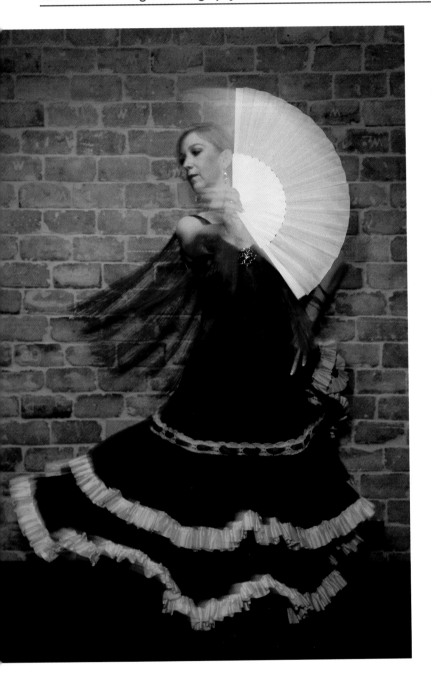

Fine-Tune Flash Exposures with Exposure Compensation

Flash photography is part art, part science. The art part is up to you. The science part is up to the camera, and, in part, up to you because, for among other reasons, you can control the flash output with the +/- Flash Exposure Compensation feature on your accessory flash or that's built into your camera.

By checking your image on your camera's LCD monitor, it's easy to see if a subject or part of a subject is over- or underexposed. If the subject is too dark, then increase the exposure using the + key. If it's overexposed, decrease the exposure using the – key.

When I took my first shot of this flamenco dancer, the fan she was holding was overexposed. By reducing the flash output by – $1\frac{1}{2}$ stop, I succeeded in getting a good overall exposure of the scene.

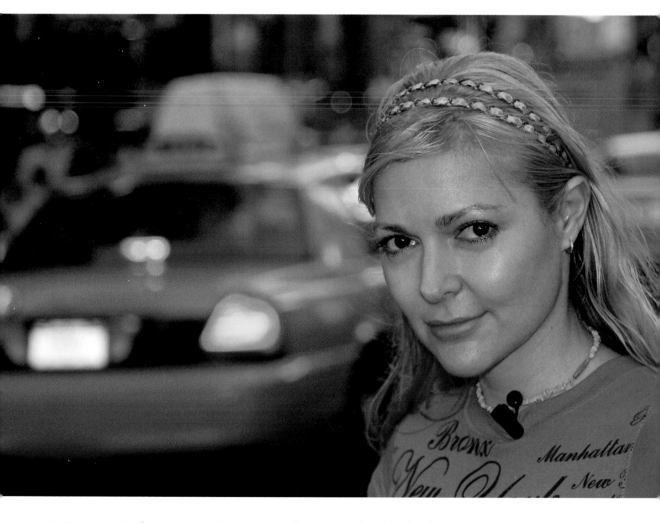

Nice Nighttime Shots Using the Night Portrait Mode

When I simply want to take a fun shot, I use the Basic (fully automatic) mode on my camera. These Basic modes (Green, Portrait, Night Portrait, Sports, Landscapes and Flash-off) bring point-and-shoot photography to the digital SLR. More often than not, the pictures turn out okay – and sometimes even better than okay!

One of the Basic modes I like to use is the Night Portrait mode. In that mode, the camera sets a slow shutter speed to record the background light, and the built-in flash pops up to illuminate the subject.

But here's the deal; depending on the specific camera model, you may not be able to adjust any of the other camera settings (ISO, white balance, etc.) in this or any of the Basic modes. Therefore, if your subject is over- or underexposed, I recommend switching to the Manual exposure mode to ensure a good exposure.

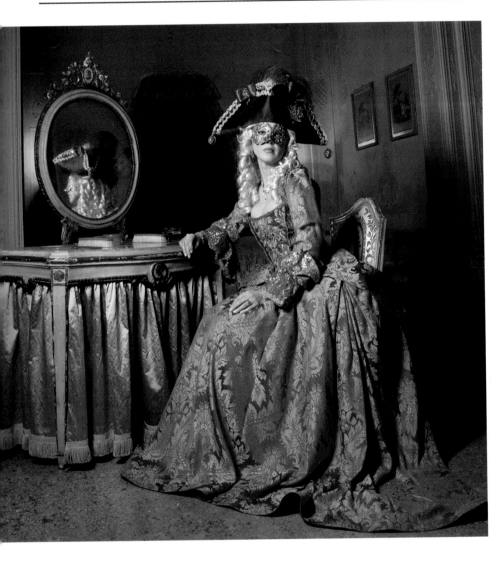

Make Pictures, Don't Just Take Pictures

Simple as it sounds, there is a big difference between taking a picture and making a picture. When you take a picture, you simply point and shoot. When you make a picture, you think about all the elements in a scene and how they can complement each other. You think about the lighting and the background and the foreground. And you think about the mood you want to create with your picture.

For this picture, which I took during Carnevale in Venice, Italy, I made the picture by adjusting the lighting (from one strobe) and posing the subject so that her reflection appears in the mirror. I also had her look directly into my lens for direct eye contact.

The next time you set up a portrait session, think about the big difference between taking a picture and making a picture – and make a good one!

Position the Subject in the Foreground

When taking an environmental portrait, that is, a picture of a person in his or her environment, it's best to place the subject close to the camera, as illustrated by the top photograph. By doing so, the person becomes the main subject and does not get lost in the scene, as illustrated by the bottom photograph.

When traveling, I often see this mistake. Recently I was in Washington, D.C. and saw a tourist photographing his son on the steps of the Capitol building while he was standing 100 feet away with his camera. I am sure the Capitol looked great, but my guess is that the young boy is unrecognizable in the photograph. Had the dad moved his son much closer to the camera, the picture would have been much more personal.

The message: get up close and personal with the subject.

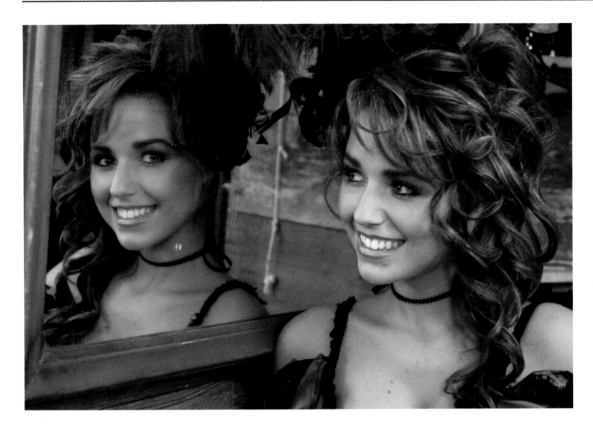

Go with the Grain

My dad had a great photo philosophy about film photography: If a picture is so boring that you notice the grain, it's a boring picture no matter what.

All digital cameras produce images with some digital noise ("grain" in film terms). As the price of a digital camera goes up, the amount of noise it creates usually goes down. What's more, as the ISO increases, so does the digital noise in the image. It's also important to know that a compact digital camera, because it has such a small imaging chip, will have a lot more noise at ISO 400 that a pro digital camera at ISO 1000.

I took this natural picture of a cowgirl on my Canon EOS 1Ds Mark III with the ISO set at ISO 1600. There is a bit of noise in the image. Although the image is not "clean" (free from digital noise), it is one of my favorite images from that photo session.

Keep in mind that digital noise also shows up more in the shadow areas of a scene. Also, noise is exaggerated when a picture is sharpened in the digital darkroom.

You can reduce noise in a digital file in Photoshop, Adobe Camera RAW, Apple's Aperture or Adobe Lightroom. There are also plug-ins that can help you reduce noise. My favorite is Nik's Define (www.niksoftware.com). You can learn more about these applications and other noise reduction plug-ins by doing a Google search.

Wonderful Window Light Pictures

Rembrandt, the famous painter, was known for the portraits he painted by window light. Window light offers beautiful lighting for photographs too. It's soft and flattering to the subject, and it offers ratio lighting; that is, one side of the subject's face is brighter than the other (due to the light fall-off).

I took this picture of my friend, Vered, in a local restaurant in Croton-on-Hudson, New York. The light was nice enough. But to make a nice Rembrandt-style portrait, I had Vered face the window and look slightly upward – which created reflections called "catch lights" in her eyes.

Due to the relatively low light, I set my ISO to 800 so I could shoot at a shutter speed of $1/30^{th}$ of a second. Because I was using my Canon 24-105mm IS (image stabilization) lens, I could handhold the camera at that slow shutter speed and still get a sharp shot without the need of a tripod to steady the camera. Without an IS lens, I would have needed a tripod or other camera support to steady the shot.

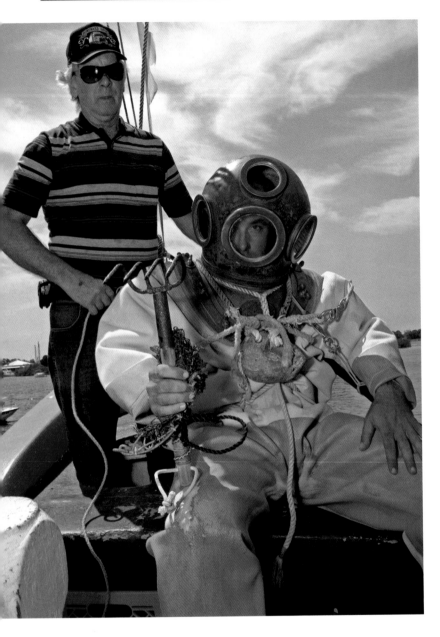

Daylight Fill-in Flash Photos

Check out this shot of a sponge diver and his assistant that I took at Tarpon Springs, Florida. I took the shot at midday, when the sun was overhead. It created harsh shadows on the assistant's face, not to mention made it very difficult to see the diver's face inside his helmet.

However, in this picture we can clearly see the assistant's face and we can see into the diver's helmet. That's because I used a flash for a technique called "daylight fill-in flash" photography. The goal is to have a picture not look like a flash picture. Here's how to do it.

First, set the camera on the Manual exposure mode, take a shot and check your exposure on your camera's LCD monitor. Don't worry that you can't see into the shadow areas of the image.

Next, turn on your accessory flash (or pop up your in-camera flash) and take a shot. If the subject is too washed out, reduce the flash output with the +/- Flash Exposure Compensation feature of your flash or via your in-camera Flash Exposure Compensation feature. If it's too dark, increase the flash exposure.

If you look at this image, both the sky and the diver's face are properly exposed. Did I get it right the first time? Sure. Only kidding! I had to take a few shots, and then fine-tune my flash exposure using previously mentioned techniques, for this "keeper."

Painting with Light

Calling all artists! If you like painting, you'll like this technique. It's called painting with light and it's fun and easy – and creative!

How creative? Well, just compare the painting with light photograph on the right compared to the photograph on the left, which was taken with an on-camera flash bounced off the ceiling.

All you need is a flashlight and tripod to start the fun. Oh yeah, you'll need a camera, too.

First, you'll need an almost totally dark room, because you don't want any stray light falling on your subject.

Second, mount your camera on a tripod and set the ISO to 400 or 800.

Third, set the exposure so that you have a shutter speed of at least 10 seconds.

Fourth, set your camera to self-timer and press the shutter release button.

Fifth, once the shutter is released, begin to paint the subject with light, using the flashlight like a paintbrush. Start with the main points of interest – the girl's face and hands in this case. Try to keep at least three feet away from the subject. That will prevent "hot spots" caused by the beam of the light.

Because you'll be painting at different speeds, you'll need to experiment with this technique. When taking the photograph above, it took me about a dozen tests to get an image I liked.

Soften the Light with a Diffuser

I photographed this girl on a sunny day in harsh sunlight. Yet, the light is soft and pleasing. That's because I had an assistant (her mother) hold a light diffuser between her and the sun, which she was facing. The diffuser softened the light and eliminated the harsh shadows.

The result was similar to the light we get on overcast days, which are ideal for taking people pictures.

Diffusers come in different sizes and collapse to about one third their size for easy toting. I used a diffuser with a 36-inch diameter (when opened). You can get diffusers that have a diameter of 6 feet and even more.

Fill in Shadows with a Reflector

Check the lighting on this subject. At first glance, it may look like studio lighting, because we have a nice hair light on the subject's hair and we have nice lighting on the subject's face – especially her eyes.

Actually, I created the lighting quite simply. First, I had her turn away from the sun. Then I had her mother hold a 36-inch gold color reflector at camera left (the girl's right) and positioned it so that the sunlight was reflected onto her.

Reflectors come in different sizes and collapse for easy toting. They usually have a gold side, which reflects a warm light, and a silver side, which reflects a cool and brighter light.

When using reflectors, you should tell the subject beforehand not to look at the bright surface. Also, don't hold the reflector too close to the subject, as it may cause your subject to squint.

Get Everything in Focus

In this picture, which I took in Mongolia, everything in the scene is in focus. When I take a picture like this one, which I call an environmental photograph, I use a wide-angle setting on my wide-angle zoom lens and a small f-stop (20mm and f/11 in this case).

I take an environmental portrait when the background and foreground elements help to tell a story about the subject and the location – the story I want to tell with my photograph.

When taking people pictures with a wide-angle lens, you don't want to get too close to the subject; otherwise, the subject's features will be distorted. I try to stay at least three feet away from the subject when shooting with a wide-angle lens.

The Classic Head Shot

Models, actors, actresses and business people use headshots to give potential clients a good likeness of themselves. Even professional photographers have been known to post their own head shots on their Web sites.

When taking a headshot, I use a 70-200mm zoom lens set between 100mm and 200mm and set at a wide f-stop (f/2.8 to f/4.5).

Those lens settings blur the background and help make the subject stand out in the frame, as illustrated by this picture.

When using telephoto settings on zoom lenses and telephoto lenses at wide f-stops, focus becomes more critical than it does with wide-angle lenses, because depth-of-field is shallow. Therefore, it's important to focus carefully on your subject's eyes, and to check your focus by magnifying the image on your camera's LCD monitor.

To compress the brightness range (caused by strong shadows), I use a reflector, diffuser or a flash – topics covered earlier in this chapter.

Watch the Background

If there is one thing about people photography that drives me nuts it's when the photographer does not check the background to see if any objects – branches, signs, fences and even rock formations – look as though they are growing out of the subject's head.

If a distracting object is in the background, we can blur it by using a telephoto lens set at a wide aperture. But in most cases, it's just easier for the photographer (or the subject) to move a bit to the right or left to avoid this photo faux pas.

Capturing Sports Action

When I took this photograph of my son and his friend playing lacrosse, they were running toward me at almost top speed. Because I wanted a sharp shot, I set up my camera for capturing sports action. Here's the technique.

First, I set the ISO to 400, which makes the camera's image sensor more sensitive to light, allowing me to shoot at a higher shutter speed than I could at a lower ISO. When I am photographing action, I always use a shutter speed of at least $1/500^{th}$ of a second. The faster the subject is moving, the faster I set the shutter speed.

Then I set the focus mode on my camera to AI Servo – which tracks a moving subject right up until the moment of exposure.

I also make sure the IS (image stabilization) switch on my telephoto zoom is set to the ON position. That way, I don't need a tripod or a monopod to hold the camera steady – unless I am using a lens longer than 400mm.

Next, I set my camera to rapid frame advance, so at the touch of the shutter release button, my camera takes several frames per second.

When I compose the picture, I leave some dead space around the subject so that no body parts are cut off. (This picture is cropped from the original, as are most of the pictures in this book.)

Always Look Back

Simple as it sounds, if you take the time to look back (and up and down) when you are out shooting, you'll see picture opportunities that other photographers miss when they are on a mission to get someplace fast. You may find a similar tip in the *Landscapes* section of this book. However, this tip isn't only relevant to landscapes, and I find that many novice photographers often forget to apply this tip to other types of photography, including photographing people.

This may be the shortest tip in this book, but it's still a good one – and one that I try to follow when I am out shooting, even when I am in a rush to get to another photo destination.

Get Up Close and Personal

I like my photographs to have a sense of intimacy. That's why I like to shoot relatively close to the subject with my wide-angle zoom lenses: Canon 17-40mm or Canon 24-105mm IS.

I find the closer I am to my subjects, the more the viewer of the picture can relate to them. Sure, working close requires the ability to interact with the subjects, but that's a skill that comes over time with practice. It also requires the ability to shoot fast.

So as not to overstay my welcome, I set up my camera beforehand and double-check all the settings. That way, the photo session basically becomes point-and-shoot photography, because I don't have to make any camera adjustments that would prolong the shoot.

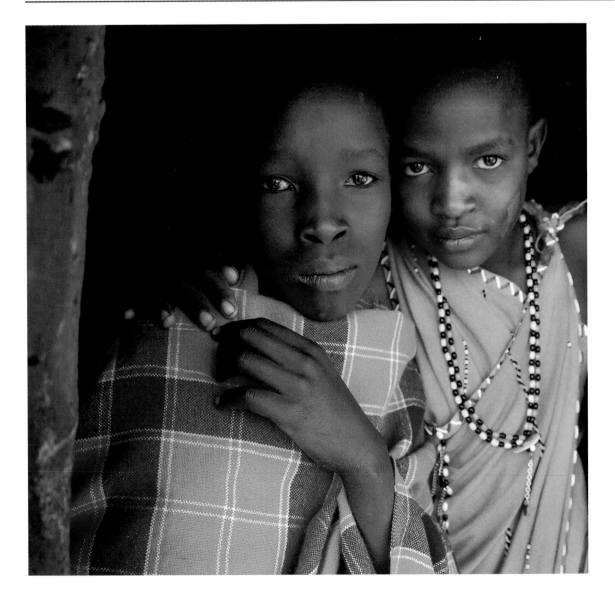

Add Catch Light to the Subject's Eyes

Light reflected in a subject's eyes, called "catch light," makes a subject's eyes sparkle – and draws more attention to them. I add catch light with a flash or with a reflector, or by positioning the subject's face in such a way that the light from the sky adds catch light.

For this photograph of two Masai boys, I positioned the subjects in the doorway of their hut on a sunny day. Light from the bright sky created the nice catch light.

The next time you are going through the checkout line at the supermarket, notice the eyes of the models on the covers of the fashion magazines. Yup! It's there: catch light.

Don't Crop at the Joints

Cropping – in-camera or in Photoshop – is of the utmost importance when it comes to photographing people. Now what I am about to say may sound funny, but it's a good way to remember the technique: Never "amputate" people at their joints: shoulders, elbows, wrists, ankles or knees. Basically, cropping at the joints makes the subject look unbalanced.

I try to carefully crop in-camera. However, cropping is the first thing I do in the digital darkroom after I open a picture. I do that for three reasons. First, I want to crop out the dead space to draw more attention to the subject. Second, I want to avoid any amputations, which sometimes happen, as was the case when I had to shoot fast while photographing this model. Third, if I don't crop out unwanted areas first in the digital darkroom, such as area that may be darker or lighter than the area I want to keep, they will affect my adjusted exposure (Levels and Curves) decision.

Choosing a Background

When I teach a photography workshop on photographing people, one thing I stress is the importance of the background, because it can make or break a photograph. Sometimes, I find a subject and then look around for a pleasing background in which to place the subject.

Other times, if I am feeling lucky about photographing a person, I'll look for a pleasing background first. That was the case for this picture. I was walking around a park by the Hudson River in Croton-on-Hudson, New York, when I saw this attractive girl hanging out at a picnic table with some friends. I wanted to get her shot, but realized that like most teenagers, she probably would feel a bit uncomfortable about being photographed. What's more, the area behind the picnic table was lined with a distracting chain-link fence.

I walked up to her and asked if I could take her picture. She said okay, and we moved to a nicer location with a pleasing background, a mural painted on the wall of the park's main building. Our photo shoot lasted about 30 seconds.

When you are out and about, in addition to keeping your eyes open for good subjects, also keep them open for nice backgrounds.

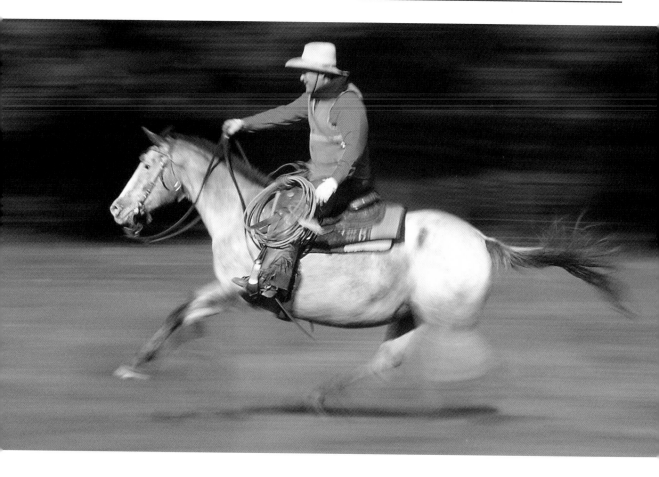

Pan to Create a Sense of Action

Sometimes I like to freeze action with a fast (1/500th second or faster) shutter speed. Other times, I like to create a sense of action by using a technique called "panning." Here's how I do it:

First, I set the shutter speed to 1/15th of a second. Then, as the subject approaches me, from left to right or right to left, I start to follow the subject in the viewfinder. When he or she is directly in front of me, I shoot and continue to follow the action for a few seconds.

To ensure a steady pan, I usually use an image stabilization lens or a tripod. If I have the opportunity, I ask the subject to do several "runs" so that I can experiment with slightly faster or slower shutter speeds to get a good pan. Quite honestly, it often takes a few runs to get it right because subjects move at different speeds, and I pan at different speeds.

Two more factors help with a good pan: one, shooting a subject against a relatively plain background; two, photographing a subject against a darker background.

Avoid Hard Flash Shadows

One of my goals when I take a flash picture indoors is to get a natural-looking photograph, one that does not look like a flash picture. To achieve that goal I try to eliminate or at least reduce the harsh shadows caused by the flash. That's relatively easy to accomplish.

One technique is to use an accessory flash with a swivel head and swivel the head so that it points toward the ceiling. When the flash fires, the ceiling reflects the light, casting a soft and evenly distributed light onto the subject. To soften the light even more, use a flash diffuser over your flash.

If the ceiling is white, you'll get good color in your picture. If it's not white, your subject will be off-color.

When bouncing a flash off the ceiling, keep in mind that the flash-to-subject distance increases, so you may have to boost your ISO to get the desired exposure. Also, you don't want to shoot too close to your subject, or the bounced overhead light from the ceiling will cast unflattering shadows in your subject's eye sockets.

For a well-balanced photograph, one in which the flash is balanced to the existing light, set your camera on the Manual exposure mode and dial in the settings for a good exposure. My guess is that due to the low available light level, you'll need to use a tripod to steady your shot during a relatively long exposure. For this shot of my business partner David Leveen and me working on one of our DVDs, I mounted the camera on a tripod for a steady shot.

Dress for Success

Here a quick tip that will add some image to your people pictures: have them dress for success – successful color pictures, that is.

In 1978, I read a National Geographic book on photographing people. One tip was to have the subject wear red – with the goal of creating a colorful picture and drawing attention to the subject. That's a good idea. Imagine what this photograph, taken by my friend Vered, would have looked like if I had been wearing a white or black t-shirt. It would not have been as colorful – nor as much fun, which was one of my goals when I set up the shot.

When photographing groups, having your subjects wear complementary colors is a good idea.

Evaluate Shooting at Eye Level

I took most of the pictures in this chapter at the subject's eye level, following a basic photo philosophy: see eye-to-eye and shoot eye-to-eye. Shooting at the subject's eye level helps the viewer of the photograph identify with the subject, which is often one of my goals in people pictures.

In this photograph, which I took in Namibia, I shot below the subject eye's level to create the impression that the person had confidence and strength – which she did, as one of the workshop leaders. Fashion photographers often photograph models this way to create the impression of superiority.

The next time you are composing a portrait, think about your camera's position in relationship to your subject's eyes – and the story that it will help you tell.

Break the Rules

In the photograph on the right, I photographed the subject from above – the opposite of the shooting technique on the previous page. I usually don't like to shoot from that angle, but it seems to work for this picture.

What's more, in this photograph you can't see into the subject's eyes. The vast majority of my people pictures allow the viewer to see into the subject's eyes. So I broke one of my own "rules."

Here is another very quick tip: Breaking the so-called rules of photography can sometimes result in better pictures than following them.

I am sure you'll agree the picture on the right is more creative than the straight-on shot on the left.

When You Hand Over Your Camera

On some occasions, we like to have our own picture taken, as was the case when I was flying over St. Thomas in a helicopter. To get this shot, I handed one of my cameras over to a fellow traveler. To ensure that I got the picture for which I was looking, I set my camera for foolproof, point-and-shoot photography. That is something I do every time I hand over my camera.

Here's how I set my camera for this shot: I set the focus point, which was locked to the exposure, so that when the traveler aimed the camera at me, the focus/exposure points were locked on me.

I also set the ISO high enough (400) so that the shutter speed (1/500th of second) and f-stop (f/8) gave me a sharp shot with good depth-of-field. I also asked him to include the window and my camera in the frame, and to try to not cut off my head.

All in all, he did a pretty good job.

Don't Be a Dummy

You may have met "Kim La Mannequin" in my Wiley DVD on lighting. In that DVD, I offer the tip of using a mannequin as a model to practice different lighting techniques, especially when using hot light and strobe light set-ups.

You can get a good mannequin for about $200. Just do a Google search for mannequins. If you practice and perfect your lighting techniques on a dummy, when a real person shows up for a portrait session, you'll be able to move your lights into position fast, and focus on the fun part of portraiture rather than on camera settings and light positions.

The Home Studio

I don't consider myself a studio photographer, but I do shoot in a studio – my home studio – when someone wants a standard head shot or a portrait.

When I shoot at home, I often use an inexpensive, three-light hot light kit (which features continuous lighting for an easy exposure), an inexpensive three-light flash kit (which features strobes), or I use my accessory flash units bounced into two or three reflectors or placed behind two or three diffusers. I have included descriptions of these set-ups in the *Gear* chapter of this book. What's more, I have a Wiley DVD that's available on that very topic: *Rick Sammon's Guide to Basic Lighting and Portraiture*. Some of the videos on that DVD are also on the DVD that's included with this book.

Here's a quick look at the kind of control you can get with all of the lighting set ups.

Top left: Two lights set at equal power and placed at 45-degree angles to the subject's face.

Top right: Three lights, one on the right set at full power and one on the left set at 1/2 power placed at 45-degree angles from the subject's face. A background light was added as well.

Bottom left: Three lights, one on the right set at full power and one on the left set at 1/4 power placed at 45-degree angles from the subject's face. Another light is placed directly behind the subject and pointed toward the subject.

Bottom right: Three lights, one on the right set at full power and one on the left set at 1/4 power placed at 45-degree angles from the subject's face. A light directly behind the subject and pointed at the subject was also added. Subject is holding a gold reflector at waist level to bounce light into shadow areas under her chin, so there are really *four* light sources in the shot.

Get Involved

When I photograph people, I like to share the enjoyable experience with my subjects. One way I do that is to show my subjects their pictures on the camera's LCD monitor. That's always a hit, and I recommend you do that when you photograph people, especially when photographing strangers in strange lands.

Another important aspect of getting involved is making your portrait subjects feel comfortable during the photo shoot, and in working with you, the photographer. I find the more I put into making the photo session an enjoyable experience for the subjects, the more at ease the subjects become, and the more "keepers" I get out of it.

What's my personal trick to put subjects at ease? Well, when I travel to exotic locations, I pack a bag of magic tricks that I get from Tannen's Magic (www.tannens.com) in New York City. Before I start photographing, I do several tricks to get the subject to like me - or at least accept me. That is what I'm doing in this photograph taken by my wife, Susan, in the Royal Kingdom of Bhutan.

Create the Dis-Equilibrium Effect

Here's an easy technique for making a picture more interesting. Simply tilt your camera down to the left or right to create what's called the dis-equilibrium effect.

As you can see from this example, the picture in the center, created using that technique, is much more interesting than the picture on the left.

Want to add even more interest to an image? Play with digital darkroom effects and plug-ins – which is what I did for the image on the right.

To enhance my image I used two plug-ins from onOne Software (www.ononesoftware.com): Photo Tools and PhotoFrame 3. In Photo Tools, I used Portrait Enhancer/David Diffuse Glow, and then I used PhotoFrame 3/Acrylic Brush to add the digital frame.

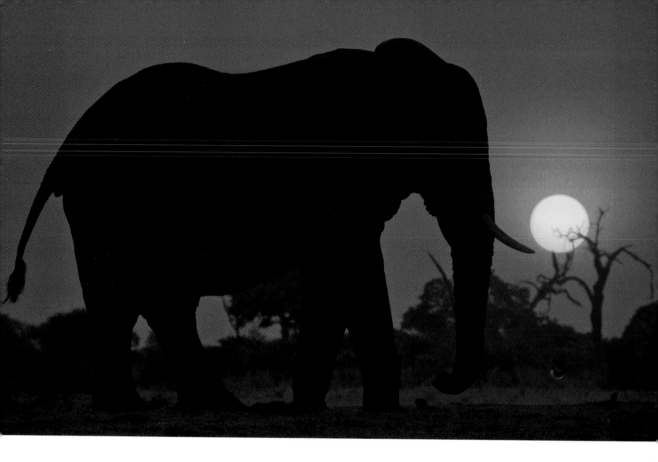

Part IV

Picturing Animals

If you want to photograph animals that fly, run, walk or swim in the wild and in zoos or wildlife parks - you've come to the right place. In this chapter, I share my favorite photos from the Arctic to Antarctica, and many places in between.

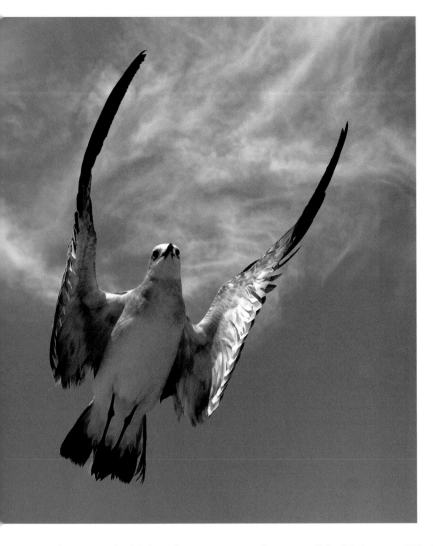

Stopping Action

One of the cool things about digital SLR cameras (and top of the line compact digital cameras) is that you can control the shutter speed to either stop or blur action.

When I photograph fast-moving animals, and even slow-moving ones, I often choose to freeze the action because I want a sharp shot.

A shutter speed of $1/500^{th}$ of a second is usually fast enough to freeze most fast-moving animal action, but when the animal is moving extremely fast, as was this seagull in flight, I had to use a $1/2000^{th}$ of a second shutter speed. I learned that through magnifying the previous images on my camera's LCD monitor, and seeing that in the pictures taken at $1/500^{th}$ of a second the bird was a bit blurred.

When photographing fast-moving animals, I recommend setting your camera's frame advance to the highest frame-per-second rate possible. Doing so will help ensure a nice photograph of the animal; in this case, one in which one of the seagull's wings was not covering its face.

In addition, you want to set your auto focus mode to the focus-tracking mode, which is covered on the next page.

One more tip. When composing your pictures, try to leave a fair amount of space around the animal. That way, if it moves up, down, left or right, you'll have a better chance of framing the entire animal, and not cutting off any of its body parts with the edge of your frame. This picture is cropped. In the original picture, the bird, which now fills the frame, comprised only about 50 percent of the image.

If you want to a blur subject movement, see the lesson on *Panning to Create a Sense of Action* in the *People Photography* chapter.

Focus Tracking Mode

One of the advantages of getting a high-end digital SLR is that it focuses faster than an entry-level digital SLR. That's important when photographing moving subjects, especially when the subjects are moving toward you.

To get sharp shots of rapidly approaching subjects, digital SLR cameras offer what is called a focus-tracking mode (called AI Servo on Canon cameras and Continue Focus on Nikon cameras) that actually tracks a moving subject right up until the moment of exposure.

On entry-end digital SLRs, focus tracking may not work with all telephoto lenses, and some telephoto lenses may not auto focus. Before you buy a camera, make sure it will perform to your expectations.

Combine focus tracking with the tips on the preceding page and you should get sharp shots of fast-paced action.

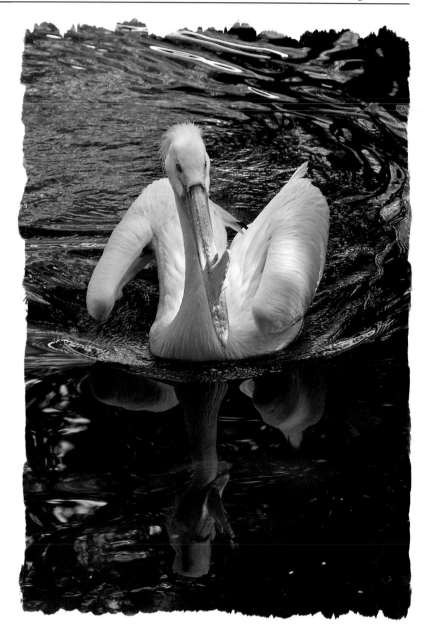

By the way, I am sure you noticed this artistic digital frame I added to frame my pelican photograph. I added it in a Photoshop plug-in called Photo Frame Pro 3 from onOne Software (www.ononesoftware.com). The frame has nothing to do with focus or the camera, but I wanted to share the idea of using digital frames in this book, and this seemed as good a place as any.

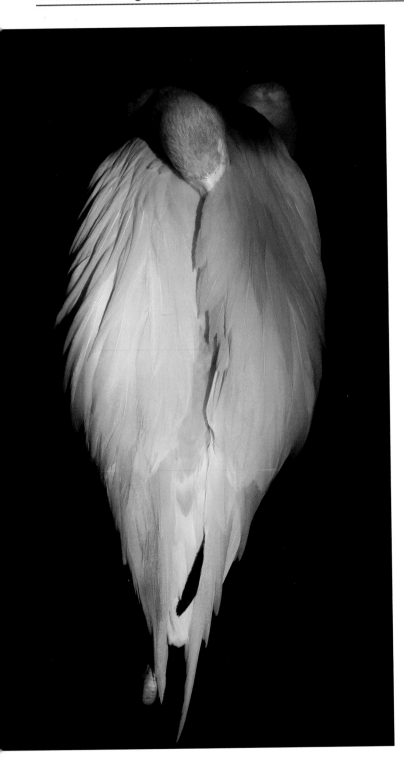

See Art in Nature

I am the first to admit that I am not a fine-art photographer. However, I do like to photograph the art I see in nature.

Art is about many things, including highlights and shadows, and the subtle differences between them. Few works of art look flat and lack contrast.

Here's something I learned long ago about light that helps me "see the light," which, in turn, has helped me pick out artistic subjects and scenes in nature: "Light illuminates, shadows define." In other words, light lights the scene. No light, no photograph. When it comes to shadows, if there are no shadows, a scene or subject looks flat – having little contrast. It's the shadows that add contrast and detail – and define the subjects in an image.

If we learn how to see the highlights and shadows in a scene, and especially when we are on the lookout for dramatic lighting, as illustrated in this natural-light photograph of a flamingo, we are on our way to artistic images.

Art, of course, is also about the subject – the flamingo in an artistic position in this example. I doubt that a picture of one of my old running shoes in the exact same lighting conditions would be considered art by anyone . . . but who knows? Art is in the eye and mind of the beholder.

Shoot for the Peak of Action

Here is my favorite shot from a sequence of pictures I took of a hippo at Homosassa Springs Wildlife State Park in Florida. It's my favorite because it shows the hippo with its mouth wide open (in anticipation of a feeding session). The other shots in the sequence are certainly not as dramatic, and some, like the shots of the hippo with just its eyes above the water, are boring.

To capture the peak of action when photographing any animal, I first take a test shot of the scene to check my exposure. Then, when the animal moves into the scene, I set my camera on rapid frame advance and begin shooting.

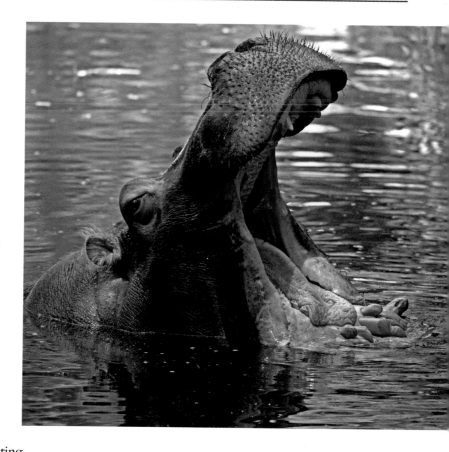

One of the advantages of a high-end digital SLR is that the maximum frame-per-second rate is faster than that of a low-end digital SLR. For example, my Canon EOS 1D Mark III shoots up to 10 frames per second. My Canon EOS Digital Rebel XTi shoots up to three frames per second.

When shooting action sequences, you should keep in mind that RAW files write slower to a camera's buffer than JPEG files because RAW files are larger. Therefore, if you are into shooting an action sequence with your image quality set on RAW, your camera may "lock up" at the peak of action as the camera's internal buffer fills faster with fewer larger files. The same thing can happen when shooting JPEG files, but because of their smaller size they write faster and you'll have less chance of the camera locking up. For example, with my Canon EOS 1D Mark III, I can shoot up to 110 continuous frames in the JPEG mode, but only up to 30 continuous frames in the RAW mode.

I am sure you have heard about "fast" memory cards that let the camera write to them faster than standard memory cards. If you have a high-end camera and shoot action sequences, they can be beneficial. However, on an entry-end camera, you will probably not see any difference in write speed.

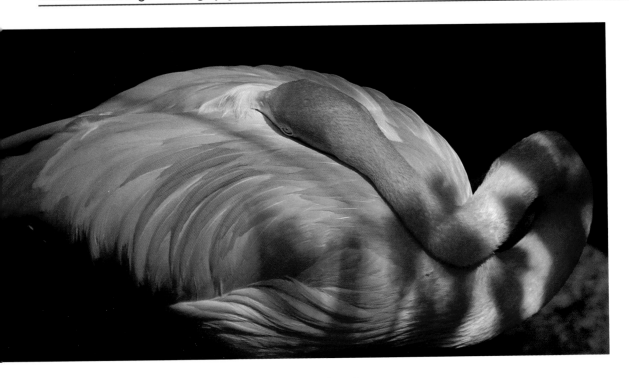

When Bracketing is a Good Idea

When I give a presentation, one of the most frequently asked questions is, "Do you bracket your exposures?"

For those of you new to photography, bracketing is taking additional exposures of a scene at over and under the recommended setting – thereby ensuring that one of the exposures will be correct. Most digital SLR cameras offer manual bracketing, where you adjust the exposure after taking a picture using the camera's +/- minus control (in automatic mode). Some SLRs also offer automatic bracketing, a feature in which you set the camera to automatically take additional exposures over and under the recommended setting.

When I used to shoot slide film, I bracketed my exposures, because when shooting slide film, the exposure had to be right on. I sometimes bracketed over and under the recommended exposure by 1/4 and 1/2 of an f-stop in both directions.

If you shoot JPEG files, you really should bracket your exposures because, like slide film, your exposures must be right on target, as your ability to adjust the exposure on JPEG files is limited. RAW files, on the other hand, have wider exposure latitude, so your exposures don't have to be perfect in the original image. What's more, you can rescue overexposed highlight areas and underexposed shadow areas more effectively from a RAW file.

Because I only shoot RAW files, I don't bracket my exposures. If you shoot JPEGs in tricky lighting situations, such as this flamingo partially illuminated by sunlight, then I suggest bracketing to get the best in-camera exposure.

Make Fences Disappear

I photographed this cheetah at a wonderful wildlife park, Fossil Rim Wildlife Center (www.fossilrim.com.) It's about an hour south of Dallas, Texas.

The cute cheetah cub was behind a chain link fence, but as you can see, it looks as though I photographed the animal in the wild. That's because I used a simple technique to make the fence disappear. Here goes.

Use a long telephoto lens in the 200 - 400mm range. In this situation, the longer the lens the better your photograph will be.

Set the aperture as wide (lowest number) as it goes.

Remove the lens hood and place the lens right up against an opening in the fence (or as close as possible).

Focus carefully on the subject.

Shoot. The long-lens/wide f/stop combination will blur the fence to the point where it becomes invisible in most cases.

If possible, it's best to pick a part of the fence that is not in bright sunlight, because sunlight falling on the fence may create bright light streaks in your photographs.

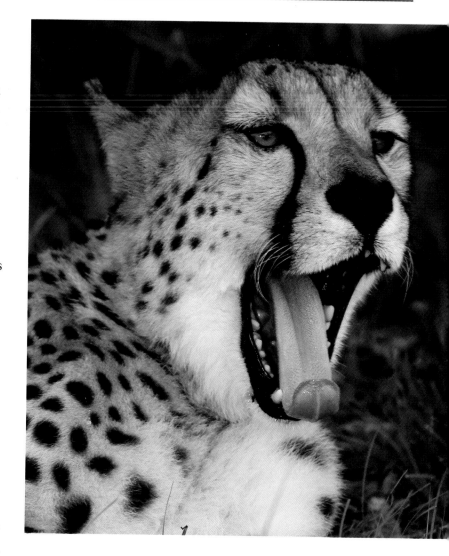

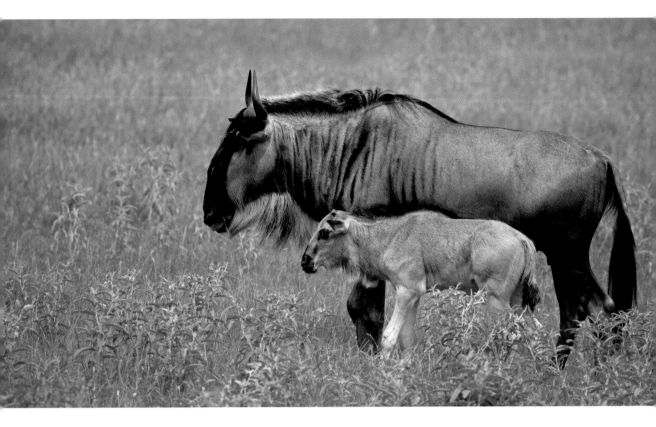

Place the Subject Off-Center

Here is another photograph I took at Fossil Rim Wildlife Center. I'm using it here to illustrate a basic composition technique: placing the subject off-center. When you place the subject off-center, you give the viewer of the photograph the opportunity to look around the frame to see what else may be of interest – rather than having him or her get stuck on the subject in the dead center of the frame.

Another popular composition technique is to imagine a tic-tac-toe grid over the scene in your viewfinder and place the subject where the lateral and horizontal lines intersect.

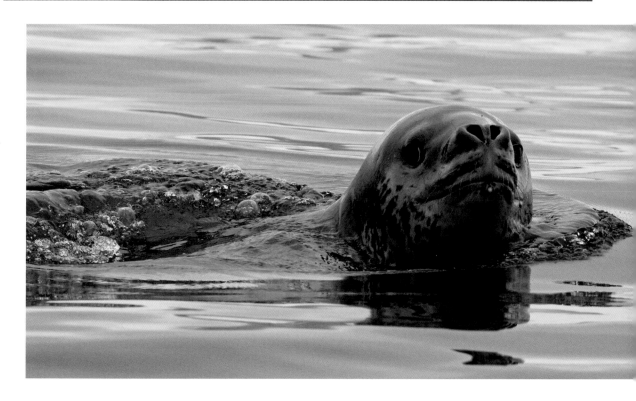

Steady as You Shoot

Let's talk shutter speeds. The shutter speed you choose can freeze or blur action – and make the difference between capturing a sharp shot or a blurry shot. For now, let's just focus on getting sharp shots.

A shutter speed of 1/125th of a second sounds fast enough to prevent a blurry handheld picture caused by camera shake. That is, if you are using a 100mm or shorter focal length lens or a 200mm Image Stabilization (IS) lens. However, if you are using a 400mm or longer lens, even an IS lens, you may get a shaky shot. Here's the deal – and some general guidelines to follow for handheld pictures.

When using a non-IS lens, don't shoot at a shutter speed below the focal length of the lens. For example, when shooting with a 400mm lens, don't use a shutter speed below 1/400th of a second.

Image Stabilization lenses let you shoot at slower shutter speeds, usually three stops but sometimes four stops below the traditional focal length/shutter speed rule. For example, with my Canon 70-200mm f/4 lens, which features four stops of image stabilization, I can handhold the camera set at 200mm and get sharp pictures at a shutter speed of 1/50th of a second.

To help steady your shots, tote a tripod, monopod, beanbag, camera clamp – or just brace yourself against a wall or tree.

I photographed this leopard seal in Antarctica with my 100-400mm IS lens set at 400mm. My shutter speed was 1/250th – and I still got a tack sharp shot using the techniques I outlined above.

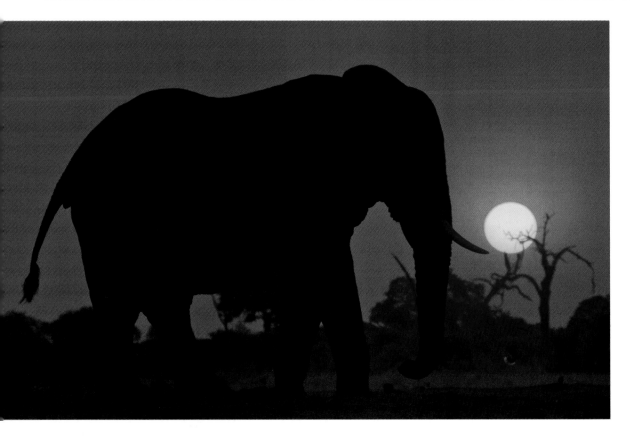

My Favorite Wildlife Telephoto Zoom Lens

I enjoy taking wildlife pictures, but I am not a full-time professional wildlife photographer. Most of those folks use fast and expensive fixed focal length lenses to get them up close and personal with their subjects.

Technically speaking, fixed focal length lenses are sharper than zoom lenses. For folks like us, however, zoom lenses in my opinion are a better choice. They are more affordable for one thing. For another, when you are locked into a shooting position, as I was when photographing this sunset scene in Botswana, you can zoom in and out of the scene, fine-tuning your composition in camera. Also, we can always sharpen our pictures in the digital darkroom for our enlargements.

Fixed focal length lenses are usually faster (having a wider maximum f-stop) than zoom lenses, making them better suited for low-light photography. That's also not a big deal for us, because we can easily boost the ISO in low light and reduce the digital noise associated with higher ISO settings either in-camera or in the digital darkroom.

Having said all that, my favorite zoom lens for photography is my Canon 100-400mm f/4 Image Stabilization lens for two reasons. One, it can get me "close" to a subject. Two, it gives me the flexibility of zooming in and out so I can get the best possible in-camera composition. I used this lens for my picture that I took in Botswana of an elephant at sunset.

My Favorite Wildlife Wide-Angle Zoom Lens

My favorite zoom lens for wildlife photography used to be the Canon 16-35mm f/2.8 zoom lens. However, when Canon introduced the 17-40mm f/4 lens for about half the cost, I sold my 16-35mm lens on eBay® and picked up the 17-40mm lens – which is the lens I used for this picture that I took in the Galapagos of a sea lion and its pup.

The lens is super sharp at f/8, which is the f-stop at which most lenses are the sharpest. At either end of the f-stop range, the pictures are not tack sharp – but still very acceptable. But again, I sharpen them in the digital darkroom.

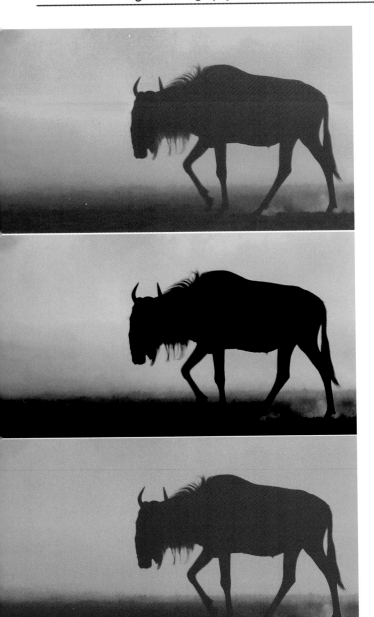

Shooting Silhouettes

When we shoot a silhouette, we remove some of the reality of the scene, which was my goal when I photographed this wildebeest in Kenya. That's because in reality, we can see more in the shadow areas of a scene than our cameras can record. Thus when we shoot a silhouette and remove some of the "reality" of the scene, our pictures become more artistic and creative – and eye-catching, too.

The key to getting a dramatic silhouette is to have the subject strongly backlit, as was the case when I photographed this wildebeest at sunrise.

To add to the drama of the scene and to intensity the silhouette, I set my exposure compensation to –1 1/2. Usually the stronger the silhouette is, the more dramatic the photograph.

In the digital darkroom (using Apple's Aperture in this case), I increased the saturation and contrast, which also added to the drama of the image.

Hey, since I have the space, here are two more digital darkroom tips: One, desaturate the image to create a nice black-and-white image. Two, play with color balance as I did on the bottom image, adding a red-hot sunlight cast to my original orange-tone image.

Oftentimes, to shoot silhouettes, you need to follow one of my photo philosophies: You snooze, you lose! In other words, get up early and stay out late to capture scenes like this, scenes that sleeping photographers miss.

Using Tele-converters

Want an easy and affordable way to get close to distant animals without spending a fortune on expensive super telephoto lenses? Rather than spending big bucks on lenses that I would use only once in a while, I use a Canon 1.4x tele-converter on my 100-400mm zoom lens. With the converter mounted between my lens and the camera, my 100-400mm zoom becomes a 140-560mm zoom.

The Canon 1.4x tele-converter costs about $300, which is much less than a longer zoom.

You may be wondering why I don't use a Canon 2x converter. Well, traditionally, 2x converters produce images that are a bit softer than those made with 1.4x tele-converters and you only lose one stop of maximum aperture compared to two with a 2x converter. Therefore, I use the 1.4x tele-converter and crop and enlarge my pictures in the digital darkroom.

One more thought on tele-converters: You absolutely get what you pay for. I have led more than a few Africa workshops where some of the participants used inexpensive tele-converters. Most wound up in the trash bins at the camps after the participants reviewed their results on their laptops.

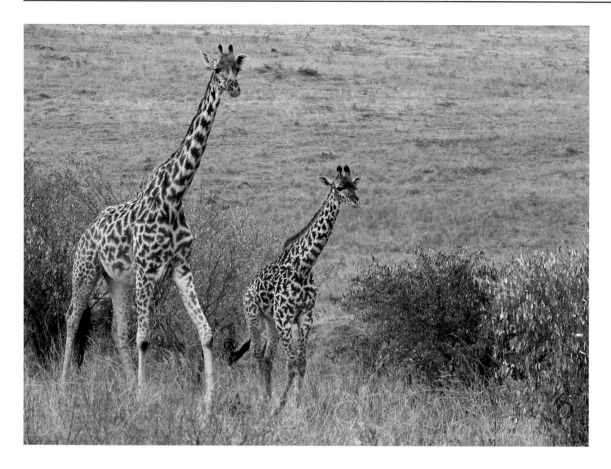

Noise and Sharpness

It may not look like it, but I photographed these giraffes in low light with my ISO set at 1000 – a potentially digitally noisy (what we used to call grainy with film cameras) situation.

I applied in-camera high ISO noise reduction to the image. Before I tell you why, here's the scoop on noise.

There are two types of noise in digital images: luminance noise (grey-black specks) and chromatic noise (pastel-colored specks). Noise shows up more in the shadow areas than in bright areas, and it also shows up more on plain areas (like the sky) than in detailed areas. Noise in a digital file (the captured in-camera image) increases as the ISO setting is increased. And as the price of the digital camera increases, which means a better image sensor, the noise decreases, which is a big advantage when shooting at high ISO settings.

In the digital darkroom, we can reduce both the chromatic and luminance noise. But luminance noise adds to the sharpness of and detail in an image, so reducing luminance noise in the digital darkroom may not be the best idea.

When I choose to reduce the noise in-camera, I only reduce the chromatic noise – and maintain the sharpness and detail of the image.

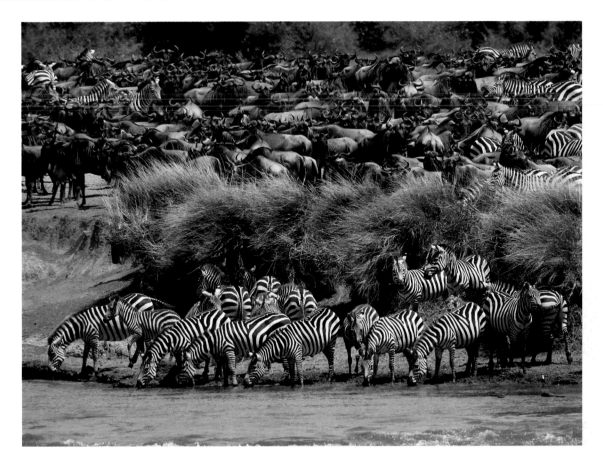

Don't Cheap Out on a Telephoto Lens

Looking at this picture, you can't see any chromatic aberrations where the zebra's white stripes meet the black skin (or vice versa if you adhere to the opposite notion). That's because I used a moderately priced telephoto zoom lens (Canon 100-400mm IS) that does not produce any chromatic aberrations, and also because the image is relatively small on this page.

"What the heck is a chromatic aberration?" you ask. Well, when all the light rays entering your camera are not focused on the image sensor properly, chromatic aberrations – red/cyan or blue/yellow fringes, can show up where light and dark areas meet.

Had I gone the cheap route and shot with an inexpensive lens, you still may not have seen the chromatic aberrations because the picture, again, is relatively small on the page, and because chromatic aberrations don't always show up. However, they are more prevalent with low-end lenses, and in any enlargements, chromatic aberrations will become more apparent.

You can reduce chromatic aberrations in the digital darkroom, to a point. If you are serious about your photography, I highly suggest investing in the best lenses (and tele-converter) you can afford.

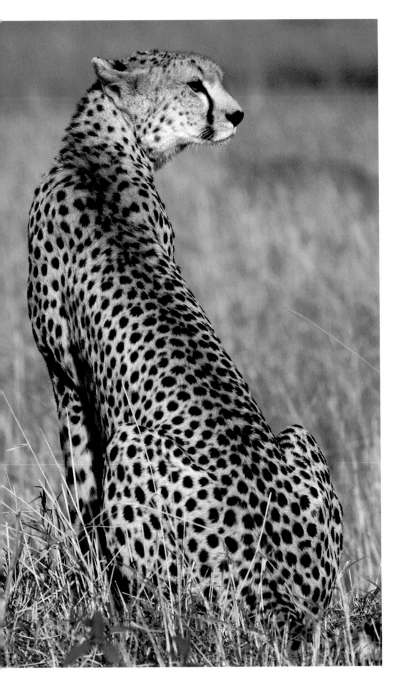

Shoot Sharper Pictures with a High Frame Rate

If you were to take a picture of this posing cheetah (or even of a friend) with a telephoto lens in low light, you might not think that for a handheld shot, shooting at a high frame rate would be necessary. You might be right! But to be on the safe side, I often do just that. Here's why.

When shooting with telephoto lenses (which exaggerate camera shake) at slow shutter speeds in low light, there is a chance of camera shake. When you set your camera at a high frame rate (3 to 5 frames per second), you only have to press the shutter release button once. So at slow shutter speeds, there is a chance that the second or third picture may be sharper than the first.

Image stabilization lenses (Canon) and vibration reduction lenses (Nikon) can also help reduce camera shake at slow shutter speeds. But hey, why not do everything possible to get the sharpest possible in-camera image?

Setting a high frame rate also achieves something else. It gives you a better chance of getting a picture of the animal with its eyes open. Animals blink, too, you know.

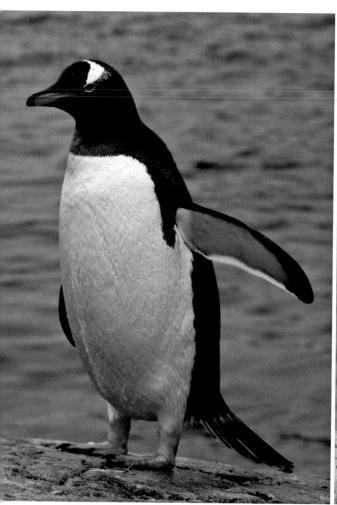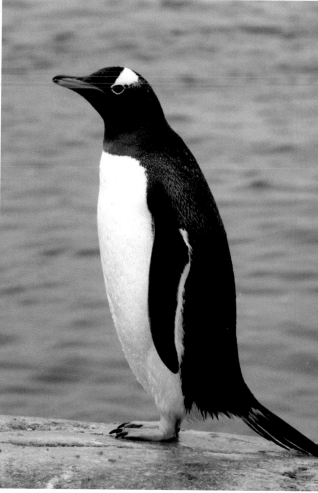

Expose for the Highlights

Here's a good example of what happens when you don't expose for the highlights – and when you do. I took the picture of a penguin on the left with the exposure set for the highlights, and I took the picture on the right with the exposure set on automatic.

In the picture on the right, the highlights (white feathers on the penguin's breast) are washed out and lack detail. That's because the dark water fooled the camera's exposure meter into thinking the scene was darker than it really was, causing it to increase the exposure, thereby overexposing the white feathers.

To get a much better exposure, I set the exposure compensation feature on my camera to – 1. Now, that may sound as though I would be underexposing the scene, but in reality, I was properly exposing the highlights.

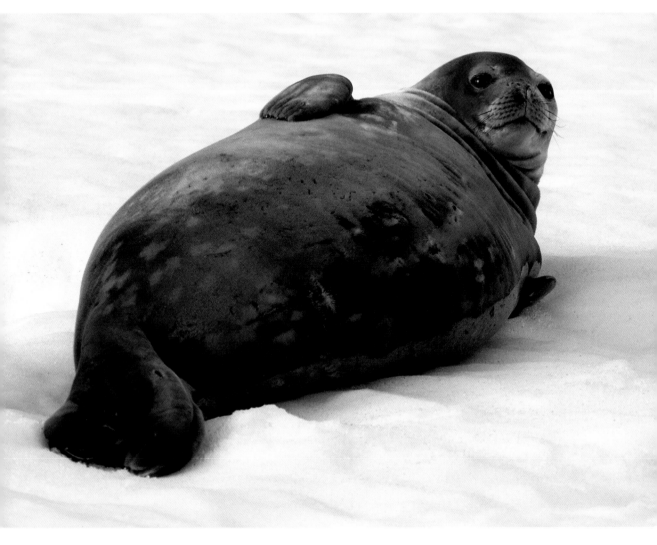

Shoot RAW Files

On an important related note to exposing for the highlights, keep in mind that you can rescue overexposed highlights up to one stop in the digital darkroom if you have shot a RAW file. However, if the camera has not captured the detail, such as when you've shot in a JPEG file format, there is no hope for rescuing the detail within these overexposed highlights.

Shooting RAW files is especially important when there is a wide contrast range in the scene – a big difference between the dark and light areas, as in the picture of a seal that I photographed in Antarctica. If there is not a lot of contrast, you might get the same results with a large JPEG file, but why chance it – especially when you have a once-in-a-lifetime chance at a great photo opportunity.

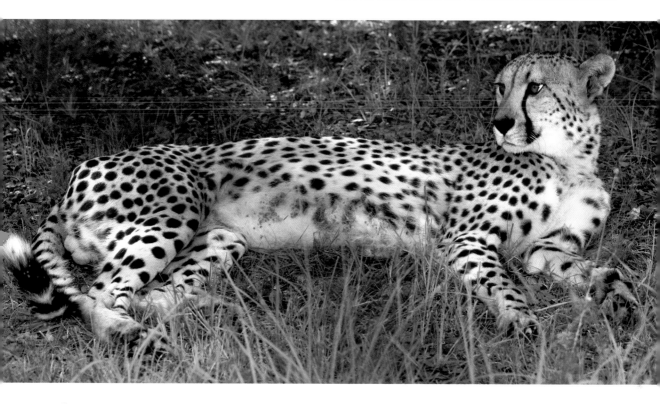

The Eyes Have It

When I photograph an animal, unless I am shooting a silhouette, I feel if the subject's eyes are not well lit and in sharp focus, I have missed the shot.

To get the eyes in focus, I use the focus lock on my camera to lock in the focus on the subject's eye, recompose my shot, and then shoot.

To lighten the eye or eyes, I try to wait until the animal looks up toward the sky or at least has its eyes well lit from some other light source. I also use a flash to add some light to the subject's eyes, and if the animal is far away, I use a flash extender, which fits on the flash and extends its range. Do a Web search for Better Beamer and you'll find several places that sell this useful flash accessory.

When using a flash, I don't want my pictures to look like flash pictures. Rather, I just want to add some light to fill in the shadows and to add some catch light to the animal's eyes. (More on fill flash in the *Daylight Fill-In Flash Photography* lesson in the *Photographing People* chapter.)

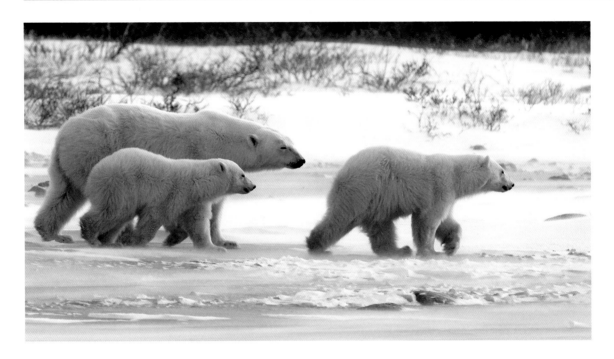

Shooting in the Snow

Brrrrrrr. I hate the cold! I do, however, enjoy taking pictures in snowy locations. This shot of a polar bear mom and her cubs, which I took in the Canadian sub-Arctic when it was –35°F, is one of my favorites. No! I was not outside, freezing my buns off. I was in a heated vehicle shooting with the window open. Still, it was near freezing – because all the windows in the vehicle were open so all the other photographers could also shoot.

When you shoot in the snow, here are some quick tips to help you get good shots – and to keep warm.

Dress appropriately, from head to toe. I highly recommend using hand warmers (which fit inside gloves) and feet warmers (which fit in your shoes) to keep your fingers and toes toasty. You can find these products at just about any camping or outdoor store.

Check out a few pairs of gloves to find the ones that let you adjust your camera's controls while wearing them.

When it comes to exposure, I suggest setting your exposure compensation to +1. (More on that in the *Brightness Values and the +/– Exposure Compensation Control* lesson in the *Digital SLR Must-Know Info* chapter in this book.)

Keep your camera and extra batteries as warm as possible, because cold sucks the life out of batteries quickly.

Use a lens hood to shield the front element of the lens from direct sunlight, as well as from snowflakes.

Use a camera protector as added protection against snow. (See the *Photo Gear that Rocks* chapter of this book for more info.)

I also highly recommend drinking hot chocolate before you go outside.

Keep Both Eyes Open

When you compose an animal picture, which eye do you close, and which eye do you keep open? Think about this before you read on.

When I shoot, I always keep both eyes open. The reason is that with both eyes open, I can see what's around my subject. I can see other animals that might come into the frame, and where my subject may move – or run.

Sports photographers also shoot with both eyes open because they need to see if other players may come into the frame, and they need to see where the players may move.

In this picture, taken in Botswana, the leopard was looking at a warthog, eyeing a potential meal. Nothing happened, fortunately for the warthog, but I was ready to capture the action because I used the "both eyes open" shooting technique.

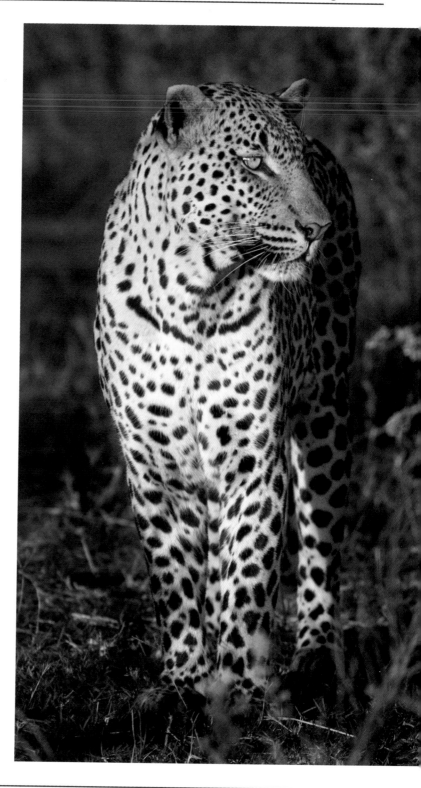

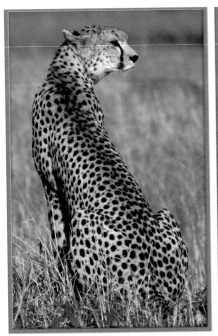

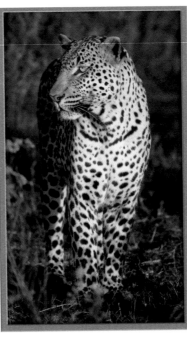

Displaying Your Prints

Take a white piece of paper and cover the top pair of pictures on this page, and then do the same for the bottom pair of pictures. My guess is you like the top pair better – because the animals are looking inward and not outward. In other words, the pictures act like a pair, and not two individual prints.

When you display a pair of prints or multiple prints, the direction in which the animals or subjects are looking is important in your print display.

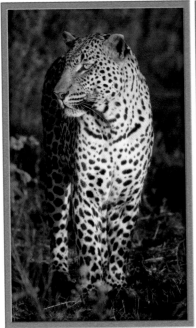

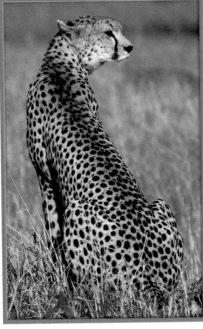

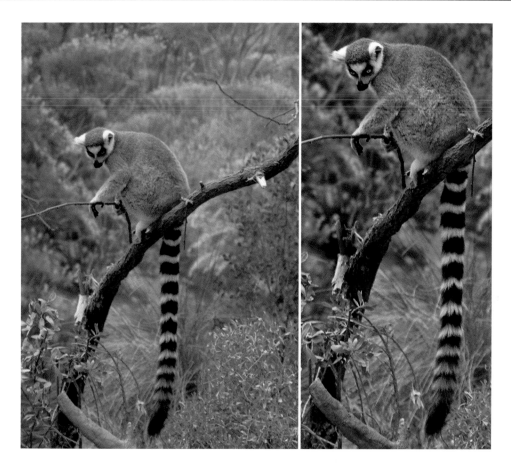

Envision the End-Result

As always, when we look at one of our pictures, it's important to visualize the enhancements that are available to us in the digital darkroom. I do that for every picture I take. Here is just one example. The adjustments I used are available in Photoshop, Aperture and Lightroom.

I took this picture of a ringtail lemur at New York's Bronx Zoo. The picture lacked contrast and was cool (in color), due to the lighting conditions. So, I increased the contrast a bit and warmed up the picture by increasing the yellow tones. I also boosted the color saturation a bit for more vivid colors.

The animal was too far away for a tight shot. A simple crop brought the animal "closer."

The white part of the broken tree was a distraction, so I used the Burn tool to darken it. I also used the Burn tool to darken parts of the painted background. I then used the Dodge tool to brighten the animal's eyes.

As a final step, I sharpened the image.

A good way to envision the end result is to ask yourself what you don't like about a picture – and to be familiar with the tools and adjustments that are available in the digital darkroom to help you create your vision of what you like.

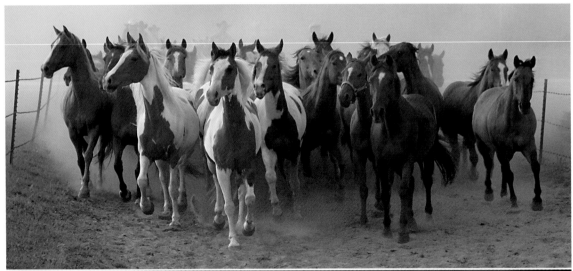

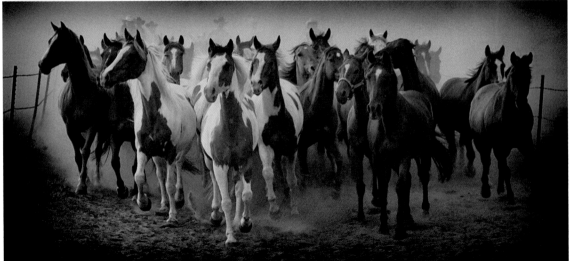

Play with Plug-ins

On the previous page I touched on some very basic digital enhancements that are available in Photoshop, Lightroom and Aperture.

You can expand your creative horizons in these applications by adding plug-ins, some of which I cover in the *Cool Web Sites* chapter.

Here is just one example of how one of my favorite plug-ins, Silver Efex Pro from Nik Software (www.niksoftware.com), helped me transform a modern-day looking photograph into a photo that looks as though it was taken "yesteryear." To create this effect, I used the Antique Plate 1 filter.

Play with plug-ins. Your workflow may become your fun flow!

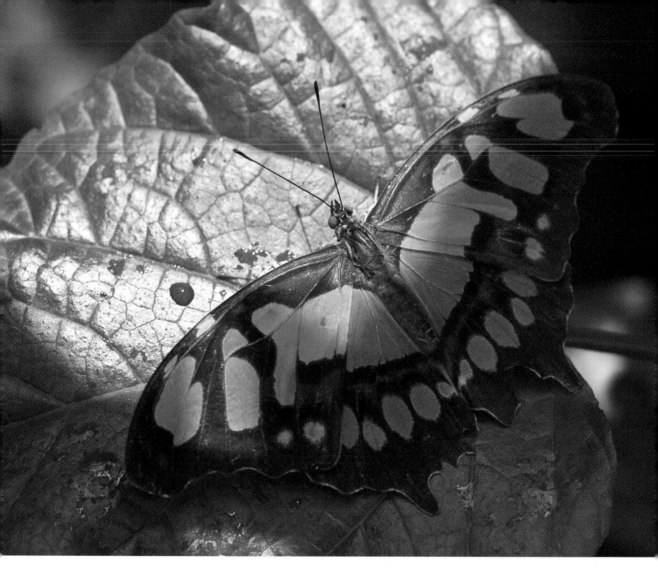

Close Ups

This is the place to get up close and personal with small subjects – photographically speaking, that is. Learn how to picture them life-size and larger than life.

True Macro Photographs

For true macro photographs, you need a macro lens, as opposed to the macro or close-up setting on a zoom lens. Macro lenses let you get much closer to a subject than zoom lenses that have a macro or close-up setting. This picture of a newborn butterfly was taken with a Canon MP-E 65mm macro lens, which offers tremendous magnification – much like a bellows system does for an SLR camera. It's a specially designed, manual focus macro lens that actually lets you fill the frame with subjects as small as a grain of rice.

The remaining photographs in this section were taken with the more commonly used macro lenses: 50mm and 100mm. The main difference between these two lenses is that the 100mm lens provides a greater camera to subject distance, so you don't frighten skittish subjects, such as butterflies.

Some of the pictures in this section appeared in my coffee-table book, *Flying Flowers.*

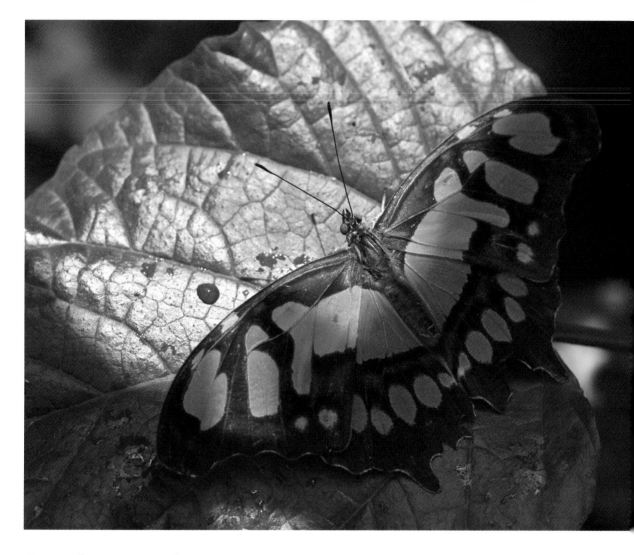

Steady Your Shots

Macro lenses exaggerate camera shake, as do telephoto lenses. To reduce the chance of a blurry picture caused by camera shake, which is most noticeable in available light pictures, you need to use a tripod. I used the tripod with a ball head (for easy positioning) when I took this natural light photograph of a butterfly that was partially in the shade.

To further reduce camera shake, use a cable release or your camera's self-timer to trip the shutter. You can also use your camera's mirror lockup feature to help steady your shots, although you won't be able to view your subject through the lens.

Keep in mind that as steady as your camera may be, subject movement is also exaggerated at close distances. When taking natural light pictures, be very aware of subject movement.

Compose Carefully

The background can make or break a close-up picture. Try to compose a picture so the background complements the main subject and does not detract from it.

From a compositional standpoint, this is one of my favorite close-up photographs. In this book I talk about composing a picture with the subject off-center, and imagining a tic-tac-toe grid over the scene and placing the subject where the lines intersect. I was thinking about those techniques when I composed this picture.

When taking both natural light and flash pictures, it's important to "see the light"; that is, the highlights and shadows in the scene. For me, the shadow of the flower, created by a nearby light bulb, adds a nice touch to this picture, as well as adding a sense of depth and dimension to it.

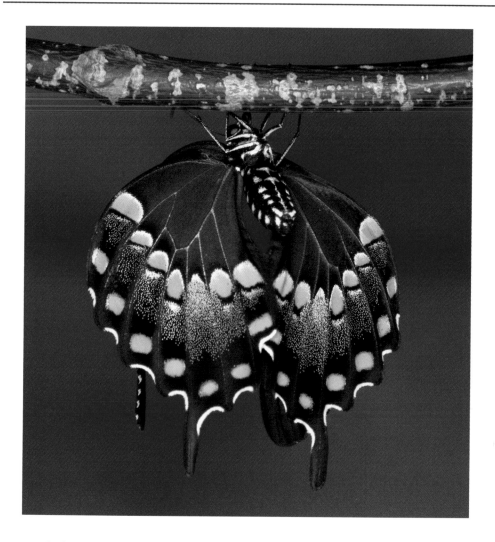

Add a Background

If the background is too distracting in a scene, you can change it by adding your own background. It's simple, easy and fun!

Photograph a leaf with your macro lens, make an inkjet print, and use the print as a background. For more creative control, try blurring the leaf in Photoshop using the Gaussian Blur filter (Filter > Blur > Gaussian Blur) to simulate the effect of using different aperture settings.

The distance you hold the print from the camera also affects the amount of blur. The further away you hold the print, the softer it becomes, because depth-of-field decreases when you stay focused on the subject.

Need another background idea? Try using a solid color t-shirt. I have used black and green t-shirts with much success!

Add Creative Control with a Ring Light

If you are really serious about close-up photography, and really want to take creative control, invest in a ring light, sometimes called a ring flash. A ring light (mine is pictured in the *Photo Gear* section) fits on a macro lens and can provide ratio (1:1, 1:2, etc.) as well as shadowless lighting. You control the light output on the Canon ring light that I use (others may be different) by turning it on and off and adjusting the power output of the two flash tubes that encircle the lens.

In addition, you can use the ring light's Flash Exposure control (the +/- settings) to fine-tune your exposure, and to take a daylight fill-in flash picture, which I cover in the *Photographing People* chapter of this book.

The light from a ring light also adds contrast to a picture, making it look sharper than a natural light photograph. I used a Canon Macro Light MR-14EX on my 50mm macro lens for this close-up picture of a butterfly's wings.

You cannot use a ring light on a wide-angle lens. If you do, you'll get a hot spot in the center of the frame.

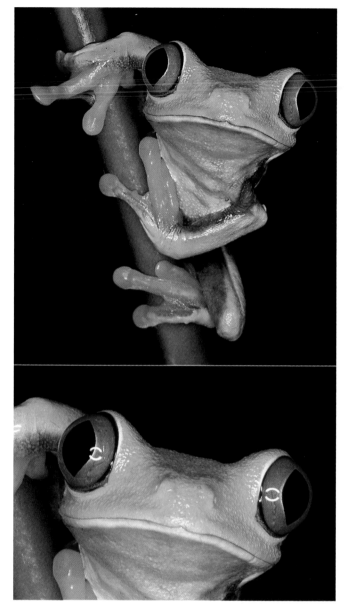

Retouching When Using a Ring Light

Ring lights are wonderful accessories for close-up photography. There is, however, one problem when using them when photographing reflective objects, such as the eyes of the red-eye tree frog. As you can see in the bottom image (cropped from the original top image), the reflections of the flash tubes show up in the animal's eyes. There is no way around that when taking a picture. Therefore, you need to clone out the reflections in the digital darkroom.

For best results, zoom in on the photo on your monitor so that the eyes (in a case like this) almost fill the monitor. Then select a small, soft-edge brush, select the Clone Tool, and carefully clone out the reflections. As usual, I believe the smaller the brush size used the better.

Focus carefully

In close-up photography, as with telephoto photography, focus is extremely critical. You need to focus on the most important element in a scene, such as the eyes of a butterfly. It's also important to shoot at a small aperture for good depth-of-field (unless you want the area in front of and behind your subject out of focus). In that case you would use a wider aperture.

I set my 50mm macro lens at f/16 for this close-up of a caterpillar and focused on its head, yet the tail end is still out of focus – because I was so close to the subject.

If you are wondering why I did not choose f/22, which provides more depth-of-field than f/16, check out the *F-stop Info* topic in the *Digital SLR Must-Know* chapter of this book.

To check your focus before you shoot, use the depth-of-field preview button on your camera (if it has one), which, when pressed, stops down the lens to the chosen aperture.

You can check your focus after a picture is taken by using the magnifying feature on your camera to zoom in on the picture displayed on the camera's LCD monitor.

Learn About Your Subject

When I produced my butterfly book, *Flying Flowers*, I worked with some of the top butterfly experts in the country. Working with them gave me a wonderful understanding of butterflies. I also learned how to spot some of the more camouflaged butterflies, such as this dead leaf butterfly, in nature.

I believe the more you know about your subject, the more you appreciate it and the more you, well, love it. One of my photo philosophies is that you really need to fall in the love with the subject, from a photographic standpoint, in order to get a good picture.

If you have an idea for a book on photography and are not an expert on a subject, team with an expert. It will give you – and your book – credibility.

By the way, when working with my experts I learned the scientific name of the dead leaf butterfly: *Kallima inachus*. Do a Web search on this butterfly and you'll see that when it has its wings open, it's alive with color!

Shoot a Sequence, Tell a Story

This tip actually applies to all the sections in this book. When we are taking close-up photographs, as well as when we are photographing animals, landscapes, people and so on, putting on our "storyteller" hat helps us tell a story of the subject. We can tell the story in many ways; one is by shooting a sequence, as I did here when I photographed the birth of this dagger wing butterfly.

We can also tell a story by simply taking wide-angle and close-up views, and by zooming in and out – and by photographing the subject from different angles.

The important thing to remember is that as photographers, we are, at heart, storytellers.

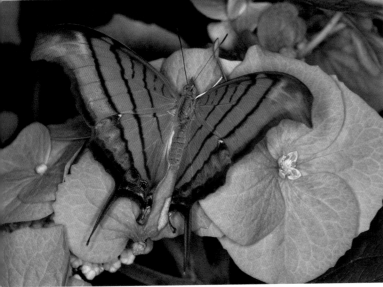

Go Wide

Macro lenses have shallow depth-of-field, while wide-angle lenses offer good depth-of-field, especially when set at small apertures. Wide-angle lenses are usually used for landscape and scenic photographs. However, they can also be used for close-up photography, getting everything in focus from what's right in front of the camera to almost infinity.

To get this shot, which I took in Mexico in a colony of 30 million monarch butterflies, I set my 16-35mm lens at 16mm. I set the aperture at f/11. Following the standard practice for setting the lens for its maximum depth-of-field, I set the focus one-third of the way up the tree using the focus lock on my camera, recomposed my shot and took the picture.

Hey, I know this is a super busy shot, but that busyness helps to tell the story of this incredible event in nature.

Part VI

Photo Gear that Rocks

There is an old photo adage: Cameras don't take pictures, people do. However, you still need a camera and some cool accessories to capture the image you see in your mind's eye. Here you'll find info about my gear and my recommendations.

Digital SLRs vs. Compact Cameras

Most serious photographers use digital SLR (single-lens-reflex) cameras because they offer several advantages over digital compact cameras. First and foremost, most digital SLRs accept more than 50 different accessory lenses for creative framing and depth-of-field control of subjects, near and far. Other important benefits over compact cameras include better image quality, faster and more accurate auto focusing, more custom functions, improved durability, lower digital noise, in-camera noise reduction and faster image writing speed of large files to a memory card.

One of the main features to consider when buying a digital SLR is the size of its image sensor. There are full-frame image sensor cameras, such as my Canon EOS 1 Ds Mark III (left), and less than full-frame image sensor cameras, such as my Canon EOS 1 D Mark III (right). The difference? With a less than full-frame image sensor camera, lenses have a magnification factor, so they appear to function as slightly longer lenses. For example, on a camera with an image magnification factor of 1.3x, a 100mm lens functions like a 130mm lens. Keep in mind the depth-of-field does not change when the lens is used on a 1.3x camera; it's still a 100mm lens. Only the field of view is different as it acts like a 130mm lens. That's great for wildlife and sports photographers, but not great for indoor photographers and landscape photographers who shoot with wide-angle lenses and need a wide angle of view. With a full-frame sensor camera, a 100mm lens functions as a 100mm lens.

Many of the pros I know, however, carry compact cameras as backup cameras and fun cameras. I'm one of 'em. Pictured here is my Canon PowerShot SD800 IS (image stabilization). It's a great fun camera that I keep with me at all times.

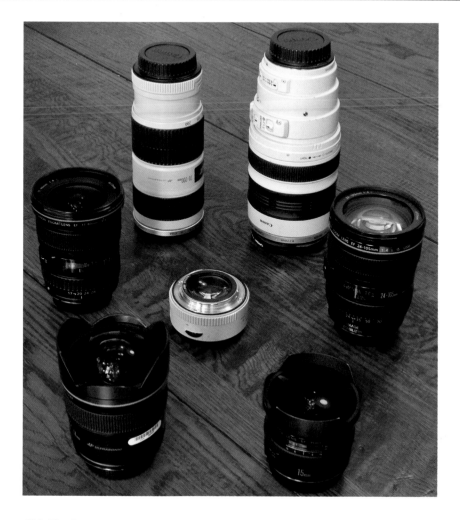

SLR Lenses

As I mentioned on the preceding page, most SLRs accept more than 50 accessory lenses. When choosing a lens, I believe it's best to stick with the camera manufacturer's lenses for optimum image quality, auto focus speed and color consistency throughout the lens line.

I actually don't use anywhere near 50 lenses. My six Canon lenses are pictured here (clockwise starting at 9 o'clock): 17-40mm, 70-200mm, 100-400mm, 24-105mm, 15mm fisheye and 14mm ultra-wide. My Canon 1.4x tele-converter is pictured in the center of the image. Throughout this book are examples of when and why I use these lenses.

I also use macro lenses for my close-up photography. I talk about these specialty lenses later in this chapter.

In choosing your lens system, keep in mind that portability and access to lenses is important. On my workshops, folks who show up with too many lenses get too few shots – because they are usually digging through their camera bags trying to find just the right lens while everyone else is shooting.

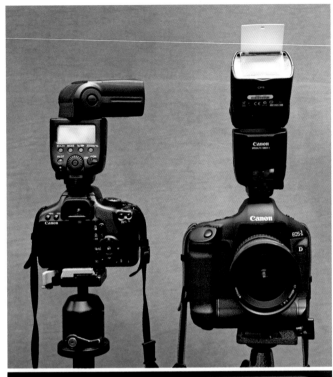

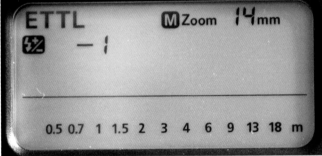

Accessory Flash Units

When it comes to serious flash photography, you really need to use an accessory flash unit (as opposed to a camera's built-in flash).

Not all accessory flash units are created equal. In choosing a flash, you want one with a swivel head (as shown in the top picture) so you can bounce the light off a wall or ceiling for softer and more creative lighting.

Most accessory flash units feature built-in diffusers and mini-bounce cards to soften the light for on-camera flash shots. The diffusers and mini-bounce cards slide in and out of the flash head for easy use.

You also want a flash unit that offers variable flash output control, which lets you increase or decrease the automatic exposure (a decrease of –1 is illustrated in the bottom picture).

Accessory flash units are also way more powerful than a camera's built-in flash, which means that they will illuminate subjects at greater distances than a camera's built-in flash.

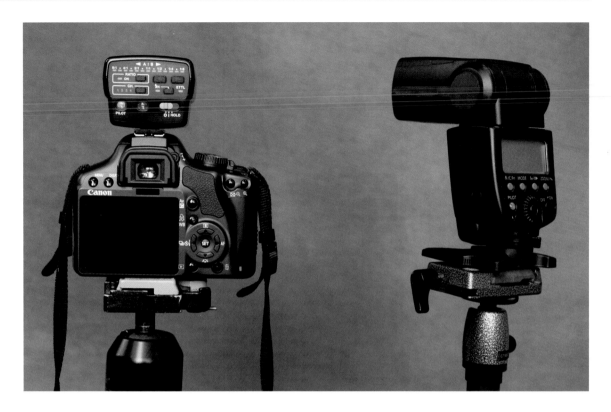

Remote Flash Operation with Wireless Transmitters

A wireless transmitter is an essential accessory for any serious photographer. Mounted in a camera's hot-shoe, it can fire a flash (or multiple flashes) when the camera's shutter is released.

Several creative options are available when you use a wireless transmitter along with a flash or multiple flashes. From the wireless transmitter, you can create ratio lighting with your accessory flashes, meaning you can increase or decrease the power output of the flashes.

On a flash or flashes, you can use the +/– Exposure Compensation feature to fine-tune flash exposures – over and under the "correct" setting. And if you set several flashes to different channels, you can fire them independently by selecting different channels on the wireless transmitter.

Here you see a flash mounted on the stand that comes with my Canon 580 EX flash. On the bottom of the stand is a tripod socket for easy mounting on a tripod. You can also use the stand to support the flash on a table or other flat surface.

Of course, you can also hand-hold a flash and fire it from a wireless transmitter for off-camera, creative flash photography.

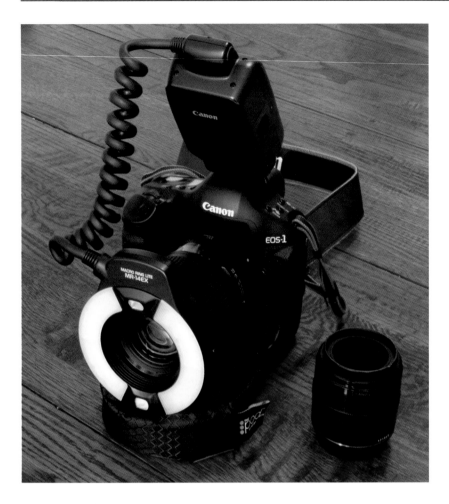

Special Macro Gear

Most of the photographs in the *Close-Ups* chapter of this book were taken with my Canon 50mm and 100mm macro lenses and my Canon ring light, the Macro Ring Lite MR-14EX. As I mentioned in that chapter, the main difference between the two lenses is that with the 100mm lens (mounted on the camera in this picture), you don't have to be as close to the subject for a great close-up as you would with a 50mm macro lens. That is beneficial when photographing skittish subjects such as butterflies.

The ring light consists of a power unit that fits in the camera's hot-shoe and a light that fits around the lens.

From the power unit you control +/– flash exposure compensation. It's there that you also create ratio lighting, adjusting the light output individually from each of the two flash tubes. You can also activate the focusing lights on the ring light from the power unit.

Different kinds of ring lights are available from camera manufacturers, as well as from independent manufacturers. In choosing a ring light, make sure it has all the features you need for your creative close-up photography.

It's in the Bag

Having the right bag for your gear is actually more important than most photographers realize. Basically, you want a bag that will protect your gear, offers easy accesses to your cameras and accessories, and is easy to carry or tote.

I use three different types of bags. From the top left and going clockwise, I use a backpack when I am trekking around outdoors so if I trip and fall my gear is protected. I use a pull-bag when I am shooting in a city with a workshop group for which I need a lot of gear, and I use a shoulder bag for easy access to my gear when shooting by myself in a city.

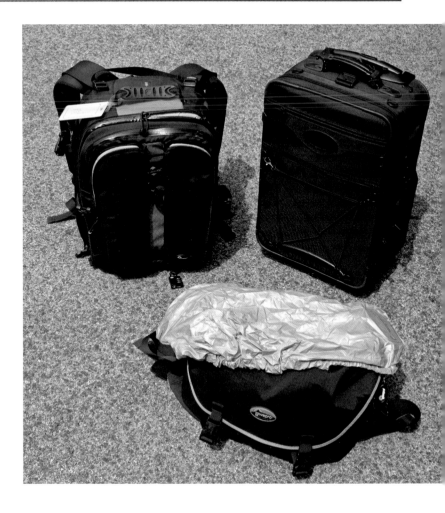

Both my backpack and shoulder bags have pullout water repellent covers that have saved my gear on more than one occasion. All the bags have adjustable compartments for customizing them for individual gear.

All my bags are made by Lowepro (www.lowepro.com).

When shooting in the snow and from small boats, I use a special backpack from Lowepro, called the DryZone, which actually floats if you accidentally drop it in the water. It's pictured, along with me surrounded by beautiful icicles in Croton-on-Hudson, New York, two pages from now.

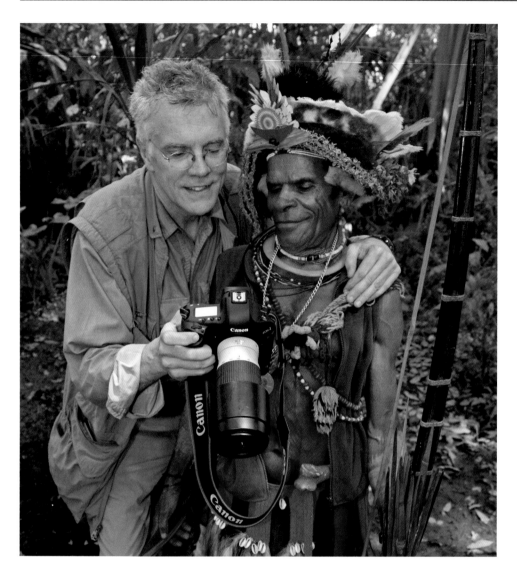

Third Carry-on

Getting camera gear on an airplane is getting harder and harder all the time. As I write this, most airlines allow one carry-on bag and one personal item, such as a laptop computer. I get around that by wearing my photo jacket (with zip off sleeves) when I travel, stuffing accessories like filters, extra batteries, flash diffusers, etc. in the pockets.

Naturally, a photo jacket or vest is a great in-the-field carryall, giving you easy access to accessories.

When it comes to buying a photo jacket or vest, check out several, and try them on before you buy one. Comfort is important, too. My suggestion is to get a lightweight jacket or vest with lots of inside and outside pockets. Mine is from ExOfficio (www.exofficio.com).

Snow and Rain Gear

When it's snowing or raining, I protect my camera and myself from the elements.

To protect my camera, I use a Storm Jacket (www.stormjacket.com). Storm Jackets come in difference sizes to accommodate wide-angle and telephoto lenses and keep my camera dry. To keep the front element of my lens or a filter free from rain and snow, I use a lens hood.

An option to a store-bought camera protector is a plastic garbage bag. Simply wrap it around your camera and cut an opening for the lens.

As I mentioned earlier in this chapter, another way I protect my equipment from water is to keep it in a waterproof bag when it's not in use. More specifically, I use the DryZone from Lowepro (www.lowepro.com). This backpack is partially made of scuba diving dry suit material and seals tight – so that if the backpack is dropped in water, it floats.

Backgrounds

When I teach a photography workshop, I stress the importance of the background, saying that it can make or break a photograph. In portraiture, the background is especially important, because we want the viewer's attention placed on the subject.

For portrait sessions, I use collapsible backgrounds from Westcott (www.fjwestcott.com). These backgrounds come in different sizes and colors and fold down to about one-third of their fully expanded size.

Some backgrounds are plain, while others have patterns. You can control the sharpness of the pattern by selecting a wide aperture (to soften it) or a smaller aperture (to keep it in focus). Keep in mind that the background's distance to the subject also affects its sharpness – the closer it is to the subject, the sharper it will be.

Also keep in mind that light from a light source or sources and natural light affect the background's brightness. Sometimes I use what's called a separation light on the background, a light that illuminates only the background to provide some separation between the background and the subject. Other times, I just let the natural light, or light from my front strobes/flashes/hot lights, illuminate it.

Both of these portraits are natural-light-only portraits.

 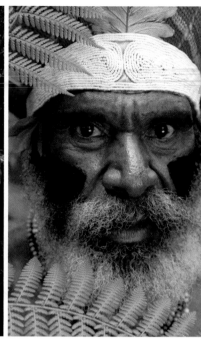

Reflectors

Reflectors bounce (reflect) light onto a subject. In this photograph, our guide on Papau New Guinea is reflecting skylight onto the face of a Huli Wigman. The reflector is not only lighting the man's face, but it's adding a nice "catch light" to the subject's eyes.

Reflectors are sold separately and in kits. Gold surface reflectors bounce a warm light, and silver surface reflectors bounce a cool light. Kits usually contain gold and silver reflectors that zip over diffusers (which soften the light). Black zip-on covers (which reduce light) and white zip-on covers (for bouncing a very soft light) are also found in kits.

Westcott (www.fjwestcott.com) offers a variety of reflectors sold separately and in kits and in several different sizes – including my own: Rick Sammon's On-Location Light Controller and Tote. Our guide is using the reflector from the kit and is wearing the handy tote on his shoulder. You'll find some before-and-after examples of this kit in use on the Tote page of my Web site (www.ricksammon.com).

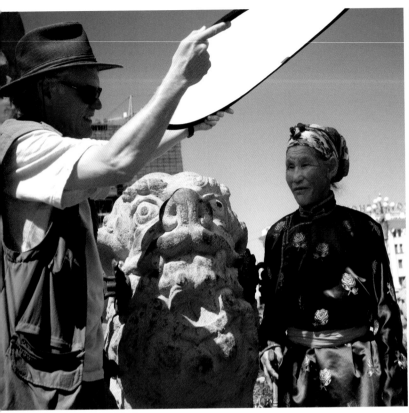

Diffusers

Diffusers soften harsh sunlight, which is advantageous when it comes to portraits, because soft lighting is more pleasing than harsh, unflattering lighting.

My friend Jack took this picture of me holding a diffuser during an impromptu photo session in Mongolia.

Diffusers are sold separately or in kits, similarly to reflectors as I described on the previous page. Westcott (www.fjwestcott.com) also offers a variety of diffusers and diffuser kits.

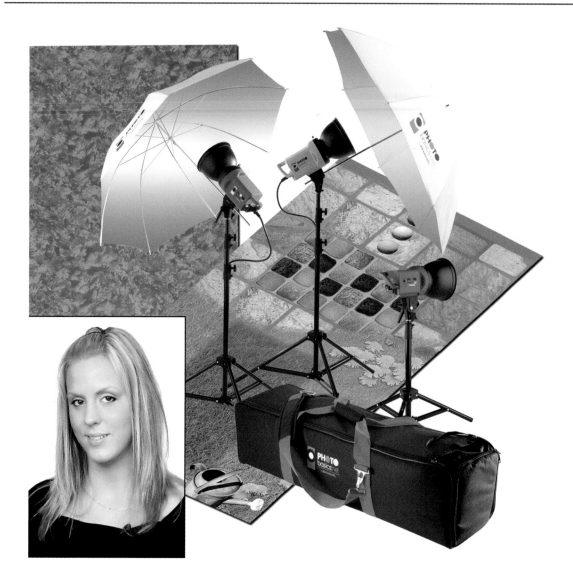

Hot Light Kits

Hot lights are aptly named hot lights because they create a lot of heat. They provide a constant light source so you can see in real time the effect (shadows and highlights) of using one or more lights and changing their positions.

Hot light kits can cost thousands of dollars, but I use a 3-light PhotoBasic kit (www.photobasics.net) from Westcott that sells for about $500. The kit, PB500, comes with two main lights, two umbrellas to soften the light, a background light, three stands, a background, a floor mat for easy light placement, and a carrying case. All three lights were used for this portrait of my friend, Kristin.

Product photo: courtesy of Westcott.

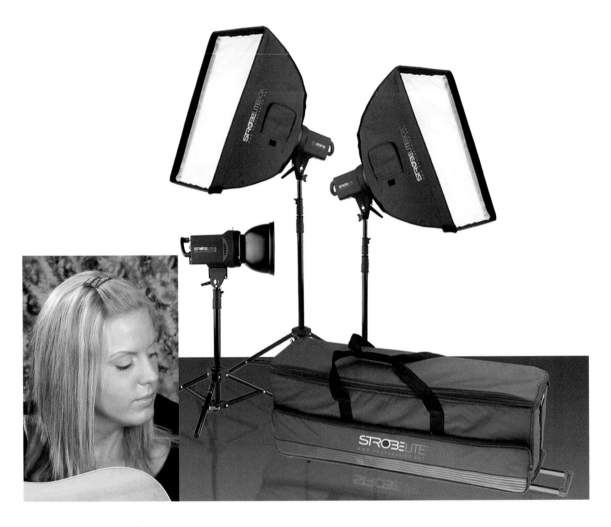

Strobe Light Kit

Strobe lights work like an accessory flash, firing in the blink of an eye. They have photocells that allow them to be fired from a main strobe that is tethered (attached by a wire) to a camera.

Professional strobe light kits can also be pricey, costing several thousand dollars. Rather than spending big bucks, I use a 3-light PhotoBasic kit from Westcott (www.photobasics.net). The kit, the Strobelite Plus 3 Light Kit #231, cost around $700 and comes with three lights, two soft boxes (to soften the light), two adapter rings (to swivel the soft boxes), three stands, a carrying case and a Westcott instructional DVD.

All three lights were used for this portrait of my friend, Kristin.

Product photo: courtesy of Westcott.

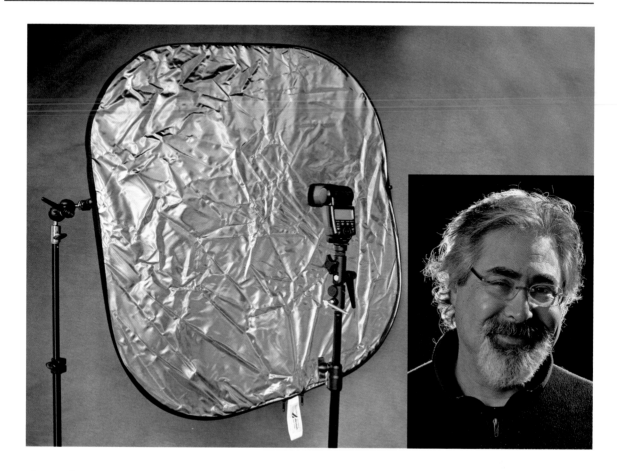

Studio Accessory Flash Unit Set Up

For my more serious studio lighting portraits, I use my accessory flash units (up to four) mounted on stands fitted with mounts for a flash. I either bounce the light from the flashes off gold reflectors (for warm light), off silver reflectors (for cool light), or I position the flashes behind diffusers for a very soft light. The reflectors/diffusers are held in place by stands with arms. I fire the flash units with my wireless transmitter, which fits in the hot-shoe of my camera.

The flash units alone cost around $400 each, and each reflector/diffuser set can cost a few hundred bucks, so this setup can get expensive.

I used a four-light setup for this portrait of my friend, David.

Check out the following Web sites for this cool gear.

Canon flash units and wireless transmitters: www.canonusa.com.

Flash stands and flash mounts: www.bogenimaging.com.

Reflectors, diffusers, stands and arms: www.fjwestcott.com

My On-Location Light Controller and Tote

As you saw in the *Fill in Shadows with a Reflector* lesson in the *Photographing People* chapter, I have my own reflector/diffuser kit, called Rick Sammon's On-Location Light Controller and Tote from FJ Westcott. The kit also features a flash diffuser, which softens the light from an accessory flash for a more pleasing and natural-looking photograph. The handy tote carries it all, plus a flash, memory cards and extra batteries.

I developed this kit because I wanted an affordable product with which photographers could control the light. That's easy to do with a little know-how, and often makes the difference between a snapshot and a great shot.

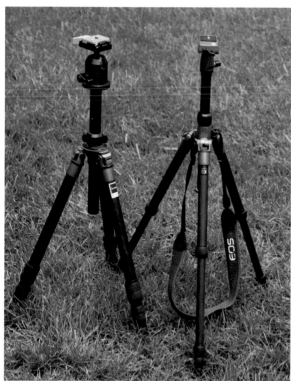 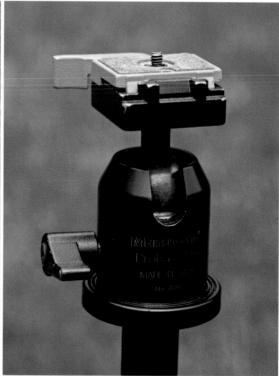

Tripods

Wowie zowie! Here you see a full-color picture of a two tripods and a picture of a tripod head.

Seriously, I know these shots, like most of the other product shots in this section, are not very exciting, but I do have some important tips about tripods that can help you when you are using one.

First, you'll notice that on one of my tripods I have attached a camera strap. Some tripod manufacturers include a shoulder strap or offer one as an optional accessory. I've done that so when I am walking around I can sling it over my shoulder and not have it hold it, which would tie up one of my shooting hands – and perhaps cause me to miss a shot.

I took the close-up shot to show you that I have a ball head attached to the tripod and a quick-release bracket attached to the ball head. The ball head swivels in all directions, which makes composition fast and easy. The quick-release bracket features a shoe that screws into the tripod socket of a camera. Pulling the lever on the bracket allows you to mount and dismount your camera in a couple of seconds.

These are lightweight tripods. When you are shooting with long telephoto lenses, which exaggerate camera shake, you'll want a sturdier tripod and ball head.

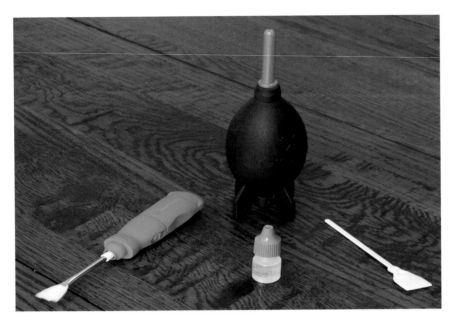

Sensor Cleaning Kit

One of the latest innovations in many digital SLRs is an in-camera sensor cleaning system, which basically shakes dust and other particles off the filter that's over the image sensor. For hard to remove particles, you'll need to manually clean the filter.

The first step is to carefully follow the instructions in your camera manual for cleaning the sensor. This involves locking up the mirror for the entire process – which means you can't lose power! Some cameras let you lock up the mirror on battery power, and others only let you lock up the mirror when the camera is attached to an AC outlet. The point is that you don't want the mirror flipping down when you are holding a cleaning device inside your camera.

Once the mirror is locked up, the first step is to use a blower (available at camera stores) to try to remove the particles.

If that does not work, other devices are available.

Pictured on the left is the Arctic Butterfly from Visible Dust (www.visibledust.com). The unit is battery powered – but don't turn on the power when it's inside your camera! The actual bristles in the Arctic Butterfly act as a magnet for dust particles. You should only turn the power on to charge the brush before inserting it into the camera. And of course, be sure to turn it off promptly after it's charged.

Another option is to use sensor swabs and a special cleaning liquid to wipe away particles. Sensor swabs are available in different sizes to match the size of the image sensor. These products are available from Photographic Solutions, Inc. (www.photographicsolutionsinc.com), and from Visible Dust (www.visibledust.com).

Of course, having your sensor professionally cleaned is an option – but that involves sending your camera to a service center, which will charge you for the cleaning.

Test All Your Gear and Bring Back Up Gear

You never want to look at your computer monitor and see what is pictured above. This is what corrupted files look like when you open them.

Actually, don't panic if you see something like this. You see, in this case, the files were not corrupted. Rather, a new card reader I had just purchased was defective – so the files looked corrupted.

My point here is to test all your equipment as soon as you get it. Having backups is essential, too.

If you do "lose" files, again, don't panic. There are software recovery programs available to help you "find" them. See the *Recovering "Lost" Files* lesson in *the Digital SLR Must-Know Info* chapter for more info.

Part VII

Home and On-Location Digital Darkrooms

Digital photography is part image capture, part digital darkroom work. This section covers getting properly equipped for the latter – you'll find tech talk here on computers, hard drives, memory cards and accessories that gives you some ideas for your own digital darkroom.

Computer – The Heart of the Digital Darkroom

Here's a picture, courtesy of Apple, of the home computer I am currently using. I'd show you mine, but it's under my desk and it's surrounded by a rat's nest of wires and cables – which does not make for a nice opening illustration for this chapter. So please forgive me for using a product shot.

It's a Mac Pro with a Quad-Core Intel Xeon processor and 4GB of RAM. Here's why that info is important: speed. The combination of the Quad-Core processor and 4GB of RAM lets me process my RAW files at speeds that were unheard of just a few years ago.

The computer has a 500GB internal hard drive and a 700GB internal backup hard dive. Time Machine, an Apple application, automatically backs up my hard drive to the backup drive. With all that space, I have plenty of room to store my many thousand photographs. However, as you'll read in a few pages, I also use additional back-up drives as a precaution – because hard drives can fail.

When buying a computer, if you have to choose between a larger hard drive and more RAM, go for the RAM. The more RAM you have, the faster you can process your images. You'll especially notice the improvement in speed when you apply filters and other effects to your images. You'll also notice it when you are browsing through folders of your large files.

I have been using Apple computers for 30 years, and people ask me all the time if a Mac OS computer is better than one running Microsoft Windows. I reply, "Is a Chevy better than a Ford?" The point: Use a computer you feel comfortable driving. Both Windows and Mac OS computers will get you to the same place. Personally, however, I think Mac OS models have a better operating system.

Monitor – Where Your Creative Vision Develops

Your monitor is basically the palette on which you "develop" your images – fine-tune color, contrast, sharpness, brightness, adding creative effects and so on. If you are serious about your photography, get the best monitor you can afford.

I like to use a large monitor, the Apple 30-inch Cinema Display. At that size, I have a wide-screen, HD-quality view of my images, which allows me to check out all the details in a relatively large image. The monitor is large enough that I can view my images and adjustment windows simultaneously.

However, my business partner, David Leveen, prefers to use two monitors, as you saw illustrated in the lesson on how to *Avoid Hard Flash Shadows* in the *Photographing People* chapter. Like some pros I know, David uses one monitor to view the image, and the other monitor for his tools and adjustment windows.

Some tips on monitors: First and foremost, calibrate your monitor. If you don't, you will not get prints that match the image on your monitor. Popular calibration devices include the Spyder2Express, GretagMacbeth Eye-One Display 2, and the Huey Pro. Do a Web search on these devices and on monitor calibration, and you'll find examples that illustrate why it's a must that you calibrate your monitor.

After you calibrate, keep the room light constant. If you don't, the images on your monitor will look different at different times of the day and when you turn different lights on and off. Black shades and a constant light source are a good investment to keep the room light constant.

I believe Apple monitors don't have to be calibrated as frequently as monitors used with Windows-based computers. But no matter what kind of monitor you use, it's a good idea to calibrate it from time to time.

Software – Applications to Awaken the Artist Within

Most of my photographer friends use at least two image-editing applications: Photoshop plus Aperture (as I do), or Photoshop plus Lightroom.

Photoshop (bottom image) is the most powerful image-editing application on the planet. You think it, and Photoshop helps you create it.

Apple's Aperture (Mac OS only) and Adobe's Lightroom are also powerful image-editing applications – and they are getting more powerful all the time because they accept Photoshop-compatible plug-ins. They are also fantastic file management applications, letting you name, stack, sort, file and find images easily at super-fast speed. What's more, both applications were created for photographers, while Photoshop was actually created for designers. One more thing: You should be aware that Photoshop costs about three times as much as Aperture and Lightroom.

I use Aperture to import my images into my computer, and to name, sort and find them. I also do basic image enhancements in Aperture.

For fanciful images, such as the bottom image you see here, I use Photoshop.

End of story: I suggest using Aperture or Lightroom for most of your work, and Photoshop for special and sophisticated effects.

Accessory Hard Drives – Your Key to Image Survival

Back up, back up, back up!

Okay, that's the end of this lesson.

Only kidding, at least in part. You see, you must back up your files in at least two places because hard drives can crash, causing you to lose all your valuable images. That is unless you don't mind paying $7,000 for a data recovery service to recover data from a crashed hard drive.

Although I have Apple's Time Machine software on my Mac Pro and an internal back-up hard drive, I still back up my photos on two accessory hard drives. I keep one in my office and one in my house. That way, in case of a fire or theft, I still have all my files.

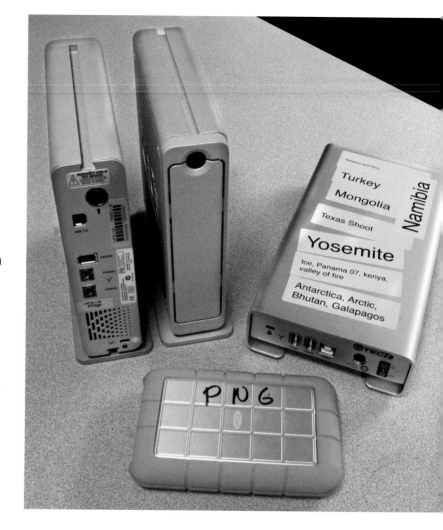

At home, I store my images on 250GB hard drives, and label them so I can easily find my photos. On location, I travel with a 160GB hard drive (the drive pictured here with the orange cover.) These portable drives run off power from the computer, so an AC adapter is not necessary.

In choosing and using accessory hard drives, make sure you have the right cables for the drive's connection ports so you can hook up your drives to your computer. The drives you see here have ports for FireWire 400 and FireWire 800 cables. My MacBook Pro laptop computer has ports for both, but my MacBook laptop only has a FireWire 400 port. When I travel, I make sure that I have the right cables for getting my pictures from my card reader to my computer.

I don't store any images on CDs or DVDs, because burning disks takes forever compared to writing files to a hard drive.

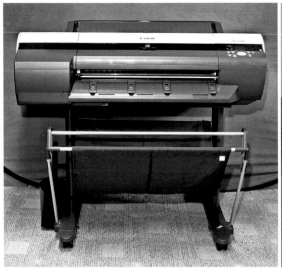
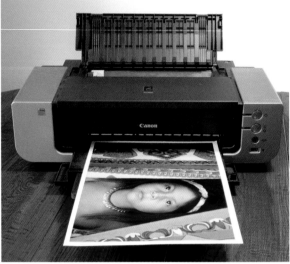

Printers – How to Show and Share Your Work

Most photographers don't realize that it is the inkjet printer that has driven the digital revolution – putting the control of the final image in the hands of the consumer.

Printers come in many sizes and cost from under $100 to several thousands of dollars. Basically, you get what you pay for, so if you are serious about making great prints, get a good photo-quality printer. Keep in mind that as the number of ink tanks increases, so does the image quality.

I use two printers. My Canon iPF 6100 (left) is a floor-standing, large-format, 24-inch printer that accepts both sheet paper and roll paper (for large prints, banners and panoramas). With a 12-color ink system, this printer can't be beat for color and big prints! My Canon Pixma Pro 9000, which fits on a desktop, makes prints up to 13x19 inches and features an 8-ink tank system. I use this printer for smaller prints.

When making a print, it's important to choose the correct paper and quality setting (in the printer's driver) to match the paper. Choose the wrong setting or paper, and your print may look like mush.

From time to time, run the printer's maintenance program. It aligns the print head and cleans the nozzles to ensure you get the best quality print.

Also keep in mind that you don't need to print a super-large file to get a great print. That will just slow down the printing process. For most prints, an image resolution of 360 PPI for the print's image size will give you a great print.

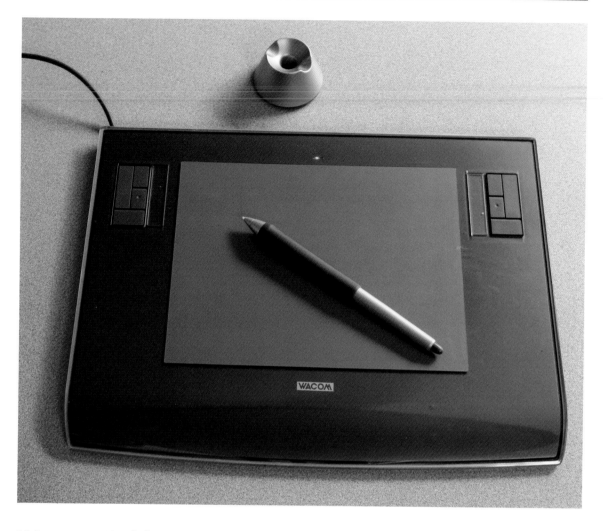

Wacom® Tablet – Paint with Precision

For the serious Photoshop, Aperture and Lightroom users, a Wacom® tablet with a stylus is a must. The pressure-sensitive stylus acts like a paintbrush, giving you precise control over the brushes in Photoshop, Aperture and Lightroom. Compared to using a mouse, it's like the difference between a painter painting with a fine paintbrush and a sponge (or a sock).

Several different models of Wacom tablets are available. Wacom Intuous® 3 tablets come in different sizes, from 4x6 inches to 12x19 inches. Mine is 6x9 inches.

Wacom Cintiq® tablets are also available in different sizes. The cool thing about these tablets is that they feature built-in, full-color monitors, so you "paint" directly on the tablets for the ultimate in creative control.

For more information, see www.wacom.com.

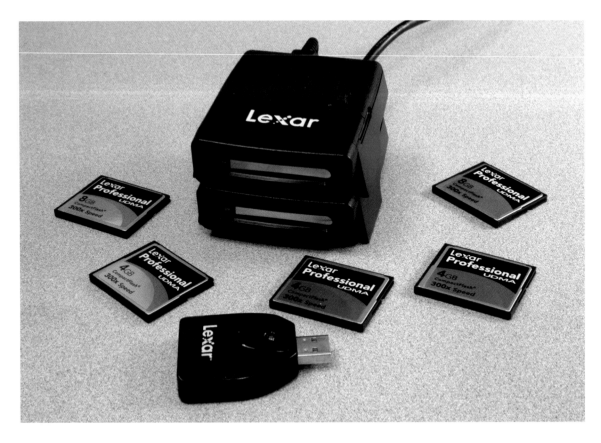

Card Readers – Movin' Images from Card to Computer

Your camera comes with a cable that lets you hook it up directly to your computer for downloading your pictures. Memory card readers, however, provide faster downloading – which is great for type-A photographers like me! In fact, I am so hyper that I use two card readers hooked up in tandem for even faster downloading.

Speaking of speed, not all card readers are created equal. Before you buy a card reader, check its specifications on the Web and compare it to other card readers. What's more, the type of cable you use affects image transfer speed. For example, a FireWire 800 cable provides faster transfer speed than a FireWire 400 cable, which provides a faster transfer speed than a USB cable.

When you travel, don't forget your card reader or readers. I travel with my Compact Flash card readers (stacked in this photo) to download my digital SLR images, and my SD (Secure Digital) card reader to download my compact camera images.

As always, a backup is a good idea when traveling far from home.

Power Backup – Prevent a Blackout

Here's another product shot, this time of my APC Back-UPS CS 500 power backup unit. Again, the rat's nest of wires around my unit does not make for a pretty picture.

Simply put, you must have a power backup unit. It will keep your computer running on battery power for a while if the AC power fails. It will also protect your computer from power surges, which can zap your motherboard and hard drive.

From time to time, check the unit's battery life with the supplied software.

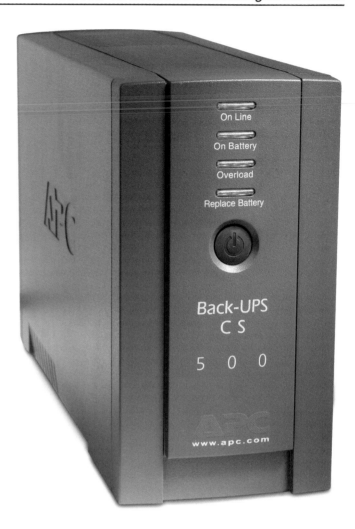

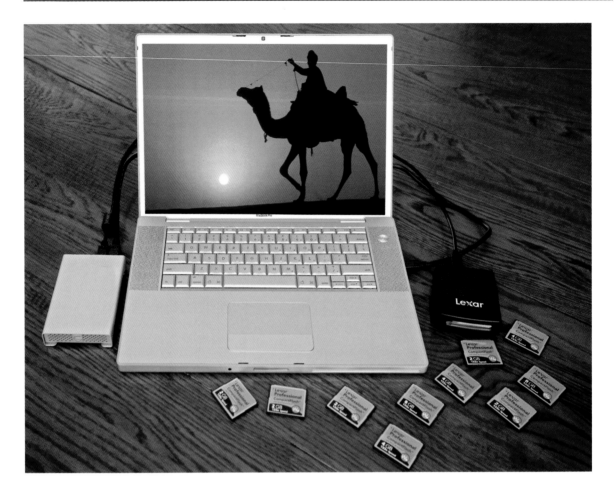

Field Setup – Digital Photos on the Go

On my workshops, I (as well as most of the participants) travel with a laptop, a card reader and a backup drive or drives. Image processing programs (Photoshop and/or Aperture/Lightroom) are loaded on their laptops, complete with the latest RAW plug-in or application update so that RAW files can be opened. That's an important point. If you have a new camera and don't have the latest RAW plug-in or application update, you may not be able to open your RAW files. That has happened to a few of my workshop participants, who were not happy campers.

When traveling, pack an AC power strip so you can charge your computer and camera battery at the same time. When visiting a foreign country, make sure you have the correct power adapter plug, which you can find at electronic stores.

If you will be on an extremely long flight, you may want to pack an extra laptop battery or bring an airplane power adapter. First Class and Business Class seats have outlets, but you may not find them in Economy Class – which is where I usually hang out.

Love Your On-Line Lab

Well, it's not exactly in your home digital darkroom setup, but you do have access to it from there! It's your on-line lab – more specifically, the lab's Web site to which you upload files for prints and press products – including the soft- and hardcover books, postcards and folded cards you see here.

I use Mpix.com. Even though they are located in Pittsburg and Kansas, I'm able to upload images from my home in Croton-on-Hudson, New York. Mpix still turns around prints and press products in 24 hours. How cool is that?

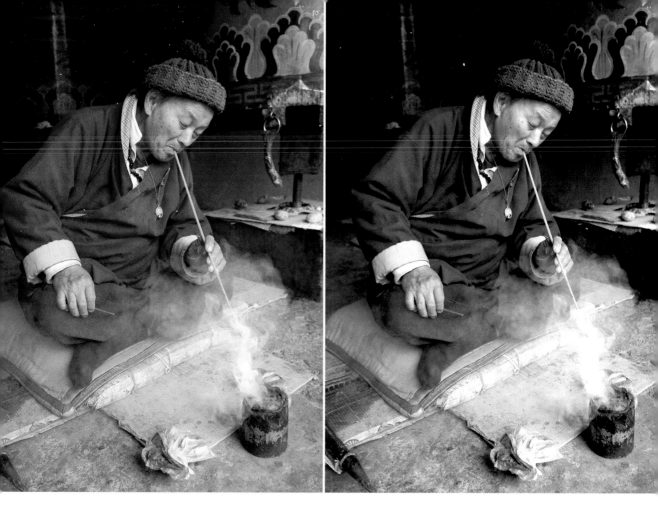

Top Digital Darkroom Ideas

Hey! This is not a Photoshop book with tons of screen grabs and step-by-step instructions. Still, I wanted to share some of my favorite creative techniques for digital darkroom fun. Good fast food for thought here. Enjoy!

Always Envision the End-Result

Digital photography is partially image capture and partially digital darkroom work/fun. When I am shooting, I am always thinking about the end result. I try to envision the possibilities that are available in the digital darkroom – using Adobe's Photoshop, Adobe Photoshop Lightroom or Apple's Aperture – the latter being the application I use most often. I recommend that you think this way, too, as it will expand your creative horizons when you are looking through your camera's viewfinder.

Here is just one example of "thinking ahead." Knowing the kind of digital magic that's available in Aperture, I took the bottom snapshot of the Golden Gate Bridge during an early morning walk in a nearby park. Using the Crop and Straighten tools, and then using the Levels, Contrast, Black Point and Saturation adjustments, I was able to create the end-result that I had envisioned during my nice peaceful walk.

Envision the end-result, and you'll be able to turn your snapshots into great shots – even favorite shots from a trip, as is the case with the top photo.

Don't be So Quick to Delete

That little delete button on the back of your camera sure is easy to use – and it's often quite tempting to press. However, before you trash a picture forever, think about how you can save it and possibly enhance it in the digital darkroom.

Check out this before-and-after pair of images. I agree the image on the left has a boring sky, or at least it appears that way in the original image. In Aperture, by simply pulling down the Curve line from the center to the bottom right in the Curves panel, and then boosting the blue tones in the Color Balance panel, I was able to create a beautiful sunset sky from that dull sky.

The message here is to think before you delete!

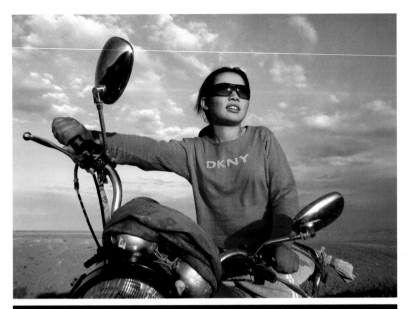

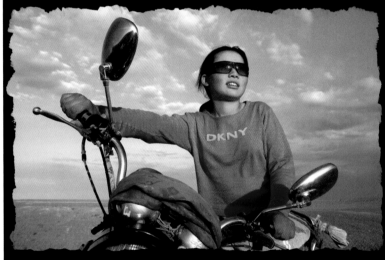

Add a Digital Frame

There is a good reason why frame stores make money: People like to see their images in a frame because a frame dresses up the image and helps to draw more attention to it.

We can quickly and easily add a frame to an image in the digital darkroom. Here I used a brush frame in PhotoFrame 3, a Photoshop plug-in from onOne Software (www. ononesoftware.com). With these frames you have dozens and dozens from which to choose. You can change the color of the background and foreground and the size and shape of the frame – resulting in an unlimited number of digital frames.

Digital frames are also found in Photoshop under Actions. Check 'em out. I like Photo Corners and the Brushed Aluminum Frame.

Warm It Up

We like pictures taken in the early morning and late afternoon because they have warmer colors (deeper shades of red, orange and yellow) than pictures taken during midday (which have a blue cast).

Slide film photographers used to use a warming filter to "change the time of day" of noontime shots, making them look as though they were taken during the golden hours.

In the digital darkroom, we can create that presto-change-o technique by boosting the red and yellow tones in the Color Balance adjustments panel.

Photoshop offers warming filters as one of its Adjustments (Image > Adjustments > Photo Filter). By varying the filters' sliders, you can vary the effect.

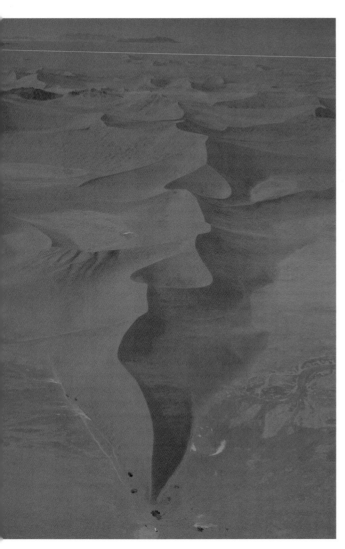 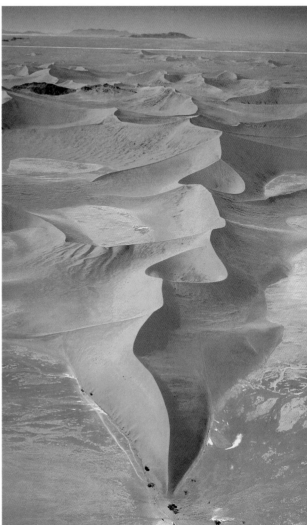

Boost Contrast, Saturation and Sharpness

Hey, it doesn't get much easier than this. Take a dull image and boost the contrast, saturation and sharpness in your digital darkroom application.

That's all I did for this photo of a Namibia sand dune that I took through a dirty, Plexiglas window of a small plane.

The resulting image looks as though I had taken it with the plane's window or door removed for clear shooting!

Create the Mirror Effect

Mirror, mirror on the wall, who has the fairest image of them all?

You do!

Well, at least you can have one of them when you create the mirror effect in Photoshop. Here's the technique (to create a horizontally mirrored image).

Open an image in Photoshop.

Duplicate it. Now you should have two images on your monitor.

Flip the duplicated image. (Image > Image Rotation > Flip Horizontal).

Now, on the same image, double the canvas size to the left of the image (Image > Canvas Size).

Finally, using the Move tool, drag the original image into the open area in the duplicated image.

Line up the images using the Move tool.

There you go! You have a beautiful mirrored image like this one, created from the Mono Lake image that's in the *Landscape and Scenic Photography* chapter.

Oh yeah, I added the blue sky with the Blue Graduated filter in Color Efex Pro 3 from Nik Software (www.niksoftware.com).

Great fun!

 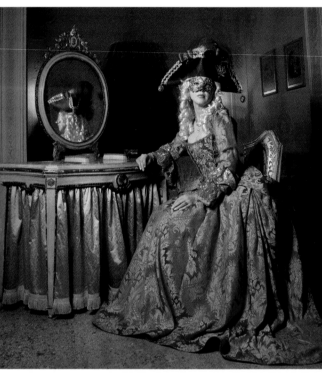

Think Selectively

This might be my most important digital darkroom tip: Think selectively, not globally.

When you think selectively, you think about the individual parts of an image that need enhancement. When you think globally, you are thinking about making enhancements to the entire image – which is sometimes not necessary and often not the best idea.

Adjustment layers and Smart Filters in Photoshop, and plug-ins for Aperture and Lightroom, make thinking/working selectively possible.

For this image, I increased the saturation of the woman's dress and her reflection in the mirror. I then used the Burn tool to darken the floor, background and part of her skin and face. As a final step, I sharpened the woman and the dresser and mirror – leaving the background a bit soft so that the main subject was prominent in the scene.

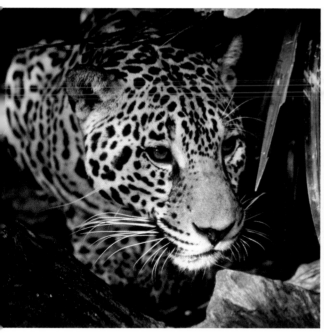

Create the Panning Effect

How many times have you attempted to create the panning effect in-camera and have had great results on your first attempt? Uh, I think I know the answer: rarely – that is, unless you were very lucky. I know, because it's difficult to get it right the first time!

In Photoshop, it's easy to create the panning effect – on your first try.

Here's an easy way to explain the process.

Make a duplicate layer (Layer > Duplicate) or copy of your image, because you never want to work on an original and lose the original file.

On the top layer, apply the Motion Blur filter (Filter > Blur > Motion Blur).

While still on the top layer, use the Eraser tool (with a soft-edge brush) and erase the blur over the subject. That reveals the sharp area of the image on the bottom, original layer.

Attention all Photoshop experts: I know that erasing pixels is a no-no! But as I said, this is just an easy way to explain the process. Converting an image to Smart Filters (available in Photoshop CS3), applying the Motion Blur filter, and then masking out the blur over the subject is the pro way to go.

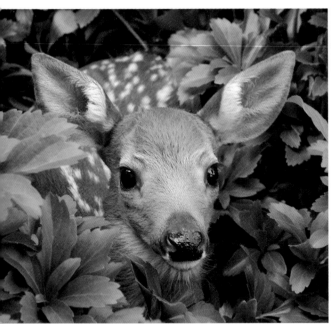 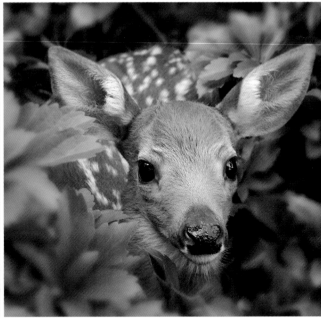

Simulate Using a Long Lens

Before reading this tip, please read the previous page.

Thank you!

The technique for this effect is the same as on the previous page, only to simulate the effect of using a long telephoto lens set at a wide aperture, which keeps the subject sharp but blurs the background and foreground, use the Gaussian Blur filter (Filter > Blur > Gaussian Blur).

When using the Gaussian Blur and Motion Blur filters, play around with the slider for different degrees of blur. Sometimes just a touch is nice, while at other times a more intense effect is cool.

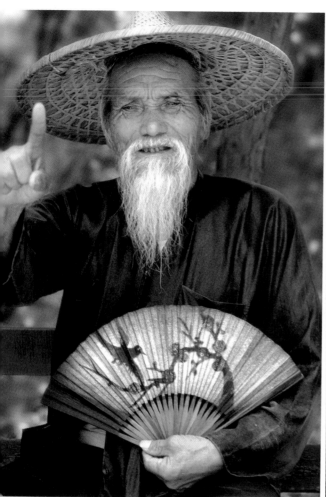

Age a Photo

Sure, it's cool to have the latest and greatest digital camera to give you the cleanest possible image – one with relatively low digital noise even at high ISO settings. And it's great to shoot with a high-quality SLR lens for the sharpest possible shot.

Sometimes, however, it's fun to go back in time and simulate the effect of an old-time photo. The fastest and easiest way I know of doing that is to apply the Aged Photo Action (Actions > Aged Photo) in Photoshop, which is what I did for this picture I took of a man in Hong Kong.

You can also turn new photos into old-looking photos in Photoshop by slightly desaturating them, adding film grain, applying Dust & Scratches, applying a bit of Gaussian Blur and/or by applying the sepia filter.

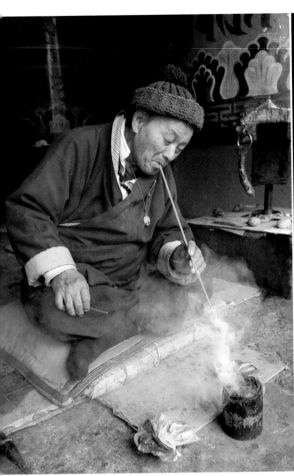
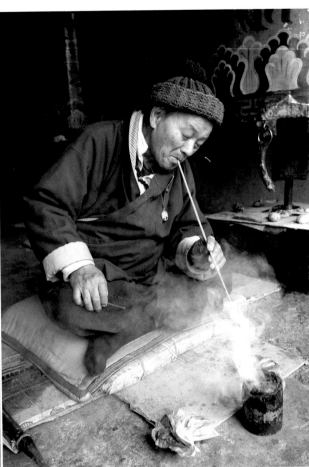

Go Black-and-White

When we remove the color from a scene, we remove some of the reality. And when we remove some of the reality, a picture becomes more artistic. In the digital darkroom, there are many ways to create beautiful black-and-white images. Here are just a few.

Alien Skin Software (www.alienskin.com) offers a Photoshop plug-in called Exposure that simulates dozens of different types of black-and-white film effects. Other plug-ins for creating black-and-white images include Color Efex Pro from Nik Software (www.niksoftware.com) and PhotoTools from onOne Software (www.ononesoftware.com).

You can also create and fine-tune black-and-white images using many of the controls that are built into Aperture, Lightroom and Photoshop.

If you want to make great black-and-white prints, make sure you get a printer that accepts the special monochrome inks that are required for fine-art printing, such as matte black, photo black, grey and photo grey – which optimize the black ink density for monochrome photo-quality output.

Add a Digital Graduated Filter

When I first started in photography, I used a graduated filter (which is dark on the top and gradually becomes clear on the bottom) over my lens to compress the brightness range in a scene. The result was that the exposure for the brighter sky was more closely matched to the exposure for the landscape – making getting a good exposure relatively easy.

Neutral density graduated filters have no effect on the color of the sky. Color filters are available to add different colors to the sky, such as light blue, dark blue, orange, red and so on.

Today, I use the digital graduated filters in Color Efex Pro from Nik Software (www. niksoftware.com). Literally hundreds of different color filters are available. In the plug-in's control panel, you can place the filter anywhere you like – so that its placement matches the horizon line in your image.

I applied the coffee graduated filter to this photo to add some color to a lack luster image of two camels I took behind the Taj Mahal.

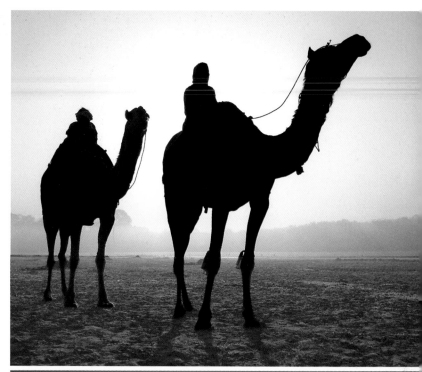

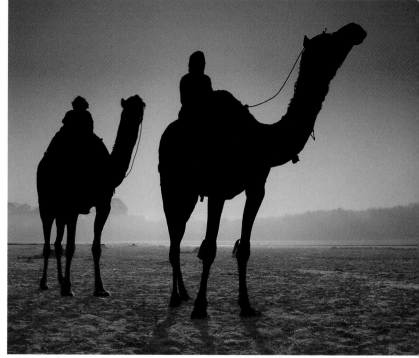

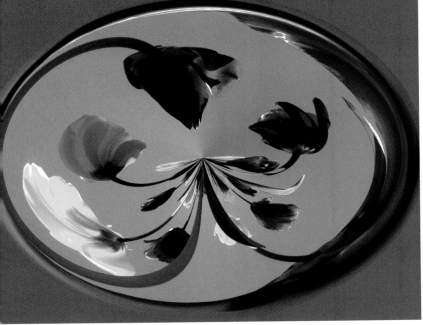

Create the Swirl Effect

At my seminars, this is the most popular Photoshop special effect. Here's how to do it.

Open an image with a strong graphic element.

Go to Filter > Distort > Polar Coordinates > Polar to Rectangular.

Then go to Image > Rotate Canvass > Flip Vertically.

Go back to Filter > Distort > Polar Coordinates, but now choose Rectangular to Polar.

This effect does not work for every image, but when it works, it really works!

Correct for Lens Distortion

When you photograph a subject close-up with a wide-angle lens, the lens can distort the subject, as it did here, creating the effect that this schoolteacher in a remote village in Bhutan was leaning over backward.

Photoshop to the rescue, once again. Here's what to do in a case like this.

Go to Select > All.

Next go to Edit > Transform > Perspective.

Now pull out the anchor points at the top left or right of the frame until the distortion effect is corrected.

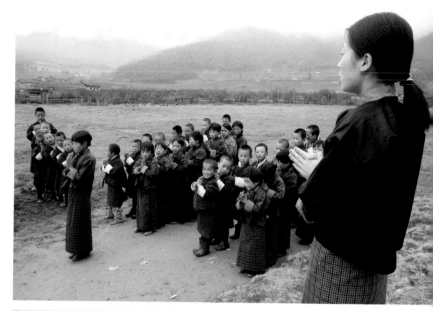

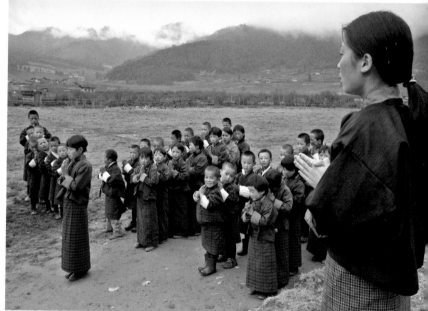

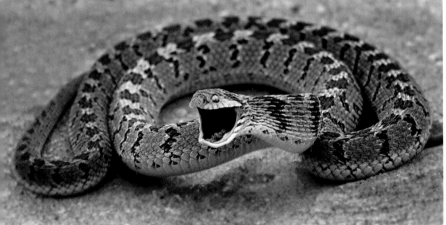

Make Your Subject Stand Out

Pictures in which the subject stands out from the background have more impact than those in which the subject blends into the background (unless the point of the picture, perhaps, is to illustrate a camouflage technique of an animal in nature or a similar point).

Here are the techniques I used in Photohop to make the snake stand out in this photograph.

I cropped the image so the snake almost filled the frame. That eliminated the dead space around it.

I used the Burn tool to darken the sand around the animal. I also blurred it using the Gaussian Blur filter.

Then I used Unsharp Mask (Filter > Sharpen >Unsharp Mask) to sharpen the snake, and I selectively increased its contrast.

Take the time to make your subject stand out in a photograph, and you'll have an outstanding picture.

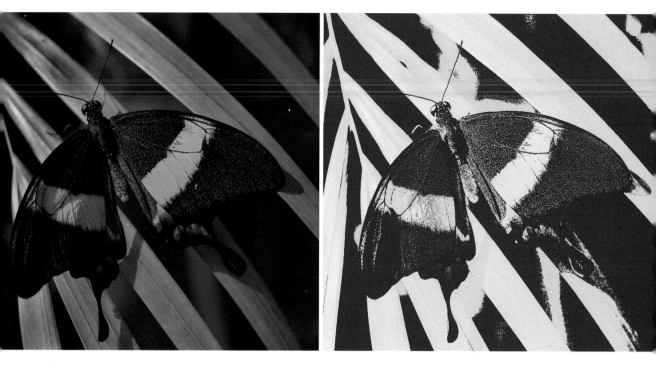

Create a Nice Note Paper Image

Feel artistic? Check out this effect.

In Photoshop, go to Filter > Sketch > Note Paper. Play around with the slider (Image Balance, Graininess and Relief) to create a one-of-a-kind image.

Keep in mind that when you apply this filter, the foreground color, which was set to blue in this case, is applied to the image. Had I selected red, for example, the image would have had a red tint.

Discover Duotones

Want to add an interesting tone to an image? Check out Duotone (which is grouped with Tritone and Quadtone) in Photoshop.

To find Duotone in Photoshop, go to Image > Mode and convert an RGB image to a Grayscale image. After doing that, you'll see Duotone in the Image > Mode pull-down menu.

When you select Duotone, you can combine two colors of ink to create an image. When you select Tritone and Quadtone, you combine three and four different inks, respectively, to create an image.

To add some color to this picture of the swimming pool at the Hearst Castle in California, I combined an orange ink and a pink ink.

Fade a Filter

Photoshop has some fantastic filters. Play around with the sliders in the filters' windows, and you can create one-of-a-kind effects.

Want even more unique effects? Try fading a filter. Here's how to do it.

Immediately after applying a filter, go to Edit > Fade Filter. You'll see the name of the filter you just applied to your image. In the dialog box that pops up, move the slider to the left to fade the filter. Play around with the different fade modes for even more effects.

I applied the Graphic Pen filter to my lifeguard stand photo and then faded it to about 20 percent.

With the Graphic Pen filter, as with some of the other filters in Photoshop, the foreground color affects the filter's effect. Here I chose a light blue as my foreground color.

Awaken the Artist Within

I can't paint to save my life – with a paintbrush that is. I can, however, use Photoshop's Art History brush (which is nested with the History Brush) in the tool panel to creatively paint over every pixel in an image for an artistic image.

The key to this technique is to use a small brush. And when choosing a brush, load a Dry Media Brush, Wet Media Brush, or Faux Finish Brush.

For more info on this cool technique, just type "Art History Brush" in Photoshop's Help window.

All about Hue

Here's another fun-filled digital darkroom quickie. Play around with the Hue sliders in your image-editing program to change the color or colors in an image.

I say color or colors because if you adjust the hue with Master selected, you change all the colors in a scene, which is how I created the middle image from the original image on the left.

When, however, you choose to change the hue of just one of the colors, you only change the hue of that color in an image. To create the image on the right, I chose Blue rather than Master to change only the blue tones in the image.

See. It really is all about hue!

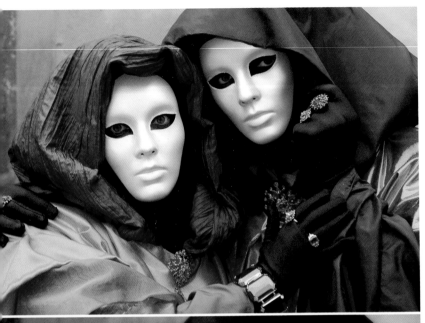

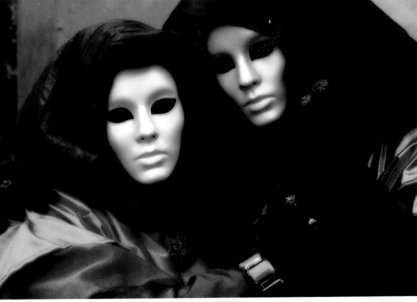

After Midnight

If you come on one of my photography workshops or attend one of my seminars, you'll hear me say that one of my favorite expressions is: You snooze, you lose. It's true. If you are serious about your photography, you need to get up early and stay up late – sometimes until midnight – to get great shots. It's all about the light.

Well, if you are tired after a hard day's work and fall asleep early, there is a digital darkroom technique for getting a midnight-looking shot.

Nik Software (www.niksoftware.com) offers the Midnight filter in its Photoshop plug-in, Color Efex Pro. I used it on one of the images I took in Venice, Italy during Carnevale. Basically the filter darkens shadows, softens the details and adds a nice overall glow to the image.

Pleasant dreams.

Posterize an Image

In the 1960s, pop art and posterized images were, well, groovy.

Today, thanks to Photoshop, creating a posterized image is quick and easy.

Go to Image > Adjustments > Posterize. Use the slider in the dialog box to vary the effect from slight to intense.

Hey man, combine it with the Swirl Effect that you read about earlier in this chapter, and you have a really far out photo, as illustrated by the image on the right.

Peace.

Retouch an Old Photo

My second tip in this chapter was about not being so quick to delete an image. Well, when it comes to old, scratched prints, don't be so quick to toss them either. Thanks to Photoshop, you can make them look almost brand new.

The badly scratched photo of my son, Marco, is a good example of Photoshop's magic. To retouch the photo, I first applied the Dust & Scratches filter (Filter > Noise > Dust & Scratches), which did a pretty good job cleaning up the image. Yes, this filter does soften an image, but for portraits, that could be (and it was in this case) a good thing.

To remove the really bad scratches and spots, I used Photoshop's Healing Brush.

If you really want to get into photo retouching, I recommend you check out Katrin Eisemann's DVDs, books, seminars and workshops. See www.katrineismann.com.

Explore Shadow/ Highlight

Check out the top image on this page, which I took at Bodie Historical State Park in California. As you can see, I was shooting into the sun – which resulted in an image with a wide contrast range. The highlights are a bit washed out and the shadows are a bit too dark. No problem!

In Aperture, Lightroom and Photoshop, there is a wonderful adjustment called Shadow/ Highlight that lets you adjust the shadows and highlights somewhat independently.

I used that easy-to-use adjustment to create the bottom image. I also boosted the saturation just a bit to add more color to the scene.

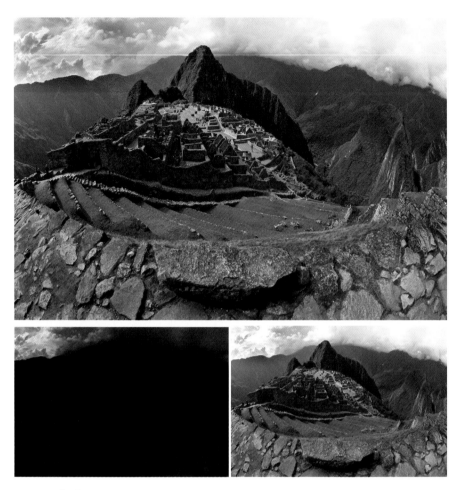

Double Process an Image

Here is an easy technique in Photoshop for getting a well-exposed image in a high-contrast situation – as long as the contrast range is no more than three f-stops.

Open a file (of course, you should be shooting RAW) and process it so the highlights look great. Don't worry about the shadows, which will be blocked up after your highlight processing – as illustrated in the bottom left image.

Now, open the image again and process it for the shadows. That's right! Don't worry about how the highlights look, which will be overexposed – as illustrated by the bottom right image.

With both images open on your monitor, drag one image over the other. If you hold down the Shift key (on either a Mac or a PC) during the dragging process, the images will be perfectly aligned.

Now, select a soft edge brush and use the Eraser tool to erase the part of the image that is either washed out or blocked up. The result, after adding some standard Adjustments such as Contrast and Saturation, should look like the top image of Machu Picchu you see here: a beautifully exposed image.

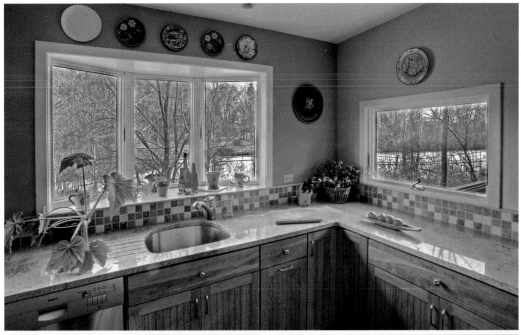

Merge to HDR

In very high contrast situations, you'll need to utilize a digital darkroom technique called High Dynamic Range.

Here's the process in Photoshop (one of several options). Place your camera on a tripod and set it to the aperture priority mode. Take several exposures over and under the recommended exposure, with the goal of capturing the entire brightness range – from the brightest highlight to the deepest shadow.

In Photoshop, go to File > Automate > Merge to HDR. Follow the on-screen prompts and your images will be merged together to produce an image with a tremendous shadow to highlight range.

For the end-result photograph of my kitchen that you see here, I took six photographs, only two of which are shown.

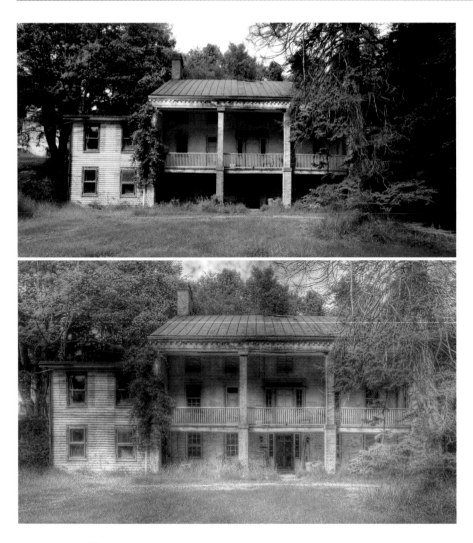

Enter Photomatix

A very cool option for creating HDR images is to use a program called Photomatix Pro (www.hdrsoft.com).

This program can accomplish the same effect as Merge to HDR in Photoshop, but it also opens a whole new world of creativity for you.

In the program, you have two modes: Tone Compressor and Detail Enhancer.

It's in the Detail Enhancer mode where your imagination can run wild, as mine did when I was working on this picture of an abandoned house.

Play with the sliders in the Detail Enhancer panel, boosting the Color Saturation, Luminance and Strength all the way up! Set the Micro-smoothing setting to Zero and boost the Micro-contrast setting.

Go wild!

Variations on the Theme

Here are some more Photomatix Detail Enhancer effects – with the help of some plug-in filter effects. I'm sharing them with you to illustrate that a photograph is really never finished. You can always go back and experiment for new, creative images.

Here are the plug-in filters I used.

Top: Midnight filter in Color Efex Pro 3 (www.niksoftware.com).

Middle: Autumn in Photo Tools (www.ononesoftware.com).

Bottom: Monday Morning in Color Efex Pro 3 (www.niksoftware.com).

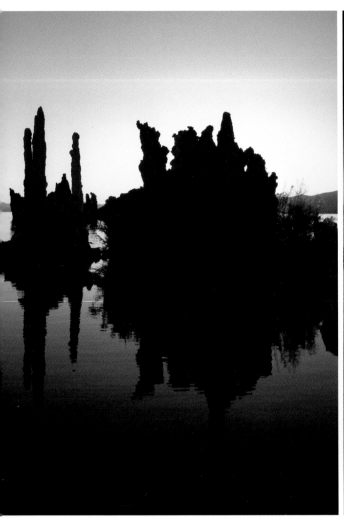

Never Stop Playing with HDR

Here is the quickest tip in this book: Never stop playing with your images in HDR, Photomatix in this case.

While playing with one of my Mono Lake photographs, I came up with a variation that was just perfect for the cover of a magazine. The variation was totally unexpected – which I enhanced by adding a sepia tone filter.

Now all I have to do is find a magazine that wants my image for its cover. The good news is that I have a good example to show the art director. If you have an image you think would make a good cover, make a mock-up, like this, and give it a try.

Good luck!

Reflection on an Image

We all enjoy looking at scenes in which a subject is perfectly reflected in a pond or lake. Here's how to create that type of image in Photoshop. As an illustration, I'll use one of my Photomechanix shots.

First, you need a photograph that lends itself to a reflection image.

Second, copy the image and flip it vertically (Image > Rotate Image > Flip Vertical).

Third, go back to your original image and double the canvas size (Image > Canvas Size).

Fourth, drag the upside image into the open area of your right side up image. Line up the images.

With the upside-down image layer activated, add the Ocean Ripple filter (Filter > Distort > Ocean Ripple). Then use Levels (Image > Adjustment > Levels) to darken the image. You are adding the ripples and darkening the "reflection" because that effect happens naturally in a pond or lake.

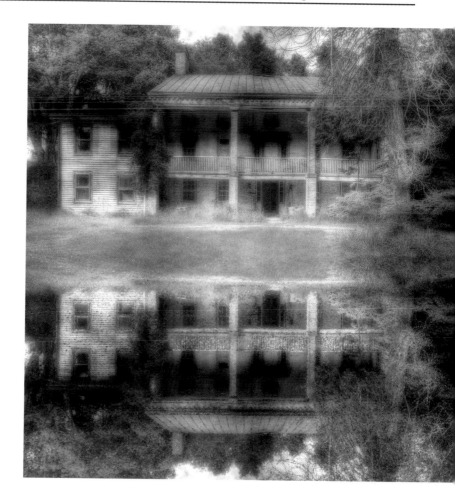

Part IX

Cool Web Sites for Great Info

Spend some time surfing these sites for the latest and greatest digital photography and digital darkroom info. Check out the forums and blogs to share your own ideas and images.

Rick Sammon
www.ricksammon.com

I thought I'd lead off this chapter with my favorite Web site: mine!

Seriously, I do spend a lot of time on my site, updating it with new and free how-to articles, free videos, my seminar and workshop schedules and cool links. While browsing my site, you'll also see a few of my favorite images and several of my YouTube videos.

If you have been on or will be coming on one of my workshops, there's a page of photos from my workshop participants. Don't be shy about contacting me and sending me your own images for that page. Email low-res files (72 PPI, 5x7, JPEG) to me at ricksammon@mac.com.

Canon Digital Learning Center
www.usa.canon.com/dlc

Sure, if you use Canon cameras and printers this site offers tons of information – articles, videos and interviews – that will help you get the most out of your gear and help to awaken the artist within.

However, even if you use another camera or printer, there is still a lot to learn there, because many of the articles (including mine on the EOS Digital Rebel) include generic information.

While you are on the site, click on the link to the Explorers of Light and Print Masters. You'll be duly impressed by the photographs of some of the top image makers in the world today – from all photographic specialties.

onOne software
www.ononesoftware.com

This is one of my favorite plug-in Web sites – because onOne software offers several plug-ins that can help you improve your images and image (as a serious photographer).

Their plugs-ins include: Photo Tools, which offers dozens and dozens of creative color effects; Genuine Fractals 5, which lets you upsize an image without losing detail; FocalPoint, which puts you in control of where the focus point is in an image; PhotoFrame, which is a cool solution for adding a digital frame to an image; Mask Pro 4.1, which is a complete collection of masking tools; and PhotoTune 2.2, which makes professional color correction easy.

While you are on the site, check out their Plug-in Suite, which bundles several plug-ins and saves you a ton of money over buying the plug-ins individually.

Cool tutorials there, too.

Westcott
www.fjwestcott.com

Got light? Need light? Virtually all your lighting and portrait photography needs (including backgrounds) can be met on this site. That goes for professional photographers and for those who are just starting out in photography.

Two "must-see" pages are the Community Gallery and the Discussion Boards. Hey, participate. Share, learn and enjoy.

Lexar
www.lexar.com

Before you check out all the tech info on the site, such as write speed of these cards, check out these pages: Pro Photographer Corner, Workflow and Technology, Tips + Lessons, Photo Gallery and Pro Articles. After you have absorbed all that great info, then check out the tech talk. You'll be impressed with the cards – and with the pros that use 'em.

NikSoftware
www.niksoftware.com

You'll find lots of plug-in magic on this site. My favorite Nik plug-ins include: Silver Efex Pro, great for creating knockout black and white images; Color Efex Pro 3.0, designed to simulate many standard filters and creative effects; Viveza, a powerful tool for selectively controlling color; and Dfine 2.0, which helps to reduce noise in digital files.

Don't miss the Learn page. Lots to, that's right, learn here!

Mpix
www.mpix.com

From the comfort of your home computer, you can upload your images to Mpix for great prints (on a variety of papers), greeting cards, calendars books, gallery wraps – and much more.

Mpix's "claim to fame" is color management. I have found that no one does it better.

Join the Mpix community by visiting the Mpix forums and blogs. You'll find a lot of info sharing here.

Got questions on uploading? Just ask on the help page.

Kelby Training
www.kelbytraining.com

Scott Kelby, Dave Cross, Moose Peterson, Vincent Versace, Joe McNally, Eddie Tapp, Ben Wilmore and John Paul Caponigro (plus your truly) are just a few of the instructors who share their photography and Photoshop know-how with you on this site.

Sign up for a month or a year. It's up to you. I guarantee you will learn a ton from each and every class.

For starters, take the Tour. Then check out the few previews.

New instructors are being added all the time. So check back from time to time to find more photo and Photoshop know-how.

ExOfficio
www.exofficio.com

Well, you will not find any photo tips on this site, but you will find clothes that will keep you comfortable when you are shooting – in both hot and chilly conditions.

Don't miss the EXO vests. They are the ones I use as my third carry-on when traveling by plane. They are also great for in-the-field shooting when you want easy access to your lenses and accessories.

Layers
www.layersmagazine.com

Layers magazine is just one of the magazines for which I write. It's the magazine for everything about Adobe. Naturally, you'll find Photoshop and Lightroom articles. But don't miss the photography column. I think you'll like what the guy (me) has to say.

PCPhoto
www.pcphotomag.com

PCPhoto is another magazine for which I write. I've been doing articles for them for about five years. Type "Rick Sammon" in the Search window and you'll find more than a few of my past articles.

While you are on the site, don't miss the Tip of the Week and all the articles on the Digital Photography Learning Center and the Feature Articles pages.

doubl⊛xposure

| Home | Cover Story | From the Editor | Education & Inspiration | Member News | Products | Events | Contests | Books | Search |

July, 2008

Cover Story: Ex Libris - An Interview with Amy Arbus

© Amy Arbus

Amy Arbus discusses her photography and the world of publishing in an interview by Robert A. Schaefer, Jr.

New!

How to Rescue and Recover an Outtake

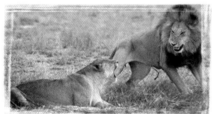

© Rick Sammon

Rick Sammon shows you how cloning, copying and pasting, increasing canvas size, and enhancing color can save a mediocre image.

New!

The Artful Imagery of Michael Going

© Michael Going

Going has had a lifelong relationship with the camera, and has been a professional photographer for over 36 years. He has carved out a unique career with his altered Polaroid images.

New!

Ken Martin's Images in Brooklyn Art Show

DoubleExposure
www.doubleexposure.com

This on-line magazine offers tons of photo info. Each month you'll find a feature story by a top pro, educational and inspirational articles, member news, information on new products, Photoshop info, dates of photo events and book reviews.

Photo.net

Photo.net is the Web's most active photography community. Millions of photographers use the site to connect with each other, explore photo galleries, discuss equipment and techniques, share and critique photos and learn about the craft of photography.

Since its launch in 1993, the site has grown to include more than 700,000 registered users and receives more than 5.5 million visits each month.

You might find someone familiar writing photography articles on this way-cool site.

© Katrin Eismann

Part X

With a Little Help From My Friends

Here you'll find great tips and images from some of my best friends in the digital photography community. Check out their work on their Web sites. Great people, great images and great info.

© Katrin Eismann

Parts Can Create a New Whole

Take your time to savor taking the initial photographs. These images were captured while exploring a eucalyptus forest, alpine moorland and dense fern groves in Mt. Field National Park in Tasmania.

Using a macro lens and an extension tube (which allows you to get extremely close to a subject), I concentrated on capturing the shape, texture and structure of the beautiful ferns.

After downloading the image to my computer, I used Adobe Lightroom 2.0 to process my RAW files. I then used Lightroom's selective adjustments to dodge the highlights and darken the shadows, which added shape and depth to the leaves. To enhance the moistness in the images, I "painted" sharpening over the highlights, which added sparkle and liveliness to my images.

When you are working on your images, explore contrast and juxtaposition by combining images together in Photoshop. You'll see that parts will create a new whole.

Katrin Eismann
www.katrineismann.com
Artist, teacher, author and co-founder and chair of the Masters of Professional Studies in Digital Photography at the School of Visual Arts (www.sva.edu) in New York City.

Digital Duo

Many digital SLRs have built-in black-and-white or sepia modes. Some even offer options to enhance gray tones while making the rest of the colors less vibrant, producing an old-fashioned hand-colored look. You can always make these kinds of adjustments after the fact using Adobe Photoshop or your favorite digital imaging software. However, shooting directly in black and white impacts how you see while making the images and getting instant feedback helps focus your vision. I'm not afraid of losing the color image for future use because I can always capture color and monochrome image files at the same time. While Rick prefers shooting in RAW and doesn't like to shoot JPEG files using monochrome mode or Picture styles, this method lets you do both, and you end up with two files: an untouched RAW file and a JPEG that has been manipulated in-camera.

© Joe Farace

Tip #1: Almost all digital SLRs offer the ability to simultaneously capture RAW+JPEG files, and these same cameras also allow you to capture monochrome images only as JPEG files. If you set your SLR for RAW+JPEG capture then select the monochrome effect you want, you'll end up with two files: one in color (RAW) and the other in black and white (JPEG.)

Tip #2: Beginning with the EOS 1D Mark II N, Canon digital SLRs with dual-memory slots let you capture RAW files on one memory card and JPEGs on the other. Yup, that means you can put all your color RAW files on one memory card and the monochrome shots on the other.

Joe Farace
www.joefarace.com
A Colorado-based photographer and author of 30 books and 1700+ magazine stories.
He's a Contributing Photographer/Writer for Shutterbug. For more photo tips visit his blog:
www.joefaraceblogs.com.

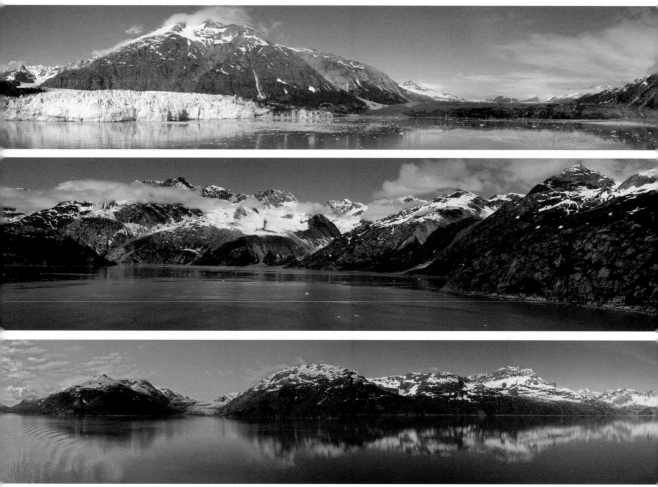

© Kate Faust

Go Wide!

Try this tip for some photo fun. Shoot a series of pictures of a scene from right to left or vice versa with the intention of making a panoramic photograph. A tripod helps, but it's not necessary. It is necessary, however, to overlap the photographs slightly. Take three to six photographs. The more the merrier.

To stitch them together, use Photoshop: File > Automate > Photomerge and follow the on-screen prompts. Don't forget to flatten the layers or you'll get some strange-looking lines in your image.

Here are some of my favorite recent panoramas from a recent trip to Alaska.

Kate Faust
www.imagerybykate.com
Photographer, painter, artist

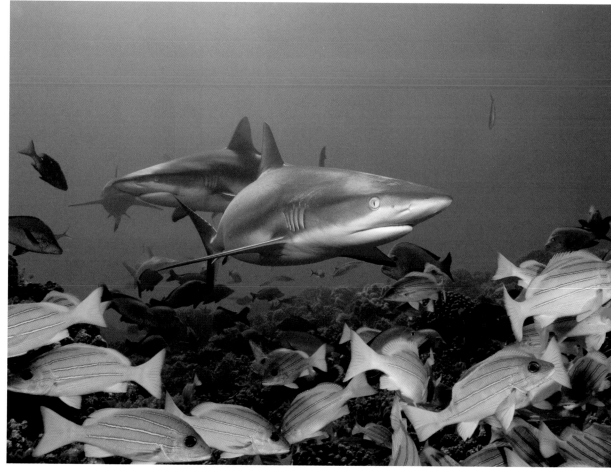

© Steven Frink

Dive In!

Underwater photography requires close proximity to the subject, because the medium is 800 times denser than air and acts as a massive soft focus and cyan filter. So, to achieve color, clarity and resolution, it is necessary to work close to the subject and use a submersible strobe.

For this image, I used my Canon 16-35mm II on my EOS 1Ds Mark III in a Seacam (www.seacamusa.com) housing. The shark is about two feet from the dome port on the housing. My strobe light helped stop the action and define color on both the sharks and nearby reef fish.

As you get closer to the subject, your pictures will increase in sharpness.

> *Steven Frink*
> *www.stevenfrink.com*
> *Underwater photographer, teacher, Canon Explorer of Light and workshop leader*

©Steven Inglima

Think in Black-and-White

Many times I find that when color is insufficient, nearly non-existent or not pleasing in one of my photographs, I reduce the image to black and white to see if it looks better, often with positive results.

To me, good black-and-white images can have as much – if not more – impact than color images, especially those with mediocre color. My theory of why black-and-white continues to intrigue photographers and movie-lovers is that it reaches a deep emotional, almost evolutionary primitive part of our psyche. To understand this theory, you'll need to understand how the human eye functions.

As humans, we have two types of light receptors in our eyes: cones for colors, and rods that see only in shades of gray. Cones work well in bright light, but don't function well in dim light, which is when the rods take over.

Humans have limited night vision compared to other animals – some of which can be predators of ours. At dusk when we become more vulnerable due to our limited night vision, our ability to see color is decreased and we begin to see in black-and-white. Thus, the same sense of urgency that we feel when we're vulnerable in the dark seems to persist when we look at images that have no color.

Thinking in black-and-white can open up a whole new world of creativity for you.

Steven Inglima
Explorer of Light, Canon USA
www.usa.canon.com/dlc

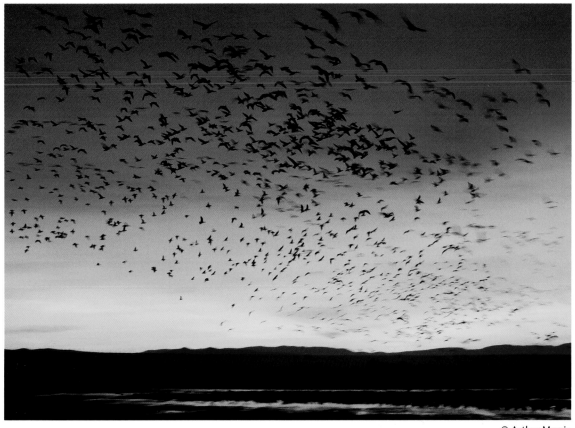

© Arthur Morris

Learn about Nature and the Nature of Your Camera

Okay, so Rick asked me for one tip for this chapter, but I thought I'd go a bit further and offer five. Here goes!

1 - If you want to learn to be a better nature photographer, study to become a good naturalist. Knowing the pattern of the Snow Geese (pictured here) migration allows me to travel to productive sites.

2 - With large groups of birds (or other animals) choose a slow shutter speed to create pleasing blurs. Note: To be effective, intentional blurs must be focused accurately.

3 - Learn to evaluate and adjust your histogram to ensure a perfect exposure in any lighting situation.

4 - Work on a tripod and use a double bubble level to ensure level horizons.

5 - Zoom lenses allow infinite framing options; fixed focal length lenses do not.

Arthur Morris
www.birdsasart.com
Photographer, author, lecturer and Canon Explorer of Light

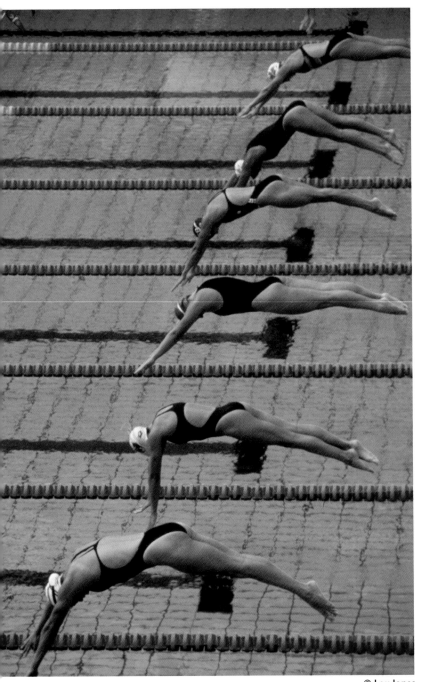

© Lou Jones

Challenge and Reward Yourself

I took this photograph at the 1992 Barcelona Olympics, one of thirteen Olympic games I've photographed.

For me, the start of a race is visually far more interesting than the finish, so get on site early and choose a position.

This kind of assignment is entirely dependent upon access, so make sure you have access to an event before you show up.

Long lenses give you access, too. The distances are often so vast that a 300mm becomes your "normal" optic, so pack your longest lens.

Shoot sports, and you'll find it one of the most challenging and rewarding photography specialties.

Lou Jones
www.fotojones.com
Photographer, author,
workshop leader

© Joseph R. Meehan

Blend and Tone

I have always been fascinated by the ethereal effect that shafts of sunlight piercing through fog (called corpuscular rays) can have on the most mundane of subjects. All too often, however, this type of light has an extreme highlight-to-shadow range beyond the latitude of either film or digital sensors. Enter Photomatix (www.hdrsoft.com), a software program that offers a combination of exposure blending and tone mapping to bring out the available color and tone information from a series of bracketed exposures. With my camera on a tripod, I used five bracketed exposures to capture the full brightness range of this farm scene at sunrise and Photomatix did the rest.

Try the Photomatix and try to get up early to catch the beauty of corpuscular rays.

> *Joseph R. Meehan*
> *www.josephmeehan.com*
> *Photographer, author, lecturer*

© Mpix Guys

Book It

If you like making photo books from your favorite photos, here are some tips for making your first book a best seller (with family and friends, anyway). These tips apply to Mpix books, but they also apply to personal book-making in general.

Use the latest version of the book's software. Updated features speed up and enhance the process.

Preview your book before ordering. Check all text, images and most importantly the cropping of your pages to ensure your book will be as you have visualized it.

Upload RGB images. RGB provides the optimal color results for on-line printing.

Avoid large amounts of solid color to reduce the likelihood of any streaking.

Use the JPEG format at 300 PPI for the optimal size and format.

Save your project frequently to avoid losing your work.

Pick the right paper type to show off your images.

Last tip: Have fun!

>*Mpix Guys: Joe Dellesega, Matt Miller, John Rank*
>*www.mpix.com*
>*On-line prints, books, cards and a host of other digital services*

The Bottom Line about the Horizon Line

Do you know where your horizon is? In many types of nature photographs, the horizon line in the image is often not apparent or important. In broad, scenic views that include a foreground, distant objects and sky, where the horizon is placed within the frame is vital. The proportion of land to sky strongly affects the impact of a landscape photograph.

When it comes to the horizon line, the bottom line is that it is important to explore all the options — up, down or center — without blinders. Even though I rarely place the subject, be it the horizon or a flower, in the center of my camera frame, I don't want to narrow my choices. If I had adhered to the "don't center" rule and my own tendency, I could not have made the photograph shown here: Cloud Reflections and Mt. Moran, which is one of my best-selling fine art prints.

As soon as you become aware of the importance of the horizon line's placement, you will be making similar decisions when designing your images.

© William Neil

Watch carefully as you raise and lower your camera to see how relationships within the frame change. How do the mood, emphasis and scale change? Think about what is most important to you in the image. When the foreground is most important, try pushing the horizon towards the frames' top edge to see if it works. When you have an amazing sky, try the horizon in a low position.

The next time you photograph the landscape, consider the horizon, and break a few rules!

William Neil
www.williamneill.com
Photographer, Author, Teacher, instructor on BetterPhoto.com,
Canon Explorer of Light and columnist for Outdoor Photographer magazine

© David Austin Page

What If?

Most often, a first impression is the best impression. However, with advancements in digital photography, the world of "What if?" can inexpensively improve a good photograph.

Such was the case when my friend, Dick Zakia, and I were recently photographing in Ireland. One day, Dick asked me to stop the car because he saw a great tree backlit against an angry sky. From our angle, the tree had a great rounded right side, but a stunted left side. Dr. Zakia headed off to the right to improve his angle. I had not planned to take a picture because it was "his" tree.

While standing by the car, I asked myself, "What if I only photographed that right side of the tree and flipped it in the digital darkroom for the left to make a symmetrical image?" So I took the picture.

The result is the image you see here. The resulting "faces" in the center of the image were a welcome, unexpected bonus. I am sure you will see them if you look closely.

I used to tell my students film is cheap, use it. Now I say pixels are free. Use them wisely and explore, "What if?"

> *David Austin Page*
> *www.David-Page-Photography.com*
> *Retired Duke University Fine Arts Photographer and former Photographic Engineer*

© Robert M. Sammon, Sr.

Family First

From an early age, I was serious about my photography, using everything from a Kodak Brownie to a 4x5 Speed Graphic to a variety of single and twin lens film cameras to a Canon Vt to a Canon EOS digital SLR. Recently, however, macular degeneration has caused me to reluctantly put down my Canon, and I do miss it.

I still love photography, however, and I often think of the professional-looking pictures that my wife and I took of family activities and our travels abroad and throughout the United States. Each image is a record of a memorable experience.

Now at 90 years old, the pictures I think about most often are the pictures I took of my family, including this shot that I took in 1955 of our sons Rob and Rick (the author of this book) playing on a cannon at Bear Mountain State Park in New York.

That image, like my other favorite family photographs, is a frozen moment in time, capturing a special day for me . . . because it was a day spent with my family.

My advice to all photographers – amateurs and pros alike – is to take as many family shots as possible. When you are my age (and even younger), they will be your most important photographs, and wonderful memories, too.

Robert M. Sammon, Sr.

Photographer and Rick's Dad, Friend and First-Round Editor for all his books

© Eddie Tapp

Create Dramatic Images

Want to add some drama to a scene? Use the Zoom option in Photoshop's Radial Blur filter to create this exciting effect. Here's how to do it.

Go to Filter > Convert for Smart Filters.

Then go to Filter > Blur > Radial Blur > Zoom. Click on the Blur Center box and use the grid to choose the center point of the blur – the church's steeple in my image.

After applying the filter, click on the Smart Filters' mask.

With black selected as your foreground color, select a soft-edge brush and "paint out" the area in which you don't want the effect applied, in this case most of the church.

Try this effect on action images, especially those in which the subject is coming toward the camera.

Eddie Tapp
www.eddietapp.com
Photographer, Photoshop expert, educator, Canon Explorer of Light and consultant

Closeness to Nature

My Celtic ancestors had an intuitive sense of spirituality illuminated by their closeness to nature. In Maine, I feel a sense of inner belonging. Each day heightens the awareness of the completing of a circle, and the more I age, the more intense and stimulating the adventure and the journey become.

I took this photograph while teaching a class at the Maine Media Workshops, a great place to take photography courses over the summer and fall (www.theworkshops.com).

My advice to photographers: Get in touch, and stay in touch, with nature.

Joyce Tenneson
www.tenneson.com
Photographer, author, workshop leader, Canon Explorer of Light, Fine Art Photographer of the Year (2005)

© Joyce Tenneson

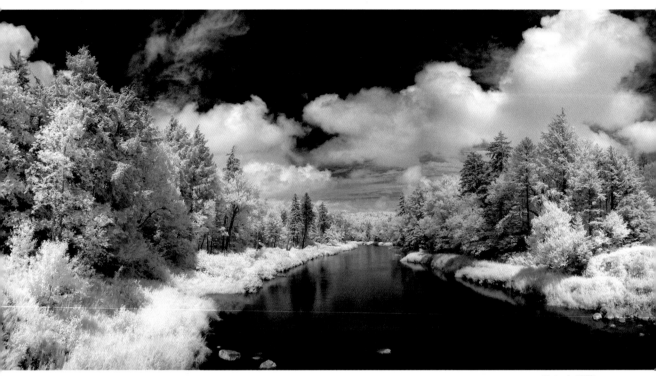

Summer into Winter

Want to turn summer into winter, photographically speaking? Go infrared! With an IR-converted camera, green leaves and foliage take on an icy, winter look.

Here's one of my favorite photographs. It was taken in the middle of the day on a hot, steamy July day in the Adirondacks of New York with an IR-converted compact digital camera. It's actually a stitched panorama of six shots taken in portrait orientation.

Go IR if you feel you are in a creative slump.

Andy Williams
www.moonriverphotography.com
Professional landscape photographer, manager of Smugmug and co-founder of Muench Workshops

© Ben Willmore

Experience the Emotion, Experiment in Photoshop

When I raise my camera to eye level, it's usually because I see something that is pulling me into a scene emotionally. So, my first tip is that the more you are drawn to a scene, the more powerful your photographs will be.

I try to capture the most compelling composition while attempting to limit the amount of potential distractions in the scene. Therefore, when you are composing a photograph, keep an eye out for distracting elements.

I take that a step further when I get to Photoshop and often remove distractions like telephone lines and parked cars to prevent the viewer from being distracted by elements that didn't attract my eye.

I then attempt to draw the viewer's attention to whatever pulled me into the scene by brightening, adding contrast or boosting color in the elements I want their eyes to explore. In the image here, I added a tobacco-colored, tinted black-and-white effect to most of the image while leaving the areas my eye was drawn to in full color. That helped direct the viewer's eye and produced somewhat of a nostalgic feeling in the image.

To learn the start-to-finish workflow I use to produce images like this, check out my High Dynamic Range (HDR) DVD at www.DigitalMastery.com

Ben Willmore
www.thebestofben.com
Ben Willmore, author, worldwide speaker, inductee into the Photoshop Hall of Fame and 40-foot long motorcoach traveler (www.whereisben.com)

© Vicki H. Wilson

Be Spontaneous

I love the snow. I spotted this large grove of trees on a rural road in the foothills of Virginia. I was attracted to the sublime symmetry of the uplifted, thin bare limbs, in contrast to the dark background. The scene evokes serenity and peace—an entrancing atmosphere, with subtle touches of green hinting at life's cycle of seasons.

My tip: Photograph without preconceived ideas. I have a passion for capturing bright colors and reflections, and this image totally defies all of my photographic tendencies and instincts.

Digital photography fosters spontaneity. Defy your natural instincts, and you may surprise yourself – and others who view your work.

Vicki H. Wilson
Former graphic design and photography instructor
at Alamance Community College, Graham, NC

© Richard D. Zakia

Shoot, Don't Think

This photograph was taken at the Museum of Confederate History in Richmond, Virginia. It is a simple snapshot taken on the spur of the moment. I keep coming back to it, searching for meaning and finding none. It continues to puzzle me and perhaps that is its meaning.

If something catches your eye and you feel drawn to it for some unknown reason, don't spend time thinking about it. Photograph it and study it later. It can reveal itself over time.

> *Richard D. Zakia*
>
> *Retired faculty member, Rochester Institute of Technology. Dr. Zakia's latest book is Perception and Imaging: Photography – A Way of Seeing.*

© Barry Zeek

Freeze It

I try to always plan my shots and not shoot from the hip. In this shot, taken on a bright, sunny day, my goal was to freeze the action.

My subject was traveling at 175 mph – pretty darn fast. Using my Canon EOS 1D Mark III, I chose a high shutter speed (1600th of a second) with the camera set to TV (time value) mode. The reason to choose the TV mode is that if the light level changes, the shutter speed remains the same, while the camera changes the f-stop to compensate for the change in light level.

I set my ISO to 100 for the cleanest possible image, because as the ISO increases, so does the digital noise in an image.

I also set my camera on the AI Servo focus mode, which tracks the subject right up until the time of exposure.

And because the subject was moving so very fast, I set my drive mode to high speed, which gave me a series of pictures from which to choose.

To help ensure sharp, clean shots of fast-moving subjects, try the aforementioned camera settings. Also shoot with both eyes open, so you can see if any other subjects are coming into the scene.

Barry Zeek
www.barryzeek.com
Specialist in high-speed motor sports photography

Part XI

What Does Your Photography Mean to You?

In September 2008, I had the pleasure of giving a short lecture at the School of Visual Arts (SVA) in NYC.

One of my Photoshop heroes, Katrin Eismann, Chair of the Masters in Digital Photography Program, had invited me to share some of my photographs and travel adventures from my books, as well as my philosophy on the all-important business side of photography.

To start off my session, as I often do, I asked the students to answer this question: What does your photography mean to you?

Over the past 10 years of teaching workshops and giving seminars, this question has been answered many, many different ways – and actually and honestly has brought some people to tears, as photography means so much to some shooters.

I always hear new "meanings." I have found that when photographers verbalize their thoughts on the personal meaning of photography, some for the very first time, it gives the individual a unique look inside their photographic soul.

Ask yourself that question. You may be surprised at your answer.

Katrin, a wonderful photographer, as well as THE Photoshop Diva, was kind enough to write down key words of the students' responses.

Saved my life

Exploring

Everything

Expression

Communicate

Frame my world

Manage my experiences

Telling a story

Get out of the house

Make my mom proud

Speak to different people

Influence others

Build-up language

Understand and feel more connected

Convey ideas

Look and look again

Lifestyle

Making Money

Play and fun

Reveal secrets

Nine of these answers were new to me. Again, I have been doing this for 10 years.

Ask yourself this question – from time to time. You answers may vary, as they have for me.

Another interesting exercise, by the way, is to put captions on your photographs. Doing so helps one see the "meaning" in an image.

Check out SVA. You'll find many way-cool Undergraduate, Graduate and Continuing Education programs. One of my favorite pages on the site is the Student Art page.

Links:
SVA: http://www.schoolofvisualarts.edu/index.jsp
Katrin Eismann: http://www.katrineismann.com/
MPS Digital Photography Program: http://www.sva.edu/grad/index.jsp?sid0 = 2&sid1 = 227
Photoshop Diva: http://www.photoshopdiva.com

Rick Sammon's Sampler DVD

What you'll see and how to see it!

What a deal! The DVD enclosed with this book includes 12 QuickTime movies from two of my Wiley DVDs – *Rick Sammon's Guide to Basic Lighting and Portraiture* and *Rick Sammon's Canon EOS Digital Rebel Personal Training Photo Workshop.*

I had a ton of fun producing these info-packed, live-action video lessons – the list of which is below.

As far a viewing them, that's easy! Simply pop the DVD into your DVD drive on your computer (not into your home DVD players). Click on a movie and away you go. Use the arrows and buttons on the bottom of the QuickTime window to play, stop, fast-forward and rewind the movies.

Enjoy! If you like what you see, check out these DVDs and my other DVDs on amazon.com.

Wiley Publishing, Inc. End-User License Agreement

READ THIS. You should carefully read these terms and conditions before opening the software packet(s) included with this book "Book". This is a license agreement "Agreement" between you and Wiley Publishing, Inc. "WPI". By opening the accompanying software packet(s), you acknowledge that you have read and accept the following terms and conditions. If you do not agree and do not want to be bound by such terms and conditions, promptly return the Book and the unopened software packet(s) to the place you obtained them for a full refund.

1. **License Grant.** WPI grants to you (either an individual or entity) a nonexclusive license to use one copy of the enclosed software program(s) (collectively, the "Software," solely for your own personal or business purposes on a single computer (whether a standard computer or a workstation component of a multi-user network). The Software is in use on a computer when it is loaded into temporary memory (RAM) or installed into permanent memory (hard disk, CD-ROM, or other storage device). WPI reserves all rights not expressly granted herein.

2. **Ownership.** WPI is the owner of all right, title, and interest, including copyright, in and to the compilation of the Software recorded on the disk(s), or CD-ROM or DVD "Software Media". Copyright to the individual programs recorded on the Software Media is owned by the author or other authorized copyright owner of each program. Ownership of the Software and all proprietary rights relating thereto remain with WPI and its licensers.

3. **Restrictions On Use and Transfer.**

 (a) You may only (i) make one copy of the Software for backup or archival purposes, or (ii) transfer the Software to a single hard disk, provided that you keep the original for backup or archival purposes. You may not (i) rent or lease the Software, (ii) copy or reproduce the Software through a LAN or other network system or through any computer subscriber system or bulletin-board system, or (iii) modify, adapt, or create derivative works based on the Software.

 (b) You may not reverse engineer, decompile, or disassemble the Software. You may transfer the Software and user documentation on a permanent basis, provided that the transferee agrees to accept the terms and conditions of this Agreement and you retain no copies. If the Software is an update or has been updated, any transfer must include the most recent update and all prior versions.

4. **Restrictions on Use of Individual Programs.** You must follow the individual requirements and restrictions detailed for each individual program in the About the DVD appendix of this Book. These limitations are also contained in the individual license agreements recorded on the Software Media. These limitations may include a requirement that after using the program for a specified period of time, the user must pay a registration fee or discontinue use. By opening the Software packet(s), you will be agreeing to abide by the licenses and restrictions for these individual programs that are detailed in the About the DVD appendix and on the Software Media. None of the material on this Software Media or listed in this Book may ever be redistributed, in original or modified form, for commercial purposes.

5. **Limited Warranty.**

 (a) WPI warrants that the Software and Software Media are free from defects in materials and workmanship under normal use for a period of sixty (60) days from the date of purchase of this Book. If WPI receives notification within the warranty period of defects in materials or workmanship, WPI will replace the defective Software Media.

 (b) WPI AND THE AUTHOR(S) OF THE BOOK DISCLAIM ALL OTHER WARRANTIES, EXPRESS OR IMPLIED, INCLUDING WITHOUT LIMITATION IMPLIED WARRANTIES OF MERCHANTABILITY AND FITNESS FOR A PARTICULAR PURPOSE, WITH RESPECT TO THE SOFTWARE, THE PROGRAMS, THE SOURCE CODE CONTAINED THEREIN, AND/OR THE TECHNIQUES DESCRIBED IN THIS BOOK. WPI DOES NOT WARRANT THAT THE FUNCTIONS CONTAINED IN THE SOFTWARE WILL MEET YOUR REQUIREMENTS OR THAT THE OPERATION OF THE SOFTWARE WILL BE ERROR FREE.

 (c) This limited warranty gives you specific legal rights, and you may have other rights that vary from jurisdiction to jurisdiction.

6. **Remedies.**

 (a) WPI's entire liability and your exclusive remedy for defects in materials and workmanship shall be limited to replacement of the Software Media, which may be returned to WPI with a copy of your receipt at the following address: Software Media Fulfillment Department, Attn.: Rick Sammon's Digital Photograph Secrets, Wiley Publishing, Inc., 10475 Crosspoint Blvd., Indianapolis, IN 46256, or call 1-800-762-2974. Please allow four to six weeks for delivery. This Limited Warranty is void if failure of the Software Media has resulted from accident, abuse, or misapplication. Any replacement Software Media will be warranted for the remainder of the original warranty period or thirty (30) days, whichever is longer.

 (b) In no event shall WPI or the author be liable for any damages whatsoever (including without limitation damages for loss of business profits, business interruption, loss of business information, or any other pecuniary loss) arising from the use of or inability to use the Book or the Software, even if WPI has been advised of the possibility of such damages.

 (c) Because some jurisdictions do not allow the exclusion or limitation of liability for consequential or incidental damages, the above limitation or exclusion may not apply to you.

7. **U.S. Government Restricted Rights.** Use, duplication, or disclosure of the Software for or on behalf of the United States of America, its agencies and/or instrumentalities "U.S. Government" is subject to restrictions as stated in paragraph (c)(1)(ii) of the Rights in Technical Data and Computer Software clause of DFARS 252.227-7013, or subparagraphs (c) (1) and (2) of the Commercial Computer Software - Restricted Rights clause at FAR 52.227-19, and in similar clauses in the NASA FAR supplement, as applicable.

8. **General.** This Agreement constitutes the entire understanding of the parties and revokes and supersedes all prior agreements, oral or written, between them and may not be modified or amended except in a writing signed by both parties hereto that specifically refers to this Agreement. This Agreement shall take precedence over any other documents that may be in conflict herewith. If any one or more provisions contained in this Agreement are held by any court or tribunal to be invalid, illegal, or otherwise unenforceable, each and every other provision shall remain in full force and effect.

Index

C